Art Materials, Techniques, Ideas:
A Resource Book for Teachers

Virginia Gayheart Timmons

Art Specialist, Secondary Schools

Baltimore City Public Schools, Maryland

Davis Publications, Inc.

Worcester, Massachusetts

An Oak Tree Press Book
distributed by
WARD LOCK LTD., LONDON

Art Materials,
Techniques, Ideas:
A Resource Book
for Teachers

Davis Publications, Inc.
Worcester, Massachusetts, U. S. A.
Printed in the United States of America
Library of Congress Catalog Card Number: 73-89254
ISBN 0-87192-057-3

Printing: The Alpine Press Inc.
Type: Linotype Palatino, by Thomas Todd Company
Design: Panagiota Darras

Consulting Editors: George F. Horn and Sarita R. Rainey

Title page photo —

Mosaic. Student, Baltimore City Public Schools. Seeds and beans, in natural colors. A clear-drying glue was used to adhere the materials to stiff cardboard. The surface was sealed with acrylic spray to enhance the colors and protect the surface. Photo by Claude Tittsworth.

Contents

Bit each section.

Collage (Quine bit)

Lot.

See also

To the Reader

The writing of this manuscript has grown out of my personal interest in the materials and techniques of art and in the myriad possibilities for their uses in the art classroom. Additionally, there was the ever-present professional responsibility for providing information and guidance in the uses of materials for the teachers with whom I have worked. Their requests for assistance have been expressed in various ways: "But I don't *have* any _____." "But what else can I *do* with it?" "Weaving? But we have no looms!" This book, then, is my attempt to answer some of the questions, some of the needs, for the beginning teacher, the experienced teacher and the classroom teacher lacking extensive experience with art materials.

In choosing materials and techniques for discussion, some limits had to be defined; an exhaustive treatment of every material, every technique was obviously outside the scope of a single volume. The choices I have made are based on personal observations of teachers and students at work; they are the materials and techniques which have elicited the most enthusiastic responses in the classroom. Certain traditional materials and techniques were omitted to make room for "newer" materials, more experimental techniques.

The teacher seeking a "how-to-do-it" pattern book will not find it here: techniques are defined only to the point where they can provide points-of-departure and, hopefully, stimulate further experimentation. Activities are suggested as they encourage varied applications of materials or techniques. Finished products by both professional and student artists were chosen to illustrate a variety of design approaches and techniques in the uses of specific materials.

The materials in this book are not offered as a "program of study" — the emphases are materials, techniques and ideas for their uses in the classroom. While realizing that materials and techniques are but the "means to an end" in art, it is my firm belief that a basic, working knowledge of them expands the artist's vocabulary for creative, personal expression.

V.G.T.

Assemblage. (Detail) Reinhold P. Marxhausen. Found objects on hardboard. Photo, courtesy the artist.

Chapter 1
Improvised Materials and Tools

Because materials and funds are not inexhaustible, it is often necessary to improvise or provide substitutions for conventional materials commonly used in the classroom and art studio. While the formulae and techniques suggested here are not intended as permanent replacements for commercially prepared materials, they have been found to be entirely adequate in classroom use. If there is doubt, test the material before using it in the activity or project that is planned.

MATERIALS

Adhesives

The following formulae will produce adhesives that are strong enough for use with paper, lightweight boards, fabrics and similar materials. They cannot, however, be used in joining heavier or non-porous materials such as glass, plastic, heavy wood and metal.

Flour Paste
 ½ cup sifted flour
 2 cups cold water
Add water slowly to flour to make a smooth paste. Stir slowly while cooking over a low flame until clear. One teaspoon of alum may be added as a preservative.

Papier-Mâché Paste
 1 cup flour
 2 cups boiling water
 2 teaspoons liquid glue
 A few drops of oil of cloves
Make a creamy paste with flour and cold water, then add boiling water and other ingredients and stir until smooth.

Library Paste
 2 tablespoons *Minute* Tapioca
 3 tablespoons sugar
 1 teaspoon vinegar
 1 pinch salt
 1 cup boiling water
Mix all ingredients and cook in a double boiler until the mixture is smooth and thick. Store in covered glass jars in a cool place.

Paste

1 cup alum (drugstore)
2 cups warm water
½ teaspoon powdered resin (hardware store)
Oil of cloves or wintergreen (a few drops)

Dissolve alum in warm water and, when it is *cold*, add enough flour to obtain a creamy consistency. Add remaining ingredients and bring to a boil, stirring until thick. Store in an air-tight container.

Paints

Simulated Oil Paint

Dry powder paint plus enough boiled linseed oil to produce the desired consistency. For a glossy finish, add a bit of varnish.

Tempera Paint

Mix dry powder paint with enough water to make a creamy consistency. One tablespoon of wallpaper paste, liquid starch or liquid glue may be added as a binder.

Finger Paint — A

2 cups flour
2 tablespoons salt
3 cups cold water
2 cups hot water
food coloring

Mix flour and salt, then *gradually* add the cold water, mixing until smooth. (A rotary egg beater will make mixing easier.) Add two cups hot water and boil the mixture until it is smooth, stirring constantly. Add food coloring (about ¼ cup to 8 oz. of boiled mixture).

Finger Paint — B

1 cup dry starch
½ cup cold water
1½ cups boiling water
¾ cup powdered detergent

Mix the starch and *cold* water in a metal container and stir until smooth. Add the detergent and stir again. Add enough powder paint to produce a strong color.

Easel Paint

1 pound powder paint
¼ cup liquid starch
⅓ cup water
1 tablespoon powdered soap (not detergent). Mix thoroughly and use for either easel paint or finger painting.

Encaustic Painting Medium (Cold Wax)

2 oz. beeswax
4 oz. turpentine
1 teaspoon sun-thickened linseed oil
½ teaspoon Damar varnish

Place all ingredients in a metal container and heat over low heat until melted. Allow to cool. Mix with powdered tempera and apply thickly, in several applications, over a tempera, watercolor or collage underpainting. After *each* application, the wax and paint mixture is melted with an encaustic lamp held above the painted surface to fuse the color.

Inks

Waterbase Silkscreen Ink

1. Equal parts of powdered tempera and liquid starch, plus enough water to make a pudding consistency.
2. Mix together: 1 part liquid tempera, 1 part glycerin and 1 part Ivory Snow soap granules.

Block Printing Inks

1. Powder paint and varnish, mixed on a sheet of glass or plastic, to the proper rolling consistency.
2. Add a bit of glycerin to thick tempera paint. The glycerin will slow the drying time, providing greater "workability."

Carving Materials

Simulated Stone

Simulated stone may be made from cement, plaster of Paris, sand and Zonolite (an insulating material obtainable at lumber yards).

In any combination, all materials should be thoroughly mixed, while dry, before adding water or other liquids.

Mixture 1: 1 part sand, 1 part cement, 3 parts Zonolite
Mixture 2: 2 parts sand, 2 parts cement, 4 parts Zonolite
Mixture 3: 2 parts cement, 4 parts Zonolite
Mixture 4: 1 part sand, 1 part cement, 1 part plaster of Paris, 4 parts Zonolite
Mixture 5: 2 parts plaster of Paris, 1 part sand, 3 parts Zonolite

Colorants: Colored ink, vegetable coloring, dry or liquid tempera may be added to the mixtures.

Procedures: Enough water should be added to produce a thick, pasty consistency that can be poured into a waxed milk container or cardboard box that has been coated inside with Vaseline or liquid wax.

A cement mixture requires about three days to harden.

Other Materials For Carving: Formulae

Mixture 1: 1 part sand, 2 parts plaster of Paris, 4 parts vermiculite. Mix with water to a pourable, pasty consistency.

Mixture 2: 1 part melted paraffin, 1 part sawdust (or sand). Important: Melt paraffin in a double boiler to avoid danger of fire. Do *not* permit younger students to prepare paraffin.

Mixture 3: Mix any quantity of plaster to the consistency of cream and stir in one-quarter the volume of Permalite. Stir well or the Permalite will rise to the top. The finished piece has a pure white finish.

Procedures: In using all of the above formulae, pour the mixture into a waxed milk carton or other flexible container which has been coated inside with Vaseline or liquid wax for easy removal. Carve with carving tools, paring or table knives, nails, ice cream sticks or other improvised tools.

Finishing: The finished piece can be left plain or finished in various ways. In general, a more handsome piece is obtained if the finish is a subtle one which permits the natural materials to show through.
 a. *Floor wax,* in three or four coats.
 b. *Oil paint,* such as raw umber, painted on, rubbed off with a cloth, then waxed.
 c. *Spray oil paint* in plain or metallic colors.

Unfired Bricks Wherever available, this native material provides an excitingly different carving material. *Unfired* bricks can be obtained from brick manufacturers in certain areas of the nation where bricks are produced. The following suggestions will be helpful: Use plastic bags or sheet plastic for the storage of unfired brick and, to prevent too rapid

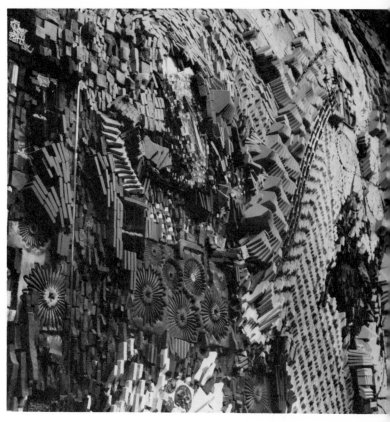

Mural. (Detail) Glen Michaels. Scrap tile, found objects and watch parts. Designed for the reception lobby of the Bulova Watch Co., N. Y., the complete mural measures 17' x 8', and is composed of over 47,000 different pieces, including 10,000 watch parts. Photo, courtesy Bulova.

drying, wrap work in progress in damp cloths. After the design has been carved, permit the brick to dry *slowly* until it is bone dry. Fire at cone 06 or 05. To decorate, apply underglaze to the greenware or to the bisque ware. Colored 010 to 05 glazes can be applied to the bisque ware.

Clay that is carved away can be salvaged for future use. Add water to the scraps of clay and set them aside for approximately two weeks. After that time, the clay should be wedged thoroughly before use and all foreign matter removed.

Modeling Materials

Aside from non-hardening modeling clay (Plasticene, Plastilene), the most widely used modeling material in the classroom is probably *papier-mâché.* Because

of its myriad techniques and applications, papier-mâché is discussed separately in Ch. 10.

The formulae for modeling materials which are given here have been tested in classroom use and are relatively inexpensive to prepare.

1. *P.V.A. (polyvinyl acetate) and wood flour.* Mix one cup of wood flour with one-fifth cup of P.V.A. (or equal parts of white glue and water). Mixture can be modeled on a flat surface or over an armature of wood or wire.
2. *Sawdust, P.V.A., water and wheat paste.* Mix 2 cups sawdust, ½ cup wheat paste and ½ cup P.V.A. to 4 cups water. If necessary, P.V.A. may be omitted but the use of it creates a more solid material. (As in above, white glue may be substituted.)
3. *Plaster of Paris, wallpaper paste, sawdust.* Two parts plaster of Paris, 1 part wallpaper paste, 4 parts sawdust. Mix ingredients thoroughly, then add 1 to 2 cups water. This makes a smooth mixture for puppet heads.
4. *Wallpaper paste and sawdust.* Mix the paste as recommended on package, then add sawdust until the desired handling consistency is obtained.
5. *Liquid glue and sawdust.* To sawdust, add enough liquid glue to form a thick paste. When dry, this material is quite hard and can be sawed, filed whittled or sanded. This is an excellent material for adding fine details to puppet heads, masks and papier-mâché jewelry.
6. *Bread paste.* Remove the crusts from white bread. Mix the crumbled bread with enough white glue to form a modeling consistency. Use for finely detailed modeling, such as decorative elements on jewelry. (Use as papier-mâché pulp is used.)
7. *Wood shavings and wheat paste.* Mix wheat paste and add *fine* wood shavings until a good handling consistency is obtained. Model on a flat surface, for best results. Economical for masks and relief sculpture.
8. *P.V.A. and Permalite.* Two cups Permalite to ½ cup P.V.A. This mixture must be modeled flat because it crumbles when built to any height.

Procedures: In all of the above formulae, mix *dry* ingredients thoroughly before adding liquid except where noted, as in 4. Sawdust and wood shavings produce rough surfaces but can be sanded quite smooth.

Coloring or paints are best applied after the product has dried. In general, finishes recommended for papier-mâché may be used (see Ch. 10) or if a simpler finish is desired, refer to those recommended for carving materials, in this chapter.

Fabric and Plaster Mix Hydrocal plaster, in any quantity, to a light creamy consistency. (Hydrocal produces a harder, more durable product but plaster of Paris may be substituted. If the substitution is made, reduce the water used by one-quarter, and add white glue in that amount.) Cut strips of fabric — gauze, old sheeting or other absorbent white cloth — and dip the strips into the plaster. The strips may then be used in a variety of ways:

1. Over an armature of wire, wood, plastic, balloons, screen or scrap materials. Fill in areas with crushed newspaper or wads of dampened fabric. The type of armature will be determined by the object to be made; consider *figures, animals, masks, decorative or display forms.*
2. *On hardboard panels,* to create a textured *painting.* The strips may be worked over previously applied relief materials including foil, cardboard shapes and found materials. Seal *both* sides of the panel with white glue to lessen dangers of warping.
3. In *dioramas,* to create *scenery.* Build basic forms from corrugated board and found objects, then cover with plaster-dipped strips.

Procedures: Work carefully to achieve desired modeling, using narrow strips for small objects, larger strips for larger objects. Permit the objects or figures to dry thoroughly — approximately 24 hours — before painting or decorating. If pieces must be joined, use more strips, then permit the join to dry thoroughly before moving it. Finishes may include acrylic paints, tempera (seal with shellac), metallic colors and, in general, those finishes recommended for papier-mâché. Finished pieces should *not* be sanded since this would roughen or fray the underlying fabric.

Gesso

1. Add white glue to spackle (patching plaster) to create a brushable consistency.
2. Add acrylic medium to spackle and mix as above.

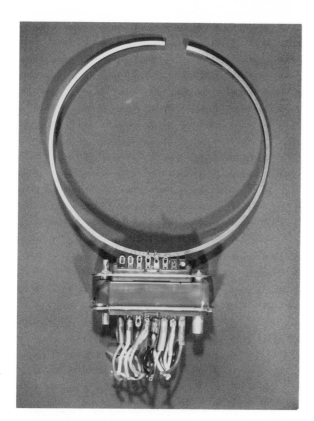

Pendant. Student. Surplus electronic materials and wire. From *Inventive Jewelry Making*, Ramona Solberg.

Pull-Top Necklace. Student. Aluminum pull-tops from beverage cans, with wire. From *Inventive Jewelry Making*, Ramona Solberg.

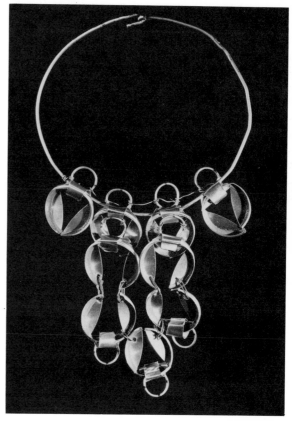

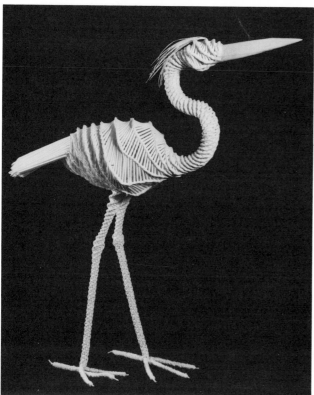

Straw Bird. Long paper "Craft-straws" are woven, knotted and twisted into a fanciful bird. The straws are equally effective in combination with other materials such as colored tissue, papier-mâché and liquid metals, such as Sculpmetal. Photo, courtesy Macmillan Arts and Crafts.

Wood Stains and Finishes

1. Mix powdered tempera paint and linseed oil or turpentine until a smooth brushing consistency is obtained. Brush the mixture over the wood and, after it has been absorbed, wipe the surface until the desired degree of staining is achieved.

2. *Shoe polish, paste wax type*
 Apply with brush or cloth, then buff to desired sheen.

3. *Shoe polish, liquid*
 Apply carefully and as evenly as possible or color is apt to be uneven or streaked.

4. *Petroleum jelly (Vaseline)*
 A simple effective treatment, particularly for a carved or burnished surface. Apply with dauber, then buff with a soft cloth.

5. *Beeswax and mineral oil*
 Melt the beeswax and thin it to brushing consistency. Apply while hot, then rub down.

6. *Varnish and oil*
 In a metal container, mix equal parts of turpentine, boiled linseed oil and spar varnish. Warm to 70°-75° F. and apply to wood surface with a cloth. After the mixture has soaked in, rub the surface briskly until it will absorb no more. After one week, a second treatment may be applied and the surface waxed.

7. *Fabric dyes*
 Test for desired color on a scrap of the wood to be treated. Dilute or use full strength, as desired. Dyed woods may be further treated with an application of a sealer such as varnish, shellac, acrylic medium or any clear spray finish. Fabric dyes tend to fade, in time. For more permanent color, use a conventional wood stain.

8. *Floor wax, paste type*
 Warm both the wood and the wax for easier application. Allow the first application to dry for approximately one hour, then buff.

9. *Paints*
 Thin paint with *appropriate* thinner (see labels), then brush or daub on wood. Allow to penetrate, then rub with cloth until all traces of wetness disappear.

10. *Glazes*
 a. Add *acrylic paints to acrylic medium.* Apply by brushing. When the glaze has dried somewhat, wipe the high spots clean with a soft cloth. Do not apply acrylic glaze over oil colors.
 b. Two parts turpentine, one part linseed oil, plus enough oil paint to produce color desired. Brush over the painted surface and, when the glaze has dried to a dull or matt finish, wipe the glaze from the high spots with a soft cloth.

Glazes of this type are usually applied over a previously painted base coat to achieve a toned or "antiqued" effect. *Latex enamel* paints provide an excellent base color since they are not disturbed by the turpentine used in an oil glaze such as (b).

11. *Driftwood, Found Wood Treatment*
 a. To retain the natural color and protect the wood, use a wire brush to remove soil and other debris. Scrape away stubborn accumulation and deteriorated, soft wood. Seal with liquid wax, thinned acrylic medium or thinned satin-finish varnish.
 b. To add subtle color stains, brush or wipe on wood stain, oil glaze (see glazes), or acrylic colors thinned with water or acrylic medium.
 c. To bleach, brush on a strong solution of

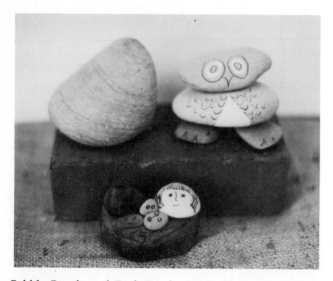

Pebble People and Bird. Beach stones. Stones are joined with strong cement; details are added with paints, inks. Acrylic paints or household paints are recommended.

household bleach and water or use commercially prepared wood bleaches. (Hardware store)

d. To char, use a propane torch. Move the flame quickly over the surface of the wood, to avoid over-burn in one area. (Caution! The burning should take place outdoors.) When charring is completed, extinguish the flame with water. Scrub the wood with a wire brush to remove ashes and soot. When the wood is free of loose particles it may be waxed or sealed as in (a). Scraps of plywood treated in this manner can be especially handsome, as the layered patterns of the wood become more pronounced.

Mortar

Two parts cement
Six parts sand
One part hydrated lime

1. Omit lime if project is installed out-of-doors.
2. Add water until the mix will stand on a trowel; use less water if lime is added.
3. For a stronger bond, use liquid latex instead of water.
4. If used in a thick bed, pour cement in two layers, using wire mesh or hardware cloth *between* the layers, for added strength.
5. Color with cement colors.
6. Mix all dry ingredients before adding water or liquid bonding agents.

TOOLS AND DEVICES

Clay Tools

Cut a *wood dowel* to length desired and shape the ends: one end may be pointed by sharpening it in a pencil sharpener; with a knife, whittle the remaining end to a spoon-like shape. To make a wire-loop tool: open up a paper clip and cut it in half, then bind one of the wire loops to the dowel with fine wire or thread. Cover the binding with epoxy cement or other strong, *waterproof* adhesive. A similar clay cutting tool may be made by cutting a thin metal strip from a can or scrap metal, shaping it into a loop and binding it to a dowel or pencil, as described above.

Weaving Needle

Break the handle from an old toothbrush: file the rough, broken end into a tapering point; tie yarn into the hole at the other end and weave. Or: make a hole — large enough to carry the yarn — in the end of a "pop-stick" or tongue depressor.

Felt Marker

Cut a strip of heavy, stiff felt (old hat, felt bag) and fold it in half. Place the loose ends between two tongue depressors and bind with strong rubber bands, wire or thread, at both ends of the depressors. Cut the strip as wide as the depressors; experiment by cutting notches in the felt, for a textured line effect.

Print Blocks

To provide blocks: (a) With waterproof cement, adhere scraps of felt, foil, strings, paper lace and cardboard shapes to a rigid backing such as corrugated or bookbinder's board. (b) Cut or impress lines in a block of plastic foam or foam food trays. (c) Shape or crumple a sheet of heavy-duty foil to create a variety of textures and plain areas. Mount the foil on corrugated cardboard; ink and print by rubbing. To make *stamps* for printing: cement "found" objects to one end of a spool, or make designs, letters or numbers of felt, wood, hard rubber and adhere these to spools or small wood blocks. Ink by usual method or brush on tempera paint.

Puppet Heads

(a) Model on wood clothespins (not clip type) and store to dry by hanging from a "clothesline". (b) For drying, stick the puppet heads on the necks of soft drink bottles. If bottles wobble, partially fill them with sand. This technique may also be used to hold the heads securely while they are being painted or decorated.

Paste Book

For neater, cleaner pasting: place the paper shape to be adhered, *face down*, on a page in an old magazine. Apply paste, brushing outward, toward the *edges* of the shape. Lift shape and adhere it to design. When the magazine page becomes smeared with paste, turn to the next page. This simple aid will keep paste off the face of cut-paper shapes — and off desks, tables.

Frames

Attach fabric or yarns for stitchery or weaving to: discarded picture frames; hoops of wood or metal from cardboard packaging drums; frames made from

bent and bound branches. Make adjustable, re-usable frames from wood canvas stretchers. (Except for the branch "frame", the frames may also be used to hold fabrics taut while batik wax is being applied.)

Portfolios

Cut two sheets of corrugated board to required size. Hinge together with cloth bookbinder's tape. Bind edges with tape and attach shoestrings for ties, if desired.

Mobiles

(a) To store while work is in progress: stretch a "clothesline" of wire across one end of the room and *above* eye level; use this line to store work *between* work sessions. Install a *second* set of hooks (nails, heavy screw-eyes) *below* the first set so that the wire may be lowered when work is to be continued. (b) To provide for added movement in mobiles, attach shapes with swivels from sporting goods store.

Scissors

To store: close blades and stick scissors, point down, in a thick block of plastic foam. This is especially recommended when working with young children. *Brushes* may be stored in the same manner — and bristles will be undamaged. Use scrap foam blocks from packing boxes. (Appliance stores, school audio-visual center.)

Clean-up Hints

(a) Fill a plastic jug with water and add a bit of detergent. With a nail, make holes in the metal jug cap, then screw it in place. For small clean-up jobs on desks or tables, sprinkle the surface with water from the jug and wipe with cloth or sponge. No sloshing basins, no spills! (b) Before mopping up freshly spilled paint or ink, cover the spill with newspapers to *soak* up as much as possible, then mop. (c) If a work surface must be washed after working with clay or plaster, first brush the *dried* clay or plaster from the surface and then wash it; there will be less "mud" to remove.

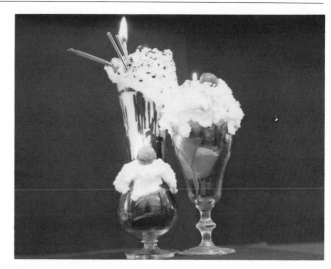

"Pop" Candles. Students, Clifton, N. J., Senior High School. Colored and whipped wax in soda glasses. Photo, courtesy Laurence Goldstein, teacher.

Box Loom. A discarded oatmeal box can be transformed into a loom for making handbags and cylindrical shapes. For further instruction, see *Fibers.*

Chapter 2
Wire and Metals

The use of metals in the art classroom has been comparatively restricted for at least two reasons: the belief that working with metals requires hard-to-get tools or "machinery"; that metals are prohibitively expensive and, therefore, unobtainable in quantities necessary for school use. Many enterprising teachers have learned, however, that simple projects require only basic hand tools such as pliers, hammers and saws available in home workshops and classrooms. While heavy *sheet metals* are admittedly expensive — particularly the "precious" metals — there are others available at little or no cost, simply for the finding. The latter include *wire, metal screen, hardware cloth (mesh)* and *scrap metals* such as tin cans. metal washers, nuts, bolts, screws, nails and metal parts from clocks and appliances. Metal foils (thin sheet) and metal pastes are usually within even the most modest art supplies' budget. With imagination and ingenuity, these materials can be used in designing jewelry, sculpture, constructions, assemblage, metal collage and hangings and can be incorporated in printmaking and other projects where metal literally plays a "supporting" role in armatures and frameworks.

The concern here is to discuss those materials, techniques and applications that have been found practical and successful in typical school programs. The basic *tools and materials* listed here are adequate; those listed as "optional" make work easier or more efficient but are not essential. Basic *processes* such as *sawing, filing, soldering and buffing* are described briefly; refer to the Bibliography for references providing detailed instruction. Methods for *finishing* metals are described at the end of this chapter.

GENERAL TOOLS AND MATERIALS

1. **Pliers:** For general use, the combination type is adequate; for jewelry, include *flat nose pliers* for shaping and bending metal, *round nose pliers* to create curved shapes and *diagonal* cutting pliers for clipping or cutting wire.
2. **Jeweler's saw** and jeweler's saw blades.
3. **Bench pin,** a wooden wedge with a V-shaped opening, fastened to the workbench with a C-clamp. Used to hold or support the metal being sawed or worked.

4. **Files** should include an assortment: general metal files such as 6" *hand files, half-round files* and for fine work, *needle files.* (Needle files are available in a variety of shapes.)
5. **Hand drill** and drill bits.
6. **Steel block,** on which to place metal for forging, or hammering.
7. **Hammers:** A ball-peen hammer and, *optionally,* a *planishing* hammer and *rawhide mallet.* The planishing hammer is used for forging; the rawhide mallet for bending and hammering metal without marring or marking its surface.
8. **For soldering:** the following are essential.
 a. *Soldering gun* or propane torch. The latter contains bottled gas and has an adjustable flame tip.
 b. *Solder* — a metal or metal alloy which is heated to join metallic surfaces.

c. *Flux* — applied to metal before heating and soldering.
d. *Iron binding wire* — to hold pieces together while they are soldered.
e. *Yellow ochre* — used to prevent solder from flowing into and dislodging *previously* soldered areas.
f. *Charcoal block or asbestos block* — for use as a working surface. These will not burn.
g. *Heating frame* — a piece of screen on which the work to be soldered is placed, so that heat can circulate under the piece.
9. **Other materials for finishing.** Emery cloth, tripoli, jeweler's rouge, buffing sticks.
10. **For jewelry** — findings that include earring backs; pin backs; cords or chains for pendants; catches.

Optional: A *ring clamp,* for holding small pieces to be filed, sawed, polished; *buffer-grinder unit; annealing pan,* in which metals are heated. A *flexible shaft tool,* used with a variety of drills and burs to eliminate much handwork; *sheet metal shears; scriber* for marking and tracing.

BASIC PROCESSES

Sawing
Insert the saw blade carefully and properly into the frame: the teeth should be pointed outward from the frame and *downward.* The blade must be taut to cut properly. When sawing, hold the blade vertically and saw on the *down* stroke. To release blade, move the saw up and down, backing out on the sawed line, or release one end of the blade and pull it through.

Piercing
To cut a shape from the interior of the metal, first make a dent with a center punch or nail within the area to be cut out. Make a small hole through the dent with a hand drill or flexible shaft tool. (The dent prevents the drill from slipping.) Release the saw blade from *one* end of the frame and insert it through the hole. Re-attach the blade to the saw frame, tightening it securely. Saw out the shape and, when it is free, release the saw blade again and remove the cut-out metal.

Forged Silver Necklace. Tom Fisher.

Filing

Use a coarse file for general shaping; use a finer file for finishing the surface. Hold the work by hand, in a ring clamp or in a vise and file, exerting pressure on the *forward stroke only*. Start at the end of the file and work *toward* the handle. To file parallel surfaces (as on a ring), push them across a file that has been secured to the workbench.

Soldering

Be sure that all surfaces to be joined are clean and that they meet neatly and evenly; do not count on solder filling the gaps. Apply flux to metal and then solder; place the solder in the correct position; learn to gauge the amount needed. With the gun or torch, heat the metal quickly to the temperature at which the solder will melt or flow.

Buffing

Polish by hand, using a *felt buffing stick* to which tripoli has been applied; finish with a felt cloth and *jeweler's rouge*. An electric buffer works more quickly and efficiently.

METALS: TYPES AND TECHNIQUES

Wire

A wide variety of wires are available and suitable for use in the art classroom. *Scrap wire* can be gathered for general use in wire sculpture or constructions;

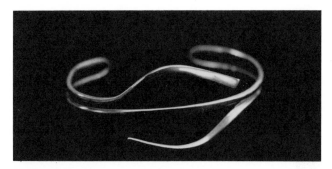

Forged Silver Bracelet. Student of Tom Fischer, El Camino Real High School, Woodland Hills, Ca. Photos, courtesy Caroline Tupper. Note that, in both (a) and (b), the piece is made from a single length of wire. Variety is achieved by flattening, or forging, selected sections of the wire and by varying the spaces between the wires.

copper, brass and aluminum wires are more expensive and may have to be purchased from special sources. *Galvanized wire* is common and readily available as scrap or may be purchased at little cost. *Piano* or *"music" wire* is extremely stiff and springy; use it for a lively mobile or a moving construction. *Copper wire* is soft and flattens easily for use in jewelry and other craft objects. *Aluminum wire* makes an excellent armature for the application of other materials; it *cannot*, however, be soldered. *Steel wire* is an excellent choice for wire sculpture and is available at hardware stores. *Picture hanging wire* is extremely versatile; use it for binding and wrapping forms. Color and variety are provided by the *plastic coated wires* from the electrical repair shop; look for them in a variety of colors.

Welding rods of brass or iron, available in various diameters, are extremely versatile and may be used in constructions and mobiles; they are especially recommended for mobiles.

Florist's wire provides an excellent binding wire.

Coat hanger wire makes a strong armature but is generally too heavy for use in mobiles where a lighter, more resilient wire moves more freely. *Nichrome* wire is used to form loops, hooks or decorative lines for glass jewelry that is fired in a kiln. The wire will not flake nor burn out. Use it also to provide a support for ceramic beads that are fired in the kiln.

Gauges

Metals, in sheet or wire form, are measured by thickness or *gauges*. (In the U.S., the Brown & Sharpe wire gauge.) When purchasing wire, remember that the *higher* the number, the *thinner* the wire (or sheet): a 20 gauge wire is thinner than a 16 gauge wire (or sheet). The most workable gauges for wire sculpture, for example, are 16 and 18 gauges for armatures and 20 or 30 gauge for binding. Use 9 gauge aluminum wire for armatures.

Wire is commonly available in three basic shapes: square, round and half-round; other shapes, including triangular and beaded wires, are available from jewelry supply companies. When purchasing wire for special purposes, give careful consideration to how the shape of the wire will function in the finished work.

Handle and store wire carefully; do not bend or crush coils or lengths of wire — this treatment makes getting a clean straight line or curve extremely difficult. Cut circles from a coil, if possible, instead of a straight length; the wire will curve more readily. *Piano wire* can be bent or cut *only* with the use of pliers and may tend to fly up when cut; cover the loose end with cardboard as the wire is cut. If wire cutters are not available for cutting heavy wire, such as coat hangers, first file notches on the wire, then snap it.

Shaping and Joining: Jewelry Techniques

Wire may be shaped in several ways: it may be wound, by hand, around a dowel, rod, stick or clothespin. *Pliers* of various kinds can be used to create shapes that are angular or curved. A wire-bending *jig* is used to create a specific shape, especially when that shape is to be repeated within a design and exact duplication is important. Make a jig by first drawing the shape desired on a block of wood. Following the outline of the shape, drive nails into the wood to form "posts" around which the wire will be bent. (Use nails with small heads.) When the outline, or nail arrangement, is hammered into the wood, snip off the nail heads so that the wire can be removed easily.

Intricate, lacy designs may be made in fine wire by simply *twisting and tying* the wire to create web-like shapes. Soft wire may be hammered or forged on a steel block: use a hammer and other "found" tools to flatten sections of the wire; use nail heads and pliers to create a variety of textures. As the wire is hammered, it becomes harder and more brittle: to prevent its breaking, heat the wire then plunge it into cold water — this *anneals*, or re-conditions, it so that it may be further textured or hammered. To make wire rings of identical size, first wrap the wire snugly around a dowel or rod of the diameter desired to form a coil. Slip the coil of wire off the dowel and cut rings from the coil; they should be identical if the wire has been tightly and evenly wound. Wire rings may also be shaped with round nose pliers.

In jewelry making, join wire units with *jump rings* (jewelry findings), with wood or ceramic *beads* or by simply *weaving* shapes together as the piece is made. Single units may be bound together with extremely fine wire. Heavier wires can, of course, be *soldered*.

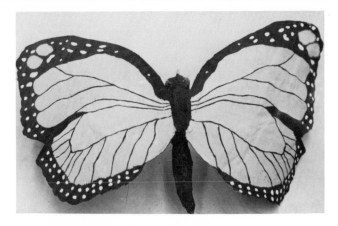

Butterfly. Student, Albany, N. Y. High School. Photo by Ernest Andrew Mills. Wire forms the armature which is covered with colored art tissue. Markings are painted on the tissue.

Suggested Activities

1. Design a stick pin or hair ornament from a single length of copper or brass wire. Twist a design, using one end of the wire, then sharpen or shape the remaining end with files and emery cloth. Consider flattening some areas of the wire by *forging*, or hammering, it out on a steel block.

2. Design a bracelet (necklace) based on the repetition of a single wire unit. Use jump rings to connect the units.

3. With wire, cage a "jewel" (marble, pebble, glass glob, bead) to make earrings, a pendant or pin. Attach jewelry findings with strong metal glue or epoxy cement.

4. Design a wire form to be incorporated into stitchery, macrame or weaving. In stitchery, attach the form with couching stitches; in macrame or weaving, use the wire form to create an open space, to add a three-dimensional element or to anchor warp threads.

Wire Sculpture

Use heavy gauge wire to form the basic armature, or skeleton, of the piece to be designed. (Consider animals, birds, human figures, non-objective designs.) Join wires by binding with finer wire, by soldering or by using a strong adhesive such as *liquid solder*, *epoxy cement*, *metal paste* (Sculpmetal), Elmer's Glue-All or automobile body putty. Use masking

tape to fasten parts in proper position, then apply the adhesive. *Do not remove tape until adhesive has hardened.* Build up, or fill in, areas by wrapping wire around the form, by attaching metal screen with wires or adhesive or by applying metal paste over sections of the form. To create smooth planes, dip a soft cloth in glue and model it over the armature then, when it has dried, apply metal paste. Apply paste in a layer ⅛" thick and permit to dry for 30 minutes before applying succeeding layers. Forms designed in this manner may be free-standing, mounted on a base, or suspended.

Bases may be wood, cork or metal, but should harmonize with the sculptured piece in color and scale. Attach to base with wire staples, epoxy cement or other *unobtrusive* fasteners.

Suspend with fine wire, nylon fishing line or fine chain. If designed as a mobile, use swivels (sporting goods stores) for greater mobility and full 360° turns. Consider incorporating stained glass, transparent plastics, colored acetate, screen or metal foil shapes in mobiles.

Metal Fabrics

Metal "fabrics" include a variety of screens from the very fine types used as insect-proof window screens to the much more open, coarser hardware cloth. The latter is not a "cloth" in the usual sense; it is a heavy square-mesh metal screen available in ⅛" mesh or ¼" mesh. It is generally used when a heavy protective screen is essential.

Sources: Metal screens can be purchased at hardware stores and building supplies' stores; they may be copper, aluminum or steel. A popular type of screen is chicken wire, used to build armatures for papier-mâché work and for building forms for stage props. Most of the screen used in art classrooms is generally obtained as scrap from the home workshop or from manufacturers of window screens.

Tools: Special tools are not essential except for wire snips which make cutting the heavier screens (such as hardware cloth) much easier. *Pliers* are helpful, especially if a great deal of twisting and binding is necessary, as might be required in making a larger form or armature.

Techniques: Since the structure of wire screen is similar to that of textiles, experiment by using the

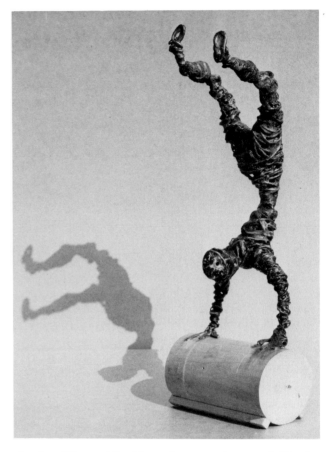

Acrobat. Wire and liquid metal, mounted on wood. Height, 14". Student, Lutheran High School, Los Angeles. **Gerald Brommer, teacher.**

same techniques used with open-weave textiles: alter the structure of screen by shifting, pulling or drawing out the "weft" wires to create open spaces in the screen. (See techniques recommended for drawn thread designs in burlap.) Create circular openings in the screen by *puncturing* it with a pencil or dowel; bind weft wires together to create a pattern. *Weave* a wire of a different gauge or of a different color through the screen; create dots by *soldering.*

Many wire screens may be treated in much the same manner as paper to create structural planes and three-dimensional forms: experiment with rolling or creasing the screen to determine its flexibility. *Roll* the screen to create cylindrical and conical shapes; to hold the shapes in place, weave and tie

short lengths of wire into the screen, twisting them securely. These forms may be used to create abstract sculptural forms or may serve as bases or armatures for more realistic forms such as animals, figures or masks.

Wire screen may be combined with other materials in a variety of art activities. *Metal shapes* may be soldered on wire (aluminum *cannot* be soldered), wire forms may be covered with metal pastes, automobile body putty or plaster. (Reinforce plaster by substituting white glue for half the water required for mixing.) Textured metal foil provides contrast in surface quality and color. (Texture the foil by hammering, puncturing or embossing it with "found" tools.) *Acrylic modeling paste* may be applied, in layers, over screen. Permit each layer to dry for approximately 30 minutes before applying succeeding layers. Color or stain the paste, as desired.

Suggested Activities

1. Design a decorative *panel* from a length of wire screen: create patterns by shifting weft wires, by puncturing holes, by drawing out weft and warp wires. Mount the panel on metal rods or dowels.
2. Design a mask from screen. To shape the mask, bend the screen, cut and overlap edges. Fasten shapes by threading a fine wire through the screen and twisting it. Decorate the mask with foil, buttons, yarn, and "found" metal shapes (washers, bottle tops). Attach decorative objects by soldering or gluing.
3. Combine wire sculpture and screen to create a fanciful bird, animal, insect or figure. Draw out some of the weft wires or separate them to achieve a fringed or shredded texture; use the screen to create basic body forms, to add wings. Experiment with binding warp threads together to create "legs" or supports.
4. Into a piece of hardware cloth, *weave* yarns, raffia, ribbon, dried grasses and scraps of tape. Leave some spaces open. Weave on *cylindrical forms* to create a design to be suspended.
5. From a *circle* of screen, create a design to be *mounted* on a panel. Create designs by shifting wires, by removing wires; add dots of solder or metal paste. When the paste has dried, burnish it with the bowl of a metal spoon. Attach to hardboard panel with decorative tacks, brads or wire staples in a contrasting or harmonizing metal.

6. Cement or tack scraps of screen to a rigid base (bookbinder's board, Masonite, etc.). Place a sheet of paper over the arrangement and roll with an inked brayer to product a *print*. Experiment by shifting the paper, by using a second color and by varying the pressure on the brayer.
7. Design a *mobile*, using scraps of screen in a series of related shapes. Attach wire arms by threading them through the screen.
8. Other uses: Build *armatures* of screen. Cover with papier-mâché, plaster-dipped cloth or cheesecloth, metal paste or automobile body putty (epoxy putty).

Sheet Metal and Tubing

Of the sheet metals, copper and brass are the most popular for use in the classroom: they are comparatively inexpensive and lend themselves to a variety of projects, especially jewelry making. They may be used alone or combined with metal tubing or wire; their surfaces may be enhanced by hammering, etching or enameling.

Less popular sheet metals include *aluminum* and *tin*. Like copper and brass, aluminum may be etched and tooled; it cannot, however, be soldered. Tin readily available as scrap, can be soldered, embossed and punched. *Pewter* and *nickel silver* are becoming more common in classroom use as newer, simpler techniques are developed for working with them.

The emphases here will be on the simpler techniques for *jewelry* design and the uses of sheet metal in *assemblage* and *construction*.

Tools include those described earlier. Tools and materials needed for specific techniques such as *enameling, etching* and *tooling* are listed in the description of the technique.

Sheet Metal Jewelry

Materials: 18 gauge copper, 18 gauge brass, brass and copper tubing, brass welding rods, steel wool, emery paper, solder, flux, jewelry findings, metal cleaner, tripoli, jeweler's rouge and emery paper.

Tools and Equipment: Jeweler's saw frame and blades, bench pin, "C" clamp, files, hand drill, drill bits, tube cutter, propane torch, pliers, ball-peen hammer and steel block.

Copper punch, for making holes for jump rings.

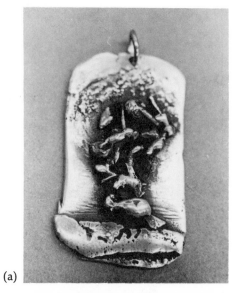

(a)

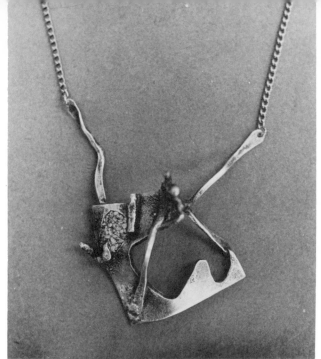

(c)

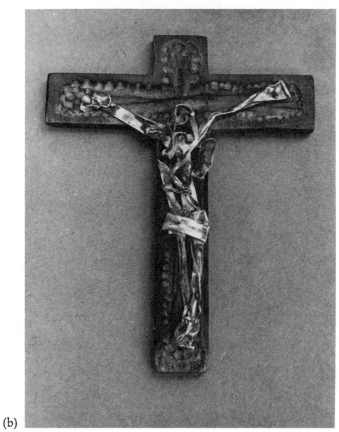

(b)

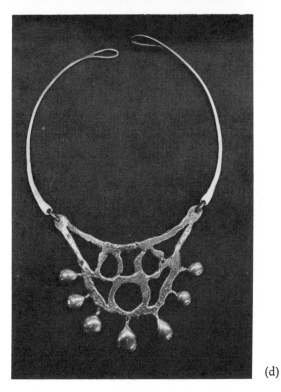

(d)

Fused and Burned Jewelry. Students of Caroline Tupper, El Camino Real High School, Woodland Hills, Ca. Note the variety of uses of the fusing technique. In (a), bits of silver are fused to a solid base; in (b), the fused figure is attached to a wood base; in (c), contrast and balance are achieved with open space. (d) Burned brass. Sections of the metal are burned out to create a variety of open spaces.

Procedure: Plan the design with emphases on simple free-form shapes. Pre-cut copper shapes are available but these often are trite stereotypes, particularly the naturalistic shapes. As a designing aid, select a shape from a continuous line "scribble" drawing or cut a basic, geometric shape from paper. Cut away *parts* of the paper shape but retain its basic form; i.e., circle, triangle or rectangle.

When the design has been determined, proceed as follows:

1. Trace the shape on the metal with a scriber or other sharp tool; a paper pattern glued to the metal will make this easier.
2. Place the metal on the bench pin and saw out the shape. (Refer to sawing techniques described earlier in this chapter.)
3. Remove the paper pattern and finish the edges of the shape with files and emery paper.
4. The shape may now be used in a number of ways: experiment with cutting out negative design areas and with bending, hammering, texturing and polishing metal shapes. Create designs by combining metal shapes with wood, wire, ceramic or glass elements.

5. Join shapes by soldering and, if adding wood, ceramics or glass elements, gluing. Use epoxy cement or all-purpose cement such as Bond's "Cement 527". (See Sources for Materials and Supplies.)
6. Brass or copper *tubing* may be sawed or cut into various lengths and then assembled in simply designed pins, earrings and pendants.
7. *Washers* of copper or brass may be incorporated into designs. *Perforated brass* sheets or the *punchings* from them may need little more than shaping and polishing to become elements in pins, pendants and earrings.
8. Refer to techniques for *soldering*, *hammering* and *buffing* described earlier in this chapter.
9. Attach *findings* by soldering or with adhesives recommended in item 5 above.

Enameling on Copper

Enameling is a process for covering metal with finely ground glass. The glass is a combination of frit and metal oxide which produces a color. The enamel is adhered to the metal by use of high temperatures produced in a kiln. Copper, silver, gold and steel may be enameled but copper, for reasons of economy, is most widely used in the classroom.

Equipment

An *enameling kiln* (Enameling may be done with a propane torch but the results are primitive, at best.)

Materials and Tools

In addition to the tools and materials listed for sheet metal jewelry, the following are needed: 18 gauge copper; spatulas; brushes, asbestos glove (optional); tongs; stilts; fork; firing rack; tweezers; sieves (mesh); enamels in powders; lumps and threads. For cleaning the metal, *one* of the following: A nitric acid solution (1 part acid to 8 parts water), Sparex compound, or vinegar and salt. Gum (tragacanth, arabic or agar) or a commercially prepared solution to adhere the enamels, such as Formula 7001.

Procedures for Enameling

Forming Copper: Cut the copper to the desired shape with metal shears or saw. Form over a stake, using a rawhide mallet, if shaping is desired.

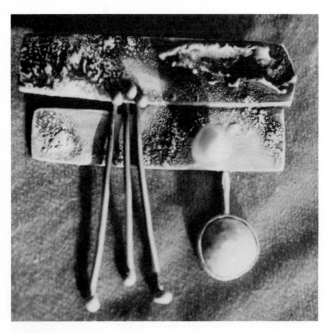

Sterling Silver Pin. Jay D. Kain. Reticulation technique; set with baroque pearl and Mexican fire opal cut and polished by Jean Kain.

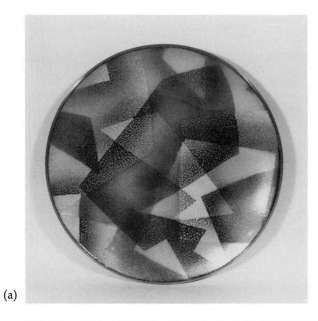

(a)

(c)

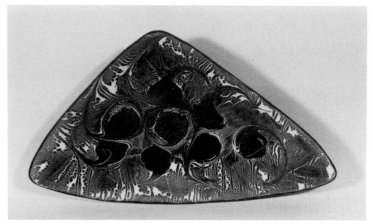

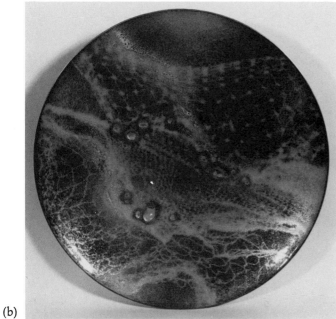

(b)

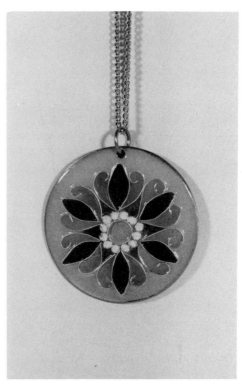

Enameling Techniques:
(a.) Stenciled tray. Audrea Kreye
(b.) Hat veiling stencil. Stan Cavanaugh
(c.) Swirled tray. Gordon Hershey
(d.) Cloisonné pendant. Tom Roehm
Photos, courtesy Audrea Kreye, teacher.

(d)

Finishing: File the rough edges with a metal rasp and jewelry files. (The edges of the metal may be filed to create a "fence" or rough edge to hold the enamel.)

Cleaning: The copper must be clean of all fingerprints and oily deposits. This can be done by using steel wool first, and then dipping in Sparex or nitric acid solution. Care must be taken to avoid handling the copper. If water does *not* bead on the surface of the copper, it is cleaned sufficiently.

Applying Gum: The gum ensures adhesion of the enamel to the surface. This is especially important on curved surfaces. The gum is applied with a brush. Gum tragacanth, gum arabic, or agar can be used.

Enamel Application: Enamels can be dusted onto the metal, applied as a wet paste, or sprayed. The dusting method is the most commonly used. In this method, the enamels should be sifted onto the gum surface in a smooth, even manner. The excess enamel should be saved by placing the copper on a clean paper while dusting.

Firing: Allow the gum to dry before firing. The kiln should be preheated to at least 1500° F. The piece can be refired many times if care is taken not to over-fire in the beginning. There are several noticeable stages evident as the enamels progress to maturity in the kiln. The first step will show the enamel black and uneven. Next, the enamel takes on a pebbly look or "orange peel" texture. It is here that the piece can be removed if additional work is to be done and re-firing is necessary. The piece has been overfired if it becomes orange-hot and the edges burn away. The mature piece will appear cherry-red and the enamel will be smooth and shiny.

Finishing Enameled Pieces: After the final firing, remove all traces of black oxidation. This may be done with steel wool or files. Always file with an outward motion and not back and forth. Round off any remaining sharp edges and corners. Rinse and dry after cleaning. If the back has been protected by a coating of Schmeer-on (See Sources of Supplies and Materials), burned spots will peel and fall off easily.

Decorative Processes

Stenciling: The use of either a positive or negative stencil is possible. Enamels are applied by dusting.

Beads and Threads: These are applied with tweezers in a design or at random; they are then fired until they adhere.

Metal Foils: The foils must be punctured by using a sharp tool or sharp needles. The holes will allow gases and moisture to escape during firing.

Cloisonne: In cloisonne, wire is used to form the design and provide "fences" to separate enamels. The cloisons are ribbons of metal soldered to a base, filled with enamels and fired. It is possible to do a makeshift cloison, without soldering, by allowing the enamels to adhere the wire to the base.

Painting: A design is drawn with the gum and the enamels are dusted over the top. The excess enamels are gently dumped off and salvaged.

Sgraffito: Apply a base coat and fire. After firing and cleaning, gum is applied to the surface and a contrasting enamel is dusted on evenly and allowed to dry. A design is then scratched or scraped into the surface, exposing the base coat. The piece is then refired.

Working Hints

1. To prevent chipping and crazing, *counter enamel*, by *enameling* the back of the piece. If this is done, leave bare those areas where findings must be attached.
2. Flux is a colorless transparent which fires to a luminous gold. For richer color effects, fire transparent colors over flux.
3. If holes must be made for jump rings or bails, make them *before* firing the piece. A *copper punch* can be used to make 1/16" and ⅛" holes.
4. A buffer-grinder outfit makes finishing easier, eliminating much handwork.

Designing with Sheet and Found Metals

Metals available for constructions and sculpture are generally limited to scrap sheet metal and found objects from home, the school's metal shop and scrap lots purchased from local sources. Techniques for joining are limited to soldering, gluing, and bolting since oxyacetylene welding is not possible in the classroom. Even within these limitations, an exciting variety of projects can be accomplished: metal assemblage, "junk" sculpture, mobiles and dozens of

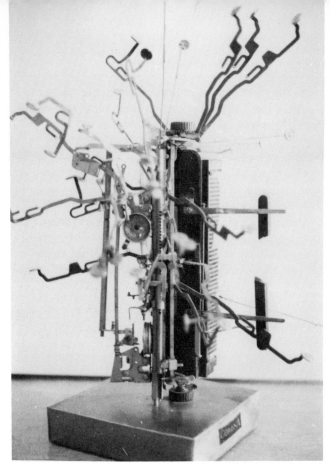

Typewriter. Metal junk sculpture by student, Bethlehem Central High School, Delmar, N. Y. Photo courtesy Ernest Andrew Mills.

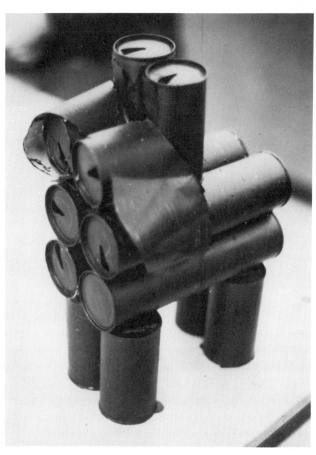

Junk Construction. Student, Baltimore City Public Schools. Discarded beverage cans are joined with epoxy cement.

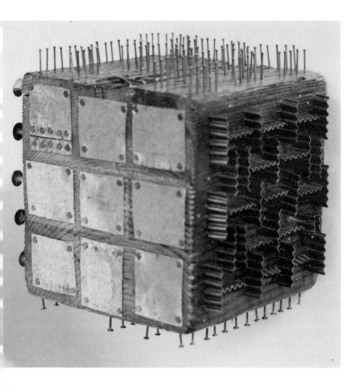

Cube. Student, Lutheran High School, Los Angeles. Gerald Brommer, teacher. Nails, sheet metal and corrugated metal fasteners are used to achieve variety and rhythm on a block of wood.

decorative craft items may be designed with scrap metals, an effective adhesive — and imagination.

Materials

Begin collecting metals well in advance and look *everywhere*! Sheet metal may include scraps from jewelry designing, the school metal shop, a construction site, home workshop — wherever metal work goes on. *Tin cans* should not be overlooked, especially the large cans from the cafeteria, restaurant and institutional kitchens. Remove labels and wash the cans thoroughly. (Do *not* use aerosol or "spray" cans since these should not be punctured.) Use the cans as units to create three-dimensional sculptural forms: join by *soldering* or use *epoxy cement*. With *tin snips* cut away rims, then cut down the seam to produce a small sheet of tin. Use the sheet, which has been carefully flattened, in a variety of problems: strips may be shaped into small cylinders or other forms — or they may be curled around a dowel. Use the forms as elements in sculpture, assemblage or mobiles. Attach small, flat tin shapes to a wood or hardboard panel to create a handsome wall piece. Attach with glue or brads. Create color accents by brushing on clear stains or lacquers or by texturing the metal *before* it is adhered by punching, puncturing or embossing.

Found objects present an unending source; look for a variety of shapes: broken clocks; appliances; kitchen utensils such as coffee pots; small pans; lids; forks; spoons; costume jewelry; automobile parts; gears; chains; locks; bolts; nuts; screws; washers; electrical supplies; metal pipes; spouting; hardware cloth; switch plates; broken toys.

Materials and Tools

Include those listed earlier for general metal work, plus a *hacksaw* for cutting heavier metals. *Cleaners*, for metal, to remove grease, rust. A generous supply of *emery paper* and *files* will be needed. *Soldering equipment*, *epoxy cement* and a strong, industrial *cement* such as Plio-Bond, for joining. Automobile *body putty* will adhere metal.

Finishes

Metal may be left as is or may be sealed with a protective clear coat of acrylic or metal lacquer. Color may be added by using *spray paint*, colored *metal paste*, *bronzing powders* or by *heating* the metal until color changes occur. (See *Finishing Metal*, at the end of this chapter.)

Working Hints

1. Clean metals thoroughly to remove all traces of oil, grease or rust. This is essential when pieces are to be soldered or cemented.
2. Remember that aluminum *cannot* be soldered.
3. If soldering is not possible, join parts by cementing, bolting, riveting.
4. Use solvents, epoxies and lacquers in a well-ventilated room; fumes may be toxic. Observe safety precautions on labels.

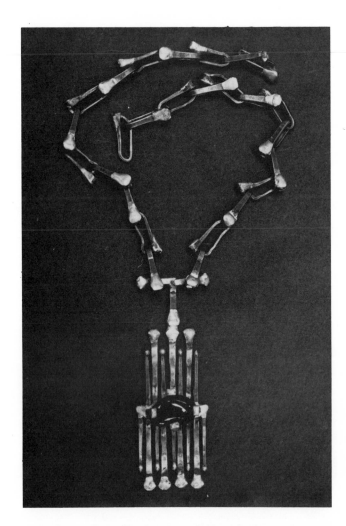

Horseshoe nail necklace, by student of Caroline Tupper, El Camino Real High School, Woodland Hills, Ca.

5. When spraying surfaces, construct a spray booth from cardboard boxes or sheets of corrugated board.

6. Do not permit oily waste to accumulate; it can be a fire hazard.

Suggested Activities

1. Design a metal *collage* from a variety of scrap metals. Experiment with texturing or coloring the metals before adhering them to a panel with cement, nails or brads.

2. Design an *"environment"*, within a box, using found metal objects. Cut "peep holes" or leave one side of the box open. Experiment with lighting the box with Christmas tree lights or a "night light" bulb. Consider lining the box with foil — plain or colored.

3. Arrange and join metal scrap to make a standing, hanging or projecting *construction*. Balance the arrangement as work progresses; join by cementing, soldering, bolting. Leave as is, or apply metallic or colored spray finishes.

4. Design a *nail relief*. Draw a design on a wood panel, painting or texturing some areas, if desired. Hammer nails, tacks and brads along the lines of the drawing; fill in selected areas. Experiment with a variety of nails and with hammering them in at various angles.

5. Plan design on wood, as in item 4, above, and hammer nails at selected points. Stretch fine wire between the points, wrapping the wire around one nail, then on to another point. A pattern will develop as the wires crisscross, converge or radiate. Keep tension uniform; apply cement or solder at strategic points, at the beginning and at the end of the work. The wood may be painted before the design is started; choose a color that will contrast or harmonize with nails and wire.

Metal Foils

Foils are very thin sheets of metal and, because of their thinness, are extremely versatile in use. They are easily bent, curled, embossed or textured; rich sparkling effects can be achieved by the application of lacquers which may be clear, colored or crackled. Heavier foils may be enameled, with care.

Sources: Foils, available in aluminum, brass and copper, are generally sold in rolls; their thickness and

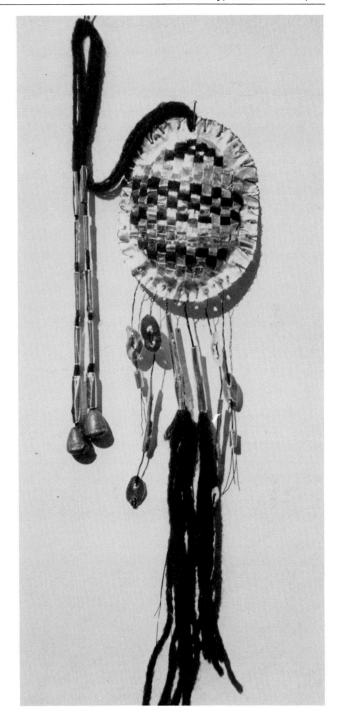

Pendant. Paula Jo Mihalow. Copper and brass foils, wire and yarn. Paper weaving techniques were used to shape the large oval which is made of interwoven foil and yarn. Tube-like shapes were formed from rolled foil. Note the variety of shapes and textures obtained from limited materials.

cost vary with the gauge. The gauges found most workable are 34 and 36 gauges. Purchase foils from arts and crafts supply houses or hobby shops. Copper *flashing* is heavier than foil and is obtainable from lumber yards; use it for sculptural pieces rather than for embossing.

Tools: Tools required vary as techniques vary: simple techniques involving little more than cutting and shaping may be accomplished with tin snips and found tools; *embossing* and enameling require additional tools, materials and special equipment. In the interest of clarity, tools and materials will be listed as they relate to techniques.

Techniques. Embossing is, perhaps, the most popular of the foil techniques: the processes are simple but varied and results can be quite handsome.

Additional techniques include the use of foil shapes in wire sculpture, mobiles and assemblage. Thin *strips* of foil may be woven into the warp threads of a wall hanging to provide contrast in color and texture.

Materials and Tools for Embossing Foil

Tin snips, for cutting. Thin sheet aluminum, brass or copper *foil.* (Annealed copper.) Either 34 or 36 B & S gauge is most satisfactory.
Leather-working modeling tools (metal).

Orange sticks, or *dowel,* shaped to a "thumb" on one end and pointed at the other.

A *scriber,* or other sharp tool to trace and draw sharply defined lines.

A *center punch,* or nail, for stippling.

Hard rubber *eraser,* for final smoothing.

Brush, for lacquer, or cotton pad.

A sheet of *glass, plastic* or *Masonite,* for a hard working surface.

Clear *brushing lacquer,* for metal.

Liver of Sulphur, for antiquing, if desired.

Related tools: Materials for padding (felt, newspapers, rubber pad, paper towels); tracing paper; steel wool and soft cloths, for polishing.

Procedures: Transfer the design to the metal in this manner:
1. Place the foil on the glass or hardboard and smooth it with the beveled edge of a ruler.
2. Place the foil on a padded surface; carefully position the drawing on the foil, taping it in place.
3. Trace the design on the foil with the scriber or other sharp tool. Remove the tracing paper design and re-trace all lines with the scriber so that shapes are clearly defined. (This will be the top, or finished side of the metal.)

Emboss, or tool, the metal:
1. Turn the metal over and place it, right side or face down, on a soft padded surface.
2. With the spoon end of the modeling tool, stretch the metal, with a downward pressure, in the areas to be raised. (Use a wide tool for large surfaces, a smaller tool for smaller areas.) Work evenly over the surface, *starting at the center of the design.* Do not be concerned with detail lines until the general heights and curvatures of all the forms are attained.
3. Examine work frequently from the front to determine whether the desired raising has been reached. Smooth the *background* and define shapes:
 a. Place the metal, *right side up,* on the smooth hard working surface and smooth the background, working *away* from the raised areas. Use a hard eraser.
 b. Stipple, dot or cross-hatch the background to provide a contrast in surfaces. Take care to avoid punching holes in the metal. Cushion the metal on the soft pad when stippling. Work from the center toward the outer edges, thus taking the stretch of the metal as work progresses.

Finish the surface:
1. Rub the entire surface of the metal with fine steel wool.
2. Prepare the antiquing solution by mixing a lump of Liver of Sulphur about the size of a large pea in four ounces of water; this makes a fairly strong solution. (Keep tightly sealed in an opaque or porcelain container.)
3. Apply the solution to the foil with a soft brush or cotton pad or by dipping the entire sheet in a bath of the solution. The metal will turn dark almost immediately. Do not permit it to dry.

4. Rinse the metal with cold water, scour with kitchen scouring powder, rinse with hot water and set aside to dry. Do *not* wipe dry. Polish the highlights with fine steel wool.
5. Spray or brush with clear lacquer or clear plastic. Do not use a thick lacquer; two thin coats are better than one thick coat.

Fill in the raised areas, if desired. (Filling in will prevent the raised areas from becoming accidentally crushed.) On the back side, fill raised areas with one of the following: plastic wood, or a modeling compound made by mixing glue (P.V.A., acrylic medium, shellac) with sawdust. Papier-mâché makes a satisfactory filler. Plaster of Paris will crack; wax will melt.

Other finishes

1. Instead of using Liver of Sulphur, the metal may be finished experimentally with spray-type finishes or acrylic paints. Commercial liquids and pastes for finishing metals are available under several brand names.

2. *Panels* may be mounted on wood, cork or hardboard. Attach panel with escutcheon pins of brass or copper, epoxy cement or wood moulding.
3. Other uses for embossed foil: jewelry boxes, cigarette boxes, lamp bases, book-ends and simple jewelry. In designing jewelry, attach the embossed foil to bases of bookbinder's board. Have the foil overlap and go around to the back of the shape. Cover the back with thin felt or other similar material and attach the proper jewelry finding (pin back, earring screws, etc.). Use epoxy cement or all-purpose glue to attach the finding.

Working Hints

1. Finding the "right" strength for the Liver of Sulphur solution depends on the degree of antiquing desired; if metal is not dark enough, re-apply the solution; if the metal is too dark, weaken the solution by adding more water.
2. Liver of Sulphur liberates hydrogen sulphide, which is toxic. Use in a well-ventilated room.

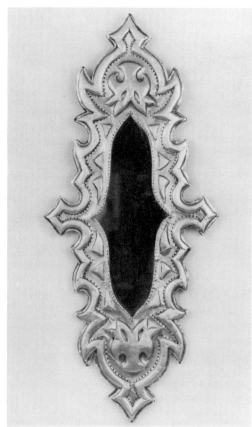

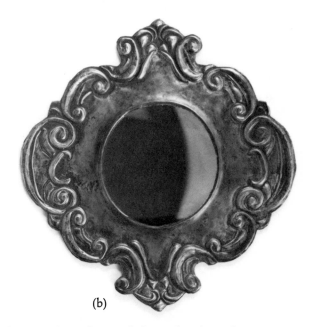

(b)

Mirrors framed in tooled metal foil. Students, Fort Lee, N. J. Senior High School, Joan DiTieri, teacher. In (a), note textural effects achieved by the perforations outlining the raised border. In (b), the raised areas are emphasized by the dark patina.

(a)

Tooled copper plaques. Students, Fort Lee, N. J. Senior High School. Joan DiTieri, teacher. Three varied approaches to design.

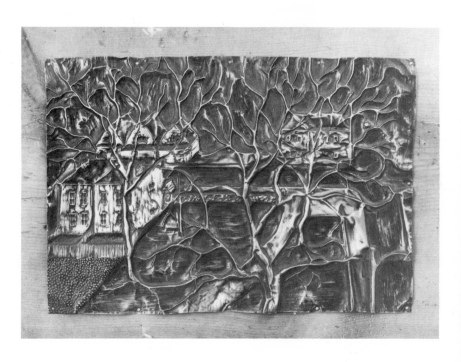

3. If a lacquered finish is not desirable, heat the copper to approximately 90° and apply a light coating of furniture wax. Polish with a soft cloth when the wax has dried completely.

 For other experimental finishes, see "Finishing Metals", at the conclusion of this chapter.

4. *Tin*, also, may be embossed. Obtain sheets by cutting and flattening tin containers. Experiment with techniques of cutting, curling and shaping.

Additional Techniques

Use tin snips to cut and shape the foil, as in paper sculpture. Experiment with bending, rolling and twisting shapes. Some foils, depending on gauge or thickness, work almost as easily as paper. Three-dimensional design units may be attached, singly or in groups, to a base, for a sculptural piece or may be mounted on a panel for a decorative wall accent. Surfaces may be "antiqued" or left as they are.

Small shapes may be enameled in a preheated enameling kiln. Follow standard copper enameling procedures, but leave the piece in the kiln for a very short period — only a minute or so. Experiment with enamels. The transparent types are especially effective. Some burning will occur, producing effects similar to welded or "antiqued" finishes. Flower shapes or free-forms may be attached to long wire stems, after firing. Where "stems" are to be inserted, use a compass point (or nail) to make an opening in the center, before the piece is fired. To attach "stem", push the wire up through center hole, then twist the top of the wire to form a loop. Slide shape up the wire until it fits snugly against the loop, then bind fine wire at the base of the shape to hold it firmly in place. These fanciful metal "flowers" may be arranged in a suitable container (weed pot, bottle) or may be mounted on a wood base. Drill holes, at a slight angle, in the wood base being careful that holes are not too large. The wires should fit snugly for proper support. A drop of strong glue may be squeezed into the hole if the wire fits too loosely.

Uses for Household Foil

Ordinary aluminum foil, obtainable at food stores, has found its way into art activities. The heavy-weight foil is generally recommended.

1. Crushed and shaped aluminum foil makes a strong, lightweight *armature* or *support*; it may be used alone, for small projects, or it may be

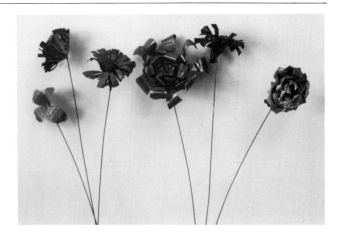

Metal Flowers. Enameled copper foil on welding rod stems.

used to build up shapes over a wire or wood armature necessary for larger projects. Model it over the face to make a base for a mask.

2. To provide a *reflective backing* for stained glass or plastics, crumple the foil slightly, then smooth it. (The crumpled surface makes a richer, more varied texture.) Adhere it to a rigid backing with strong glue, then adhere stained glass over it. If the glass is clear and a color is desired, stain the foil with acrylic paints, inks or other colors.

3. Form small *molds* for casting plastic resins. (See chapter on "Plastics".)

4. Build a *textured collage* with corrugated cardboard, string and found materials. (Do not make the relief higher than ¼".) Cover the collage with white glue, then cover it with a sheet of foil which has been crumpled then smoothed, as in (2), above. The foil should be, at least, 1½" *larger* than the design, on all margins. Model the foil over the relief surface with fingers or found tool, pressing the foil neatly around the edges of the cardboard shapes. Fold back excess foil and tape to back of the cardboard. Antique the foil by brushing on black paint, then wiping most of it away to achieve effect desired. Experiment by using a color (orange, for coppery tones) on the foil *before* adding black: Do *not* wipe away color; permit it to dry, then add black and proceed as outlined above.

5. To make a *print*, start with a sheet of foil of size desired. Crumple and texture it by creasing, pinching and folding it. Adhere the textured sheet to

cardboard and apply ink with a brayer. To print, place paper over the inked foil and roll with a *clean* brayer. Experiment by adhering lightweight cord, rubber bands, paper lace and other *thin*, found materials to the foil surface before inking it. Adhere with water-resistant glue if water-base inks are used.

Metal Pastes

Although sometimes referred to as "liquid" metals, these *metallic compounds* are actually more paste-like in consistency. The compounds, which lend themselves to a wide variety of art activities, share some general characteristics: they air-harden without the addition of chemicals or firing and when completely hardened, may be treated in very much the same way metals are treated. They may be filed, sanded, steel-wooled or buffed to a true metallic luster; designs may be incised or carved in a hardened surface. The metal paste is applied directly from tube or can with a palette knife, stick, or fingers, in modeling techniques or, if a thin metallic finish is required, by brushing. (A thinner is mixed with the paste to achieve a brushing consistency.) The pastes will ad-

here to metals, plaster, wood, leather, fabrics, ceramics, papers and boards and to *some* plastics.

Pastes in aluminum, bronze, "gold" and steel finishes, or colors, are available under several brand names (See Sources for Materials and Tools.) and are sold in tubes or cans in various sizes. The liquid thinner is sold in one pint or one gallon cans. Prices vary.

Manufacturer's directions for use should be followed meticulously since specific working properties vary: some of the pastes are strong adhesives and will resist chipping, cracking and shrinking; others are not so reliable. Test the material to determine potentials and limitations.

Tools: No special tools are required for using the paste alone although a thin flexible tool such as a *palette knife* is recommended for building up surfaces and modeling. A *brush* is required for thin applications. If the paste is to be applied over an armature of wire or metal screen, then *tin snips*, *pliers*, *files* and *steel wool are required.*

Techniques

1. *Direct Modeling.* Apply the paste directly to pre-shaped wire forms, armatures, or to plaster, wood or papier-mâché forms. (Refer to techniques for *wire sculpture* and *papier-mâché* for building hollow-core armatures.) The paste may be applied thinly or thickly, depending on the effect desired. If a surface must be built up, apply the paste in thin layers, permitting each layer to dry before applying the next. A layer ⅛" thick requires a half-hour drying time; ¼" requires 6 hours. These drying times are essential for the proper fusing of the layers; infra-red lamps will speed the process. Permit a finished piece to dry for at least two days before further finishing is attempted. (Because masses must be built in layers, metal pastes are *not* recommended for casting.)

2. *Embedding.* Apply metal paste in a thin layer to a rigid backing such as bookbinder's board, metal or other hardboard and, while the paste is freshly wet, press the material to be embedded firmly into place. This technique may be used in *mosaics*, *jewelry design*, *collage* and *assemblage* techniques. Small, lightweight materials such as mosaic tiles, watch parts, stained glass "jewels", wires, small pebbles, shells and metal washers are

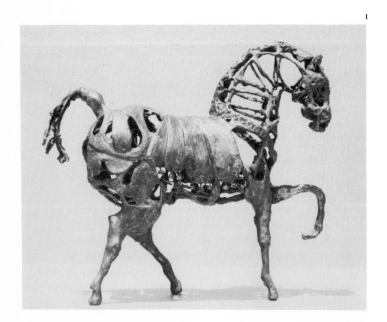

Horse. Wire and liquid metal. Student, Lutheran High School, Los Angeles. Gerald F. Brommer, teacher. Note contrasts achieved by the open and closed areas and the manner in which the metal paste has been applied.

recommended for embedding. In jewelry design, the metal paste may be extruded from a tube to form a bezel for a "jewel" or pebble. When the paste has dried completely, rub it with steel wool or burnish it with the bowl of a metal spoon to create metallic highlights. *Enamelled* objects may be embedded or bonded to a surface with metal paste.

3. *Inlaying.* Carve or gouge lines in wood and fill them with metal paste. Finish by sanding and polishing.

4. *Painting.* Thin the metal paste with thinner until a brushing consistency is achieved. Use in painting where a metallic finish is desired; apply to any surface (except to oily, greasy or plastic surfaces) where a metallic patina is desired. Finish by sanding or burnishing.

5. *Other uses.* Marionette parts (over wood, screen, plaster). Apply to trays; decorative boxes; models; mobiles; constructions; assemblages; collages; "junk" sculpture. Use to simulate lead lines in stained glass projects; use a tube (pastry, paper) to extrude the lines for a cleaner application. Trail left-over metal paste on a rigid backing to create a relief surface for printmaking.

6. *Finishing, coloring.* Finish dried paste by *sanding, steel-wooling* or *buffing*; *burnish* with the bowl of a metal spoon. *Color* by brushing on shoe dyes, lacquers, synthetic paints or oil base paints. *Texture* with file, saw, rasp, or ball-peen hammer. Experiment with *antiquing* the surface with various colors.

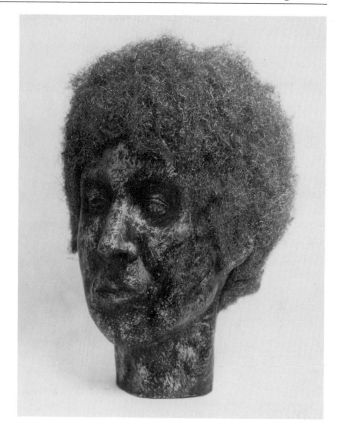

Head. "Sculp-metal" over clay, with steel wool. Student, Fort Lee, N. J. High School, Joan DiTieri, teacher. A patina and steel wool provide contrasts in color and texture.

FINISHING METALS

1. To *protect* the surface: spray with acrylic spray, lacquer or varnish designed for metal. Study labels carefully.

2. Heat metals (copper, tin) with a propane torch until color develops. When the objects have cooled, apply varnish or lacquer to keep them from darkening.

3. For blue and rose colorings on copper: brush the metal with vinegar, keeping it wet for several hours. Seal to protect the color.

4. To antique brass, steel and copper: coat the metal with *gun blue,* available at hardware stores. Five minutes after the first application, apply a second coat. When the color is uniform, rinse under running water but do *not* rub. Permit to set overnight, then buff with a soft cloth and fine steel wool.

5. *Bronzing powders* are available in a range of colors and metallic tones including blue, green, bronze and gold. Mix with *bronzing* lacquer to consistency of milk and brush on metal. (One ounce of powder, mixed as directed above, will be enough for a project of medium size.) The powders and lacquers are available at art and hobby shops, paint supply and better hardware stores.

6. *Acrylic sprays.* Available in clear, colors and metallic tones. Spray lightly, holding can at least 12" away from object being sprayed, for best results.

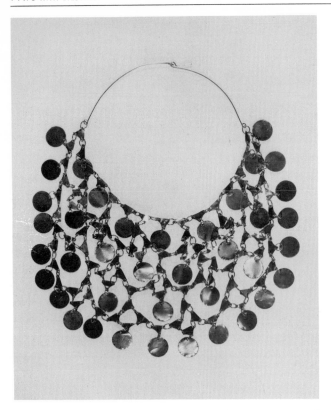

Mexican Bib Necklace. Brass. Circles and remnants joined with jump rings. The left-over negative shapes are no longer "scrap" but are incorporated in the total design. From *Inventive Jewelry Making,* Ramona Solberg.

7. Liver of Sulphur. Dissolve a pea-sized lump in 5 to 8 oz. of boiling water. Brush on metal and when black finish appears, wash the metal and rub it to remove excess. When dry, polish with soft cloth and fine steel wool. Excellent for copper, but not recommended for tin or steel; may also be used on silver. The solution deteriorates quickly; mix only the amount to be used within an 8-hour period. For unusual effects, heat metal with a torch while it is still wet with Liver of Sulphur solution. Finish and seal as directed earlier.

8. Spray metals with gray auto body primer to form a base coat. Apply white casein or acrylic paint over the dried primer, then rub or brush on casein or acrylic colors which have been diluted.

9. Coat metal with thinned metal paste (Sculpmetal, Model-Metal) and, when dry, burnish or steel-wool the surface. Add a color with shoe dye, if desired.

ADVANCED TECHNIQUES IN METAL

Refer to Bibliography for references on advanced jewelry and metal techniques such as casting; advanced enameling techniques; raising metals; designing hollow-ware.

Chapter 3
Fibers

The array of fibers that may be employed in crafts design is truly awesome: in addition to the traditional vegetable and animal fibers such as cotton, linen, jute, wool and mohair are the man-made fibers such as nylon, mylar and polyvinyl that have their origins in the chemist's laboratory. To create further variety, the textures range all the way from the slick transparency of polyvinyl chloride to fuzzy, handspun yak hair. Colors appear practically unlimited.

TYPES

Types of fibers readily available to the beginning craftsman and teacher include yarns, in a variety of weights, intended for use in knitting and rugmaking and certain types of cords designed for special uses such as macrame and stitchery. To these may be added chenilles, jutes and novelty yarns incorporating metallic and plastic fibers.

SOURCES

Sources include school supply companies, yarn shops and manufacturers of yarns of all types. There are distributors who specialize in imported yarns and threads and the more exotic types of fabrics popular with handweavers. Odd lots and "surprise" boxes are available for the craftsman who likes variety and the unexpected. (See Materials and Supplies.)

The beginning craftsman and the teacher with a limited budget can look closer to home for the fibers for initial projects: collect scraps of fibers from home, from friends and from the school's home economics department. Such scraps may include twine, embroidery threads, fishing cord, sisal, jute and a variety of yarns and threads. Unravel discarded sweaters, scarves, stoles and other loosely-woven discarded items of clothing. (If unravelled fibers persist in curling, dampen them and wind them around a cardboard core or improvised spool.) Sash cord, jump rope, shoe laces, gift wrap cord — anything that lends itself to knotting, stitching, or weaving should not be overlooked!

Are there textile mills and yarn manufacturers nearby? Scraps and odd-lots may be obtained cost-free or for a minimal charge.

Hardware stores and surplus stores are good sources for jute, sisal, nylon cords, fishing line, clothesline cord and other "fibers" intended for utilitarian purposes. These, used alone or combined with other, more colorful fibers, take on an entirely different "personality" in wall-hangings, woven forms and stitchery designs.

In addition to manufactured fibers, collect reed, raffia, straws, dried grasses, cane and other natural materials that may be used as more conventional fibers are used. These materials provide contrasts in texture, color and shape and are great fun to use.

TECHNIQUES

Techniques for using fibers vary from the simplest to the most complex: fibers may be glued, stitched, knotted, wrapped, twisted and woven. Innovative techniques employed by contemporary craftsmen often defy description; traditional techniques are used only as springboards, or starting points, in the design of art forms that would shock the early craftsman concerned primarily with the production of utilitarian "cloth."

The concern here is to describe how fibers may be used as contemporary art materials, particularly for the beginning craftsman or student.

Tabilla

This simple technique, which takes its name from the *tabillas* designed as votive pieces by the Huichol Indians, is essentially fiber collage. Designs are created by gluing colored cord, strings and yarn on a rigid support such as bookbinder's board or other hardboard that will not warp. Sketch the design or picture clearly on the board, keeping shapes fairly simple and bold. Brush a *thin* coating of glue over a section of the design and begin to press the yarn (or other fiber) into it. (Avoid letting the glue show.) Start by outlining the shape and then follow its contours until the space is filled. Outlining the shapes with a black cord will give a "stained glass" effect to the final design. A toothpick is helpful in positioning very thin cords and yarn. Generally, the use of one type of yarn throughout the design produces a rich, finished effect; the varying textures and patterns created by the lines of yarn provide contrast and interest. A variety of fibers can be used, of course, but choices

Tabilla Panel. Student. Baltimore City Public Schools. Assorted yarns glued to stiff bookbinders' board. The tabilla technique may also be used to design pins and earrings.

should be based on the scale of the project: use thinner, lightweight yarns for small pieces and heavier, thicker yarns for larger designs.

Tabilla jewelry follows the same process. Cut a backing from stiff cardboard (bookbinder's board is recommended) or tin and apply the yarns *from the center outward.* Black cord (watch cord is ideal) applied around the outer edges, makes a handsome finish. Finish ends neatly. Attach findings (safety pin, pin back, ear screw) with a strong glue such as airplane glue or epoxy cement.

Variations: In creating tabilla jewelry, first glue a small bead, a bit of stained glass or mirror to the backing, then glue the yarn around it. If stained glass is not available, a bit of colored foil under plain glass will give a similar effect. Discarded "sets" from costume jewelry may also be used in this manner.

Stitchery

Stitchery techniques are popular and practical at all grade levels and may be used in designing any number of useful and decorative objects. Collect enough *background material:* loosely woven materials such as burlap and monk's cloth are recommended because they will readily accept both thick and thin fibers, but others may be used. For stitching, use perle cotton, yarns, cords, jute, embroidery floss, chenille

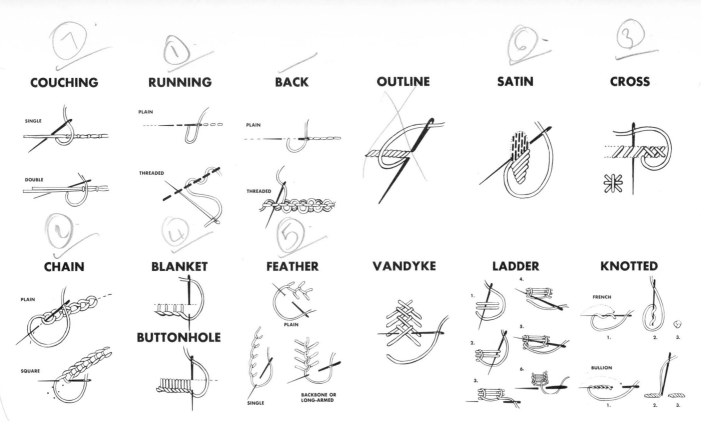

COUCHING **RUNNING** **BACK** **OUTLINE** **SATIN** **CROSS**

SINGLE

DOUBLE

PLAIN

THREADED

PLAIN

THREADED

CHAIN **BLANKET** **FEATHER** **VANDYKE** **LADDER** **KNOTTED**

PLAIN

SQUARE

BUTTONHOLE

PLAIN

SINGLE

BACKBONE OR
LONG-ARMED

1.
2.
3.

4.
5.
6.

FRENCH

1. 2. 3.

BULLION

1. 2. 3.

Basic Stitches. Reproduced, courtesy Lily Mills, Shelby
N. C.

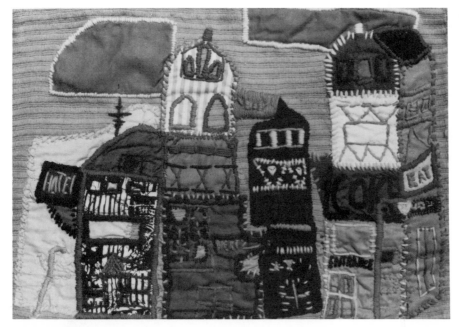

Stitchery Panel. Junior high school student. Photo courtesy
Michael T. Lyon, University of Washington, Seattle.
Shapes for buildings are cut from plain and patterned
fabrics which are appliquéd to the background. Stitches
in a variety of colors accent shapes and provide details.

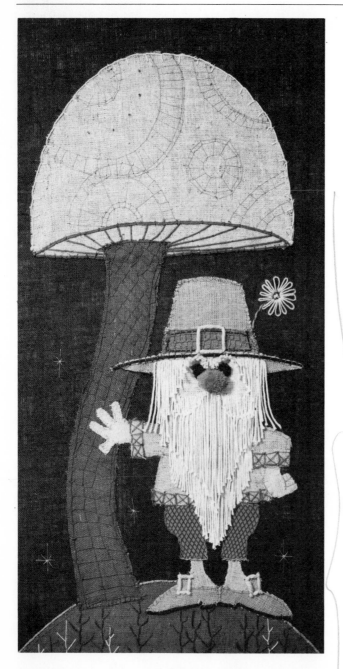

Leprechaun. Stitchery and appliqué. Variety in texture is achieved with the free-hanging yarn hair and the pompoms used for nose and eyes. Photo, courtesy Lily Mills, Shelby, N. C.

and "salvaged" fibers of all types. Provide a variety of *needles*: stitchery needles with large eyes and blunt points are ideal, especially if thicker yarns are to be used; tapestry and chenille needles, with smaller eyes, make working easier.

Scissors may be of any type, but fairly short, sharp-pointed scissors are the choice of professional needle-workers. (Use *blunt* pointed scissors for younger students.)

Basic stitches include the *running* or *straight, chain, cross, blanket, feather, satin* and *couching* stitches. There are dozens of others but they aren't essential for a handsome piece of work. An amazing variety of effects can be achieved through the use of *one* stitch, the *running* stitch. Placed close together it *fills* spaces, *outlines* spaces and, when varied in length, it creates a variety of textures. Further variety in any stitch may be created simply by varying the *type of yarn used* and by varying the *size* of the stitch. For information on designing, preparation of the back-ground material and suggested uses, see "Fabric: Techniques—Stitchery," Chapter 4.

Knotting

Of all the knotting arts, *macrame* has become the most popular. The reasons for its popularity are varied: today's craftsman has discovered that mac-rame combines naturally with other textile tech-niques; macrame can be used to make hangings, sculptural forms and decorative items as well as utili-tarian forms. The unique textural qualities of mac-rame have a universal appeal for everyone, artist and layman alike.

Although many macrame designs appear over-whelmingly complex, their great variety can be achieved through the use of only two basic knots — the *square knot* and the *double half-hitch.* Varia-tions in texture and pattern are achieved by the way the knots are tied and the ways they are combined. Other knots may be learned and their addition will provide a greater variety or design flexibility, but the traditional square knot and double half-hitch are sufficient for the beginner. (For references on addi-tional knotting techniques, see the Bibliography.)

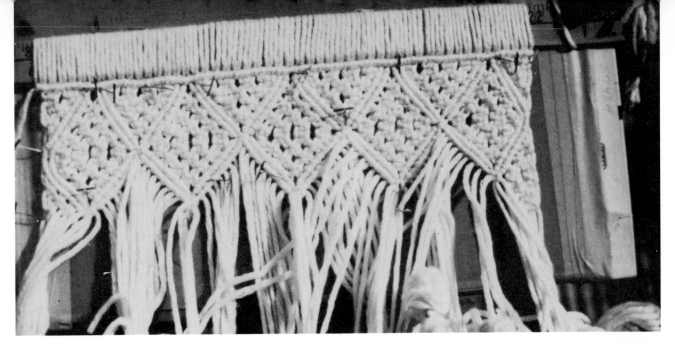

Macramé in Progress. The loose ends are fastened with rubber bands to prevent their becoming tangled. Photo, courtesy Margaret MacIntosh.

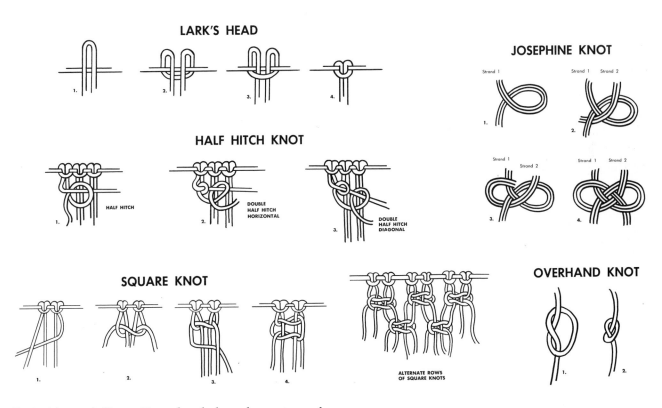

LARK'S HEAD

JOSEPHINE KNOT

Strand 1

Strand 1 Strand 2

1.

2.

Strand 1

Strand 2

Strand 1 Strand 2

3.

4.

HALF HITCH KNOT

HALF HITCH

1.

DOUBLE
HALF HITCH
HORIZONTAL

2.

DOUBLE
HALF HITCH
DIAGONAL

3.

SQUARE KNOT

1.

2.

3.

4.

ALTERNATE ROWS
OF SQUARE KNOTS

OVERHAND KNOT

1.

2.

Basic Macramé Knots. Reproduced through courtesy of Lily Mills, Shelby, N. C.

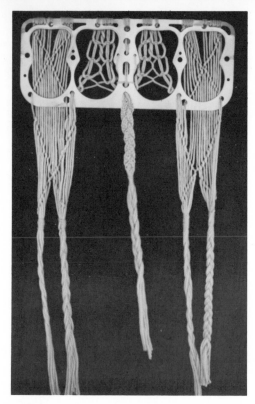

Macramé Hanging. A metal gasket provides a support for this simple but effective hanging. Photo, courtesy Margaret MacIntosh.

Macramé Bottle Covers. Ordinary bottles take on a new appearance when covered with macrame. Photo by Margaret MacIntosh.

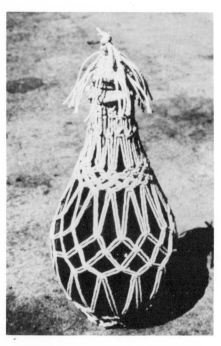

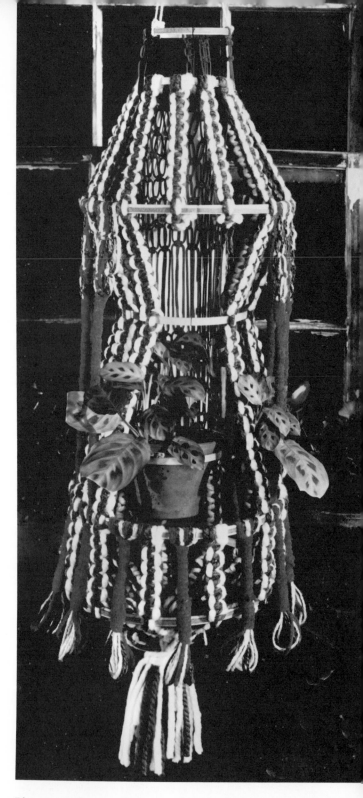

Planter. A unique design composed of simple macramé and wrapping techniques with wood hoops of varying diameters. The heavily wrapped dark cords provide both strong support and contrast within the total design. Photo, courtesy Lily Mills, Shelby, N. C.

Materials and Tools for Macrame

The basic materials and tools required for macrame are simple and readily obtainable.

Yarns or cords

Almost any yarn or cord that can be tied can be used for macrame but some guidelines should be kept in mind. The material should be hard enough to withstand the abrasive action of knotting and the tension that occurs when the cords are pulled. Highly elastic or soft yarns should be avoided for most designs since the knotting patterns tend to be obscured, or "lost" in these springy yarns. Choose the yarn or cord appropriate for the design: use hard-twisted cotton, linen, or nylon for articles that must withstand wear and cleaning (belts, handbags, eye glass cases); use softer, more elegant yarns for decorative items such as macrame jewelry and hangings. In general, avoid overly elaborate yarns with irregular surfaces and multi-color combinations because they tend to confuse, or distract from, the unique textural quality of macrame. Among the yarns and cords recommended are linen cords of all types, cotton seine twine, jute, nylon seine twine, upholsterers' twine, cotton chalk line (hardware store), polyethylene cord, mason's cord and cotton butcher's twine. Before purchasing a large amount of yarn or cord, test it by doing a sample piece to determine if it has the desired characteristics.

Tools

1. *Knotting board* on which to attach the cords. The board should be rigid yet soft enough for the insertion of pins. For small, beginning projects, a board 12" x 15" is recommended for comfortable handling and portability. Boards may be made from corrugated board or insulating board. A firm rubber cushion, a small, sand-filled pillow or a clipboard covered with a folded turkish towel provide satisfactory "boards" and will hold cords securely as they are pulled.
2. *T-pins* to hold the work securely in place so the knotting will go easier and remain even.
3. *C-Clamps* or bulldog clamps are helpful in maintaining tension on the cords as work progresses and, attached at the bottom of the board, provide a "hook" for holding cords in place.
4. *Miscellaneous*, Scissors. Rubber bands for binding the long, loose cords, to prevent their tangling. (Spool-shaped cardboard bobbins may be made for this purpose.) *Yarn needles* may be used where they make for easier handling of fine cords and for finishing.

Optional

Rings of wood, plastic or metal may be knotted into the design. Beads of various kinds may be used to create accents; handmade ceramic beads are especially handsome but others may be used.

If a holding cord — the cord to which the knotting cords are attached — is not desirable, attach the cords to a dowel, tree branch or a hoop of metal, wood or plastic.

Measuring Cords

The individual lengths of cords needed for a project should be carefully estimated. (An individual length of cord is called an *end*.) The *ends* should be approximately 3½ to 4 times longer than the finished work, but since the ends are doubled for knotting, they should be measured 7 to 8 times longer. Remember that heavier cords take up more length in knotting. To determine how many ends will be needed for the *width*, tie four ends into a square knot and measure the *width of the knot*. If it is ½", 8 ends will be needed to the inch. If it is ¼", 16 ends will be needed. These are general guidelines; be generous when measuring.

General

1. The holding cord (branch, dowel, rod) must be held steady as ends are mounted.
2. The ends, or loose cords, should not become tangled; keep them straight and in order.
3. The knot-bearing cord must be kept taut as it is used. (Use a clamp or hook at bottom of knotting board.)
4. Tie knots close together unless open spaces are part of the design. Keep tension consistent so that knots are uniform and even in construction.
5. Practice making knots on a sample piece of work until the basic knotting techniques become familiar. For practice sessions, attach cords to the bottom of a coat hanger. Attach coat hanger to work surface with masking tape and, when work session is over, store work in progress by simply hanging work on a "clothesline."

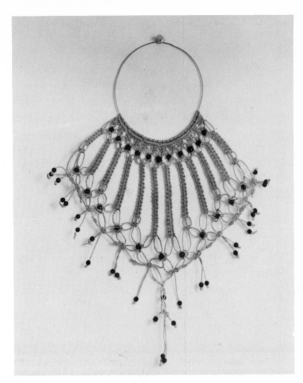

Macramé Necklace With Beads. Senior high school student, Fort Lee, N. J. In a design of this type, the cord should be stiff enough to hold a shape. Note the variety of shapes, textures and open spaces. Photo, courtesy Joan DiTieri, teacher.

(a)

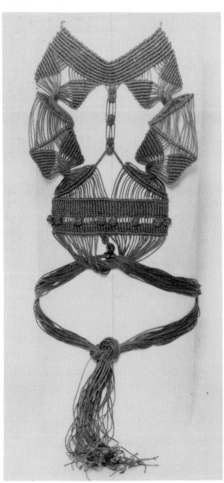

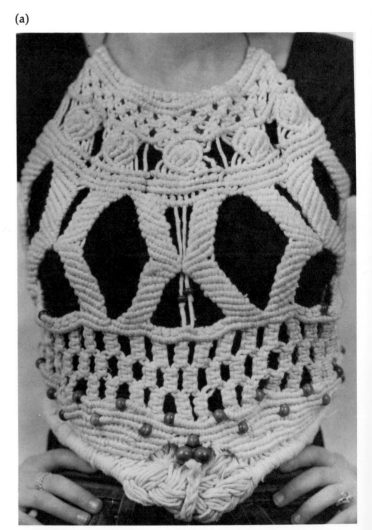

Body Pieces. Senior high school students, Fort Lee, N. J. Joan DiTieri, teacher. In (a), open spaces become an important element in the total design; (b) may be worn or displayed as a hanging.

Suggested uses for macrame:
Belts, chokers, headbands, handbags, jewelry, wall hangings, vests, decorative trims for lamp shades, room dividers, screens. Combine with stitchery in hangings, pillow tops, toys. Keep beginning projects fairly simple: belts, chokers, headbands and leashes are suggested since they require a minimum amount of material and provide the encouragement of a quickly finished, usable item.

Wrapping
The techniques of *wrapping* are very simple: a group of cords or other fibers are wrapped, or bound together, by a *separate* wrapping cord, or, alternatively, *one of the cords in the group* is used to bind all of them together. Cords may be of varying weights, colors and textures. Wrapping, like macrame, is not a new technique but one that has been "re-discovered" by contemporary craftsmen who use it in combination with macrame, stitchery and soft sculpture. When heavy cords and ropes are wrapped, rigid sculptural forms may be designed without the use of armatures of wire or wood.

Materials may include fibers of any type. Ordinary ropes, cords, twines — whatever is available — may be grouped and tied. Mix smooth and rough textures; experiment by introducing colors.

Techniques are simple: Place the cords to be wrapped closely together and, with a separate cord — or one from the group — begin to wrap the cords together. *Overlap the first wrap to prevent the coil from slipping.* When the cords are wrapped to the desired length, secure the loose end by threading it back down through the wrapped portion. If the cord is thin, thread it through a large-eye needle for easier handling. If the cord is too large for a needle, apply the wrapping loosely, then thread the loose end back down through the wrapping and pull it tightly. A bit of strong glue will help to secure the ends. Special wrapping knots — such as those used by the Peruvian Indians — may be used but simple knots, such as the overhand knot, may be used effectively. The overhand knot is made by twisting one cord around another and pulling each end tight. Vary this knotting by making one knot at the back of the bundle of cords and one at the front. Use a single cord or a double cord for knotting.

Variations: Combine with macrame, to create shapes or open spaces. In weaving, wrap warp threads together to create open spaces in the weave. Introduce three-dimensional forms in the design by wrapping wood or metal rings, sections of tree branches, hoops. Add beads, bells, shells, drapery rings and other found objects. Create larger forms by coiling sections of wrapped rope; stitch or lace these together to design soft sculpture or hanging forms.

Suggested Uses: Hangings; sculptural forms; jewelry (combine with beads, bells, drilled sea shells, metal washers, found objects). Combine in stitchery and weaving projects.

Weaving
Traditionally, weaving is done on a loom and, throughout the ages, various cultures have produced many different kinds of looms, ranging from the most primitive to the complex mechanical loom. Whatever the type of loom, the woven fabric is achieved by the interlacing of vertical (warp) threads and horizontal (weft) threads. The *warp* threads form the foundation or "skeleton" of the fabric; the *weft* threads fill in, or add the "body" of the fabric.

The contemporary craftsman, concerned primarily with weaving as an art form, has sought new uses for fabrics and new techniques for designing them. Conventional looms and traditional techniques have given way to innovative "weaving-without-a-loom" or, as some have termed it, "non-loom" or "off-loom" weaving. Off-loom weaving means simply that the weaving is done without the conventional wood loom. Instead, an improvised structure or support is made — or found — and the warp threads are strung on it. The weft threads are worked over and under the warp with the fingers, a shuttle, bobbin or any improvised tool that will pull the thread through.

The designs or forms produced on the non-loom bear little or no resemblance to the tightly woven fabrics usually associated with weaving. The nature of the non-loom encourages innovation: sections of the woven form may be solid while other areas are left open. Sections of the warp may be tied off, or wrapped, to create shapes-within-shapes. Weft "threads" may include raffia, leather, strips of felt or fur, dried grasses, reeds — practically *anything* that can be woven into the supporting warp.

The concern here will be with the "non-loom"

rather than with the traditional loom. Traditional weaves can be accomplished on the non-loom, of course, and these traditional weaves will be of interest to students interested in making utilitarian objects such as belts, bags and mats. The emphasis here, however, will be on the experimental, open-ended approach that leads to discovery and to creativity in the use of fibers.

Fibers

Collect the widest variety possible. In addition to conventional yarns and threads, collect rope, twine, sash cord, mason's cord, ribbon, raffia, straw, metallic and plastic fibers, fur, felt, feathers, reed, dried grasses, leather — in short, anything that can be interlaced through *warp* threads. *Warp* threads should be strong enough to provide the type of support needed: if a strong, tight warp is required, use traditional carpet warp, other hard-twisted cords or even fine *wire*. Softer, more elastic warp threads may be used if the finished object is to be soft and stretchy.

Looms or supports

Construct the type of loom appropriate for the project planned. Such items as mats, scarves and bags require more conventional "solid" weaving in order to withstand wear: for these projects, consider the *cardboard loom*, the *frame*, *board* or *box looms*. Free-wheeling hangings or woven sculptural forms, on the other hand, may be woven on such "looms" as shaped wire forms, tree branches and discarded hula hoops! *Before the weaving is started, decide whether the work will be removed from the loom or left on it, with the "loom" or support becoming part of the final design.* If the work is to be left on the loom, finish the loom so that, if parts of it show, it will be an attractive, harmonious part of the total design. A frame may be *painted*, *stained* or *wrapped with yarn or fabric*.

Shuttles, needles

Much contemporary weaving is accomplished with the fingers. In some instances, however, shuttles and needles make the work go easier and faster. Use long weaving needles, tapestry and chenille needles or the large-eye yarn needles. Improvise: drill a hole, large enough for yarn to pass through, in the end of a tongue depressor or "pop-stick." Tie the yarn through the hole and weave. For a handy "needle-

Weaving on a Hoop. A discarded wooden hoop is used as a loom and is retained as a frame for this design. To attach warp threads, bore small holes around the hoop or drive small brads or tacks into the edge of the hoop. Baltimore City Public Schools.

shuttle," break the handle from an old toothbrush; break it as close to the bristles as possible. Shape and sharpen the broken end with a file, then sand it smooth. Tie yarn through the hole on the other end of the handle and you are ready to weave. Make a tightly closed loop on one end of a length of stiff wire. File the remaining end smooth so that it will not "catch" on fibers. Tie yarn through the loop and weave, using the stiff wire as a needle or shuttle is used.

Related tools

Nails and *brads* of varying lengths; *hammer; saw* (for cutting wood strips); *drill* (for making holes in frames and branches, if required); *scissors; sandpaper. Wire snips* are optional but very handy. *Combs*, for pushing weft threads together.

Optional Materials

Beads, of all types, for accents of shape and color; stained glass, shells, metal washers and metal or plastic rods which may be threaded on the weft yarns or "caged" in the weft threads.

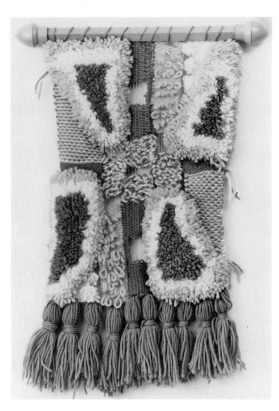

Tapestry. Senior high school student, Fort Lee, N. J. Note the variety of weaves in this small hanging. Tassels provide an effective finish. Rods of the type shown here can be found in drapery departments and in better hardware stores. Photo, courtesy Joan DiTieri, teacher.

Weaving on a Dowel. Senior high school student, Fort Lee, N. J. In this simple type of weaving, warp threads hang freely from the dowel. Note how open spaces are achieved by weaving selected areas very closely and by separating the warp threads. Strongly contrasting values accentuate the boldness of the design. Photo, courtesy Joan DiTieri, teacher.

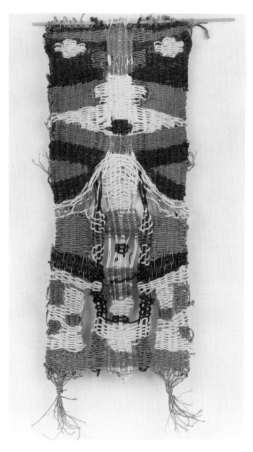

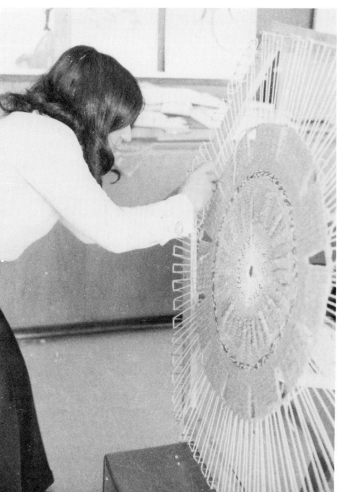

Weaving on a Frame. Senior high school student, Canastota, N. Y. High School. Frames of any size or shape may be built from scrap wood. Warp threads are attached to nails driven into the frame and may be slipped off when the weaving is completed. Photo, courtesy Ernest Andrew Mills, Assoc. Supervisor, N. Y. State Educ. Department.

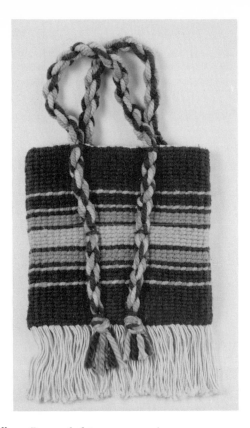

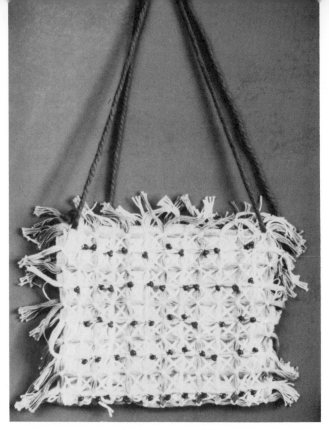

Woven Handbag. Bags of this type may be woven on a commercially available bag loom or on an improvised cardboard loom. Photo, courtesy Lily Mills, Shelby, N. C.

Handbag. Special education student, Baltimore City Public Schools. Yarns are warped vertically and horizontally to create a waffle-like arrangement, then simply tied at the points where they intersect. Shoe buttons provide contrasting shiny accents. The inner bag is of burlap.

(a)

(b)

Pillows. College students. In (a), woven bands create a striped effect; in (b), knotting and wrapping are used to break up the large open space. Photos, courtesy Michael T. Lyon, University of Washington, Seattle.

Construction of Looms

The simplest types of looms, commonly used by the beginning craftsman and in the classroom, are described here. For information on other, more traditional looms, see references in the Bibliography.

The Cardboard Loom

A very simple loom may be made of heavy cardboard (four to six ply) such as bookbinder's board. The cardboard should be cut the size desired for the finished piece of work. An uneven number of dots about three-eighths of an inch apart should be marked across each of the two short ends and a notch about one-quarter of an inch deep cut at each dot. It is important that the number of notches be uneven.

For weaving circular articles such as mats, a loom may be made by cutting a circle of cardboard and making an uneven number of notches about three-eighths of an inch apart around the edges. A hole at least one-quarter inch in diameter should be cut in the center of the circle. The warp thread should be put through the center hole, leaving a two- or three-inch end. While this end is held or taped at the center, the other end is carried over the edge, across a notch, and back through the center hole. The process is repeated, carrying the thread across each notch in turn and through the center until there is warp across each notch. The final end is then tied to the starting end. With a tapestry needle threaded with weft material, the weaving is started close to and around the center. The cardboard loom remains in the woven mat.

Other, more versatile cardboard looms can be constructed in the following manner and the technique lends itself to a variety of shapes: rectangular, circular or free-form.

Choose a smooth, undamaged piece of corrugated cardboard; bent or broken board cannot be used since the cardboard must remain rigid. When the shape and size of the item to be made are determined, measure the cardboard to size and mark cutting lines in pencil. Use a sharp, serrated knife to cut out the shape. Measure and mark one-half inch spaces around *all* the edges, one-half inch from the cut edge. With a sharp darning needle, nail or compass point, make holes all around the shape at the one-half inch marks. Tie a piece of cotton string or twine into one corner. Thread the loose end of the twine into a needle and "sew" into the holes in the cardboard,

with a *single* binding thread in each hole. Sew around the cardboard *twice* so that *each* one-half inch space is covered with twine. When each space is covered and you are back at the starting point, tie the loose end into the first hole, to anchor it. You have now completed a binding which will hold the warp threads securely in place.

Warp the cardboard loom by tieing a length of yarn into a corner. With a needle, take the warp thread across the length of the cardboard and through the opposite string loop, or "stitch," then back through the *first* loop where the yarn was tied on. This places a double warp thread from one end of the loom to the other. By threading in this manner, the double warp threads will be parallel to each other, rather than zigzagging across the loom.

When the loom has been completely warped, weave weft threads to create the design. Use a needle or other improvised shuttle. Experiment with different kinds of weaves: if solid areas are planned, it may be necessary to take weft threads through the binding stitches several times. Tie some warp threads together, or wrap them, to create open spaces; vary the yarns used.

When the weaving is completed, remove the work by turning the loom over and clipping the binding stitches from the back.

This type of cardboard loom is extremely versatile and may be used to create mats, hangings, belts, scarves and similar projects. *Pocket weaving* or *bag weaving* may be done by making the stitches *on only one side* of the cardboard, then weaving around the cardboard, on *both sides*. Free-form looms may be made to weave shapes that may be incorporated in other fabric projects such as hangings or yarn collage.

If handled carefully, the cardboard loom is reusable.

Wooden looms

The materials required for these looms are readily obtainable and inexpensive: wood strips, a wooden box, or an old picture frame are the basic materials for the loom. Nails, a hammer and, for cutting wood strips, a saw are the only other tools needed.

If *wood strips* are used, two strips equal in length are required for the sides and two other strips equal in length, but *shorter*, for the ends. The ends should be nailed on *top* of the side pieces; this is important.

A row of three-quarter inch nails should be driven about one-half inch apart along both ends of the frame allowing each nail to stand up about three-eighths of an inch. An *odd* number of nails should be used and spaced equally about three-eighths of an inch apart.

Screw eyes should be placed at each end of the two rows of nails and a heavy straight wire run through these along each side. Each piece of wire should be bent at one end so that it will not slip through the screw eye. A long nail driven in the center of each side of the frame just inside the wire will prevent it from bending in toward the center of the frame as the weaving progresses.

The methods for placing the nails and wires on the frame loom may be used in constructing the box or the picture frame loom.

Warp the wood loom in the manner described for the cardboard loom so that warp threads are parallel rather than zigzag — unless that is the effect you want. The weft threads may be carried through by hand or with a yarn needle or improvised shuttle.

The weaving processes for the frame, box or picture frame loom are basically the same; experiment with varying the warping pattern and with a variety of yarns.

Leaving two or three inches hanging, pass the weft thread under one warp thread and over the next, alternating until the other side of the loom is reached.

Pass the weft thread around both the last warp threads and the brace wire as if they were one, not as separate threads. Continue weaving back to the first side, passing the shuttle under the warp thread which it passed over on the previous row, and vice versa. Encircle the first warp thread and brace wire and repeat.

Press the weft to the end of the loom firmly and pack it with the shuttle, a ruler or other straight edge every few rows to obtain a closer weave.

Avoid knots in the weft thread. When a new thread must be joined, overlap it with the previous one and weave the new thread along with the last inch or two of the old thread.

A design may be woven in by "piecing" in a thread of contrasting color and weaving with it. When this is done, interlace the edges of the design color with the background color by including the same warp thread as the last to be used in weaving the edge of each.

The texture may be varied by "braid" weaving; that is, weaving with two weft threads, one passing under as the other passes over each warp thread, and crossing between each two warp threads.

The weave may be varied; instead of the simple over and under weave, the weft may be carried over two and under one warp thread, or other patterns may be worked out.

When the weaving is completed, the beginning ends of the weft threads should be made secure by weaving them back into the woven material. The finished work is removed from the loom by pulling out the brace wires and lifting the warp loops from the slits or nails.

Board loom

A board loom may be constructed from almost any type of hardboard; but, Masonite is recommended for the construction described here because it is comparatively lightweight, can be easily notched and wood strips can be securely glued or nailed to it.

Materials: A rectangle of Masonite, cut to the desired size, two strips of wood moulding as long as the loom is wide, strong glue and a saw. Ruler or straight-edge.

Procedure: (1) With a ruler or straight-edge, mark *both ends* of the board at one-quarter inch intervals. (2) With a saw, cut grooves between the marks; check frequently to see that grooves are evenly cut — about one-quarter inch deep — on both ends. (3) About one-half inch from each end, glue a wood moulding on top of the board. The moulding should be thick enough to hold the warp approximately one inch above the board. (Clamp the strips of moulding to the board until the glue has dried.)

Warp the board by taping the first cord to the back of the board, then winding the cord up the board, in back of the first notch, and then back down to the bottom notch. Continue until the board is completely warped. Weave with a large needle, the fingers or improvised shuttle. When the weaving is completed, remove the work by slipping the warp thread off the notches.

Note: Regular wooden boards may be used to make this type of loom but, because of the thickness of wood, nails with small heads would have to be substituted. *Bookbinder's board* could be substituted when Masonite is not available. Plywood is not

recommended because grooves would be difficult to cut and might splinter, creating uneven grooves.

Other improvised and found looms may include the following:

1. *Hoops* of metal, wood, plastic, wire. Warp the hoop by winding warp thread over and around the hoop, with warp threads crisscrossing at the center. Weave on one side, or on both sides for a layered effect. Small brads, plain or decorative, may be hammered into wood hoops — or small holes can be drilled at intervals — to hold warp threads. Consider fine wire, instead of conventional cords, for warping. Combine open and closed areas. Combine stitchery techniques with the weaving. *Experiment!*

2. *Small tree branches, twigs.* String warp threads from branch to branch or, in thicker branches, drill small holes for warp threads to pass through. Weave with a variety of thick and thin yarns and string to create sculptural forms that "sit" or hang.

3. *Shaped wire, hardware cloth (metal screen).* Design a shape that is free-standing, or one that may be suspended. To hold the wire or metal screen together, lace fine wire through openings in the screen and twist to secure. Bind individual wires together with a fine wire, such as florist's wire, or with strong thread. (Add a drop of glue, for extra security.) Weave into the form with yarns, strips of felt, plastic, pipe cleaners and other "found" yarns. Add metal shapes for bright accents (metal rings, washers, scrap foils).

4. *Dowels, rods.* Attach warp threads to dowels or rods by tieing them on or, depending on the type of rod, by nailing, knotting, or threading them through drilled holes. Only a top rod may be used, with warp threads hanging freely or taped to a table top. The use of rods at both top and bottom makes for easier handling since warp threads are held more evenly and more tautly. *Weave* with a variety of yarns; introduce wire loops or circles in the warp to create open spaces. Finish ends by knotting, fringing or by adding beads, lead sinkers (sporting goods stores) or metal washers to ends of yarn.

5. *Mesh, of varying types.* Weave into the mesh, using a yarn, chenille or tapestry needle. Work freely, or transfer a pattern to the mesh with felt marker or crayon.

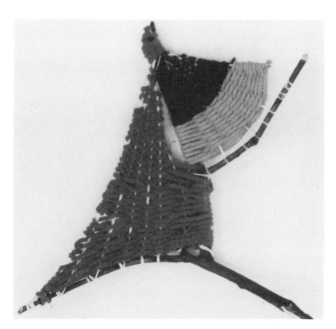

Weaving on a Branch. Warp threads are strung between the twigs; yarns are woven to fill the spaces between.

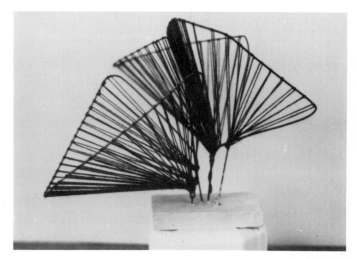

Yarn and Wire Construction. Yarn is strung between coat-hanger wire set in a wood block. Baltimore City Public Schools.

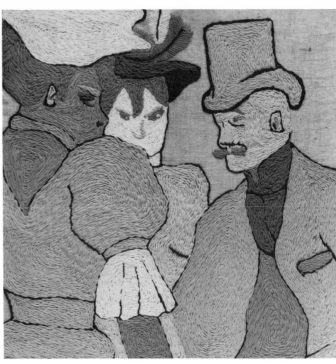

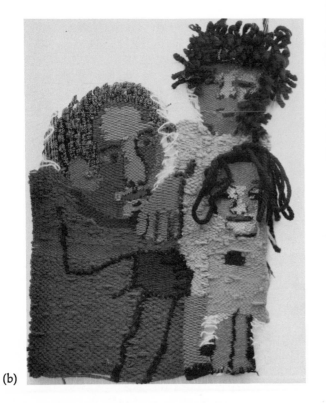

(b)

Tapestries. Senior high school students, Fort Lee, N. J. Two different approaches to tapestry: in (a), stitches vary little and the design is tightly controlled; in (b) the approach is free and yarns are handled experimentally to achieve desired textural effects, particularly in the hair. Note how contrasting values are used to accent planes of the faces. Photo, courtesy Joan DiTieri, teacher.

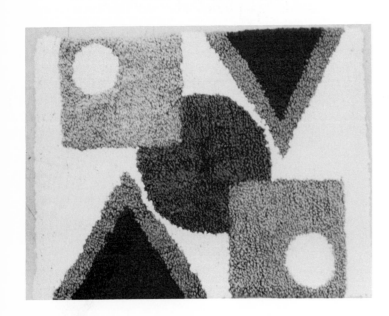

Hooked Rugs. Baltimore City Public Schools. Designs based on geometric and non-objective forms.

Hooking

In addition to rug making, hooking may be used to create colorful wall-hangings, or "wall rugs," and hooked designs may be used as elements in soft sculpture. An area of hooking can provide additional textural interest in stitchery projects, creating raised, three-dimensional forms in an otherwise flat surface.

A variety of *hooking needles* are available from manufacturers of yarns and needlework supplies. (See Sources for Materials and Tools.) The type described here is the simplest type — resembling a thick crochet needle with a short wood handle — and is the kind generally available in the classroom.

The foundation material for hooking is burlap or coarse canvas. Yarn or narrow strips cut from discarded stockings or cotton, woolen or linen materials may be used for hooking. A discarded picture frame, a frame made from four strips of wood about one and a half inches wide or embroidery hoops will serve to hold the material taut for hooking. A hooking needle or a crochet needle with a hook large enough to pull the yarn or other material through the burlap is necessary.

An original design should first be drawn on a piece of paper the actual size of the rug to be made. On all four sides of it, a margin of about three inches should be allowed which will not be hooked but later turned under as a hem. The design should then be traced from the paper to the piece or burlap or canvas. If a frame is used, the material, right side up, should be tacked or sewed to it. With or without the frame, the hooking procedure is the same.

Hooking is begun by holding the yarn or strip of cloth horizontally with one hand underneath the outline on the material and the hooking needle with the other hand on top of the material. The hooking needle is then pushed down through the mesh and a loop of yarn or cloth pulled up to the desired height but not less than one-fourth inch. The loops should be kept as near the same height as possible and be spaced without crowding but with none of the backing material showing. The outline of the design should be hooked first then the masses filled in. The design and background should be filled in until the entire rug surface is covered. When hooking is finished, the rug may be removed from the frame, if one is used. The loops may be left as they are or they may be cut, if this is preferred. The surplus burlap should be turned under and sewed to form a hem.

Other Techniques for Fibers

The techniques for working with fibers described in this chapter include the techniques most commonly used in the general classroom — yarn collage, stitchery, knotting, weaving and hooking. The basic techniques described here provide starting points for further exploration of more advanced, more varied uses for fibers.

For information on additional techniques such as *crochet, meshwork, rya weaving, pulled thread work* and other, more specialized uses for fibers see the Bibliography.

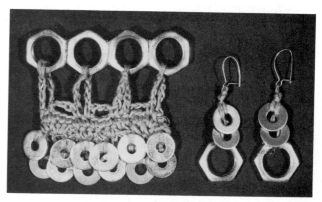

Pin and Earrings. Ramona Solberg. Crocheted yarns combined with nuts and washers. Photo from *Inventive Jewelry Making,* Van-Nostrand Rinehold, Solberg.

Patchwork. (Detail) Murel Short. One variation of the traditional "Log Cabin" pattern which is often adapted for pillows, wall-hangings and wall-quilts. Collection of the author. Photo by Claude Tittsworth.

Chapter 4
Fabrics

Fabrics and fibers provide the raw materials for an almost limitless variety of creative expression and, happily, at comparatively low cost. Their myriad textures and colors may be incorporated in practically every area of the art program including painting, printmaking, "soft" sculpture, construction and a variety of crafts. The techniques are familiar but the applications are new: fabrics, weaving, stitchery, knotting and crochet are combined, in many instances, to produce objects unknown to the craftsmen of an earlier day who were primarily concerned with making clothing or utilitarian home furnishings.

TYPES

Practically every type of fabric manufactured may be used in the general art program. Aside from the muslin and burlap commonly provided through school supplies, consider the textural variety in smooth satins, scratchy tweeds, gauzy drapery fabrics and nappy velvets and corduroys — the list is endless.

SOURCES

Collect scraps of fabric from home and school sewing centers; even the smallest scrap of patterned and printed cloth can be used in collage, puppetry or stitchery. Upholstery and drapery shops are often happy to contribute, cost-free, the scraps of fabric too small to be sold as remnants.

These shops, too, often have obsolete fabric sample "books," or sample swatches that can be used in collage, puppetry, patchwork and stitchery projects. Consult the Yellow Pages for fabric manufacturers; ask about the possibilities of obtaining scraps, "mill ends," or whatever else might be available at little or no cost. Perhaps there are yards of fabric, imperfect and therefore of no use to the manufacturer, that may be had for the asking.

Fur, felt, decorative laces and *braids* provide interest and textural accents for puppets, wall hangings and collage. As in the case of fabrics, go to the sources — the workshop, the distributor and the manufacturer.

When the fabrics have been collected, store them carefully. *Yards* of fabric should be rolled around stiff cardboard cores to avoid crumpling and wrin-

kling. Cores may be obtained as discards from shops or may be made from stiff cardboard. *Small scraps* may be stored in a laundry bag rather than in bulky, space-consuming boxes. Samples or swatches may be left as is, pasted in their "books," until ready for use. To save time, consider sorting the fabrics according to type or weight, such as plain, patterned, heavy or light. Shoe boxes, which stack compactly, provide ideal storage for small bits of materials and for work in progress.

TECHNIQUES

Since fabric can be pasted, sewed, stitched, dyed, printed, stretched, painted and woven, a complete description of all fabric techniques and applications would far exceed the scope of this book. The following techniques, common to the classroom, are described briefly and simply to provide a starting point for teacher and student. (For references describing additional, more advanced techniques see Bibliography.)

Collage

Cut shapes from a variety of fabrics — coarse, smooth, patterned, plain — and create a design by moving them about on the work surface. When a pleasing arrangement is achieved, adhere the fabric shapes to a backing of stiff cardboard or hardboard. Experiment with overlapping shapes, and by adding string, yarn or bits of braid for accent or contrast. Acrylic medium or white glue, slightly thinned with water, are recommended; "school paste" causes excessive wrinkling and does not adhere the fabric securely. Test your adhesive before using it; some spray-type adhesives discolor fabrics.

Variations: (1) Apply a glaze of acrylic color over selected areas of the collage to provide accent colors or to unify design. (2) Apply fabric shapes to a painting for accents in color and texture. (3) Use textured papers, along with the fabric scraps, to create the collage: consider corrugated board (remove top layer to expose corrugations), foil, sandpaper and other textured or patterned papers.

When completed, the collage may be left "as is" or sealed with thinned white glue, P.V.A., or any of the clear-drying aerosol sprays. *Note:* To avoid warp-

Fabric Collage. Student, Baltimore City Schools. Scraps of plain and patterned fabrics used to create an arrangement of symbols and shapes. Stitchery is used to add detail and texture. Selected areas are painted with acrylic colors.

ing, coat *both* sides of the mounting board with thinned white glue, P.V.A. or thinned acrylic medium *before* the fabric is adhered.

Stitchery

Before starting stitchery projects, check the fabric that will be the background to be sure that it is cut evenly and accurately. It may be necessary to pull a thread across the top and bottom to get a straight lines for cutting. Press the fabric to remove wrinkles and folds that would interfere with the accuracy of the design or make stitching difficult.

In measuring the fabric, allow an extra inch on all sides for hemming or finishing. For a wall hanging, allow enough extra fabric at the top to make a heading, or rod pocket, for the insertion of a rod or dowel. Fold this margin of fabric toward the back and baste or tape in place. This is especially recommended if the fabric is one that frays easily, such as burlap, or other loosely woven material.

A frame isn't an absolute requirement but will assist younger students in handling their work. It will also assist in preventing their pulling the stitchery yarns too tightly, causing the fabric to wrinkle or bulge. If frames are desired, use old picture frames or make simple frames from stiff cardboard or narrow wood strips. Staple cardboard frames at corners; fasten wood strips with corrugated wood fasteners (hardware store) or short nails.

Stitchery and Appliqúe. College student. Light-weight cotton fabrics. The frayed edges of the fabrics are not turned under, or finished, as in traditional applique but are left as they are to provide a textural quality. Note the variety of texture and line quality provided by the use of a straight stitch. Photo, courtesy Nancy Belfer.

Wall Hanging. College student. Fabric-stuffed appliqúe. Stuffing selected shapes in the design adds a three-dimensional quality to an otherwise flat design. Photo, courtesy Dr. Jay D. Kain, University of Minnesota.

Felt and Mirror Necklace. Ramona Solberg. Seed beads and stitchery provide surface enrichment in this innovative use of felt as a material for jewelry design. Photo, courtesy the designer, author, *Inventive Jewelry Making.*

Sun Theme. College student. Felt appliqué banner. Naturalistic forms are simplified and appliquéd with machine and hand stitchery. Photo, courtesy Nancy Belfer.

Create the design by sketching it on paper or by "trailing" yarns over the background fabric until a pleasing design is achieved. Keep in mind that some areas may be filled in with stitches or fabric while others remain open. If the design is to be transferred from a drawing, rub colored chalk over the *back* of the drawing. Pin the drawing in place, on top of the fabric, and trace it with a pencil. When the design is transferred, go over the faint chalk lines on the fabric with a pencil or fine-tipped felt marker to make them clearer. (Commercially prepared carbon papers, such as Dritz, are preferable, of course, but the chalk technique is adequate and less expensive.)

Begin with a simple *running stitch*: use it to outline shapes, to create textures, to fill in spaces. Create variety by varying the length and size of the stitch and by using different yarns. Attach thicker yarns with the couching stitch. The *chain stitch*, *feather stitch* and dozens of others are learned and "invented" as work progresses. A sampler-type activity may be helpful in learning a variety of stitches.

Stitchery charts, available from some yarn manufacturers, are especially helpful in introducing stitchery to large groups. If charts are not used, demonstrate stitches by making giant-size stitches, in yarn, on large sheets of paper tacked to a bulletin board or an easel.

Variations: (1) Introduce *appliqué*, by cutting shapes from a contrasting fabric and stitching them into the design. (2) As stitching progresses, thread beads, buttons, metal washers and other bright accents on the threads, stitching them securely on the fabric. (3) On a loose, open-weave fabric, use a large needle to weave yarns, string or raffia into the open spaces. Narrow strips of felt may be woven in by hand or weaving needle.

Uses: Wall hangings, decorative pillows, banners, handbags, beach bags, mats, puppet costumes, chokers and belts. (Upholsterer's webbing, sold in upholstery departments in stores, makes an excellent "base" for belts and, stitched together, beach bags and handbags.)

Tie-Dye

Tie-dye is essentially a resist technique in which cloth is rolled, folded, twisted or otherwise compressed, tied or bound, then dyed. The bound and tied sections of cloth resist the penetration of the dye and retain the original color of the cloth.

Certain tie-dye techniques are extremely complex and, depending on color effects desired, quite time-consuming. The basic technique, however, is quite simple and once it is understood, variations and refinements come easily. The following procedures are recommended for the beginner.

Almost any type of fabric can be tie-dyed if the proper dyes are used but, for the beginner, cotton fabrics are recommended. (Synthetics, wools and blends present special considerations of dyes, temperatures and handling best left to the more experienced student.) Muslin, percale, cambric, denim and other light-to-medium weight cottons are suitable; old sheeting may be used and is relatively inexpensive for beginning projects.

Use a household dye such as Rit or Tintex and follow the manufacturer's directions for mixing it.

1. Tie up the cloth. The tying may start at the center of the fabric which will produce a sunburst type of pattern but other patterns of tying should be tried: fold the cloth vertically or horizontally, then bind with twine or rubber bands.
2. Wet the cloth by soaking it in water; the water will provide added resistance to the dye.
3. Put the tied cloth in the dye bath for the recommended time, stirring it about with a stick.
4. Remove the cloth from the dye and rinse it well to remove excess dye. Untie and unfold the cloth and rinse a second time.
5. Press when drying is almost complete.

Variations: (1) If a second color is desired, tie up areas where the dye color is to be retained and put the tied cloth in a *second* dye bath. Repeat steps (4) and (5).

Remember: (1) when more than one color will be used, start with the *lightest* color, ending with the *darkest*. (2) Experiment with tying objects in the cloth — pebbles, marbles, spools, corks and other found objects that will not disintegrate in the dye may be used. (3) Fold materials around dowels, sticks or clothespins, then tie and proceed with dyeing, as outlined.

Uses: Wall hangings, banners, collages, scarves, mats, toys, accessories and clothing.

(a)

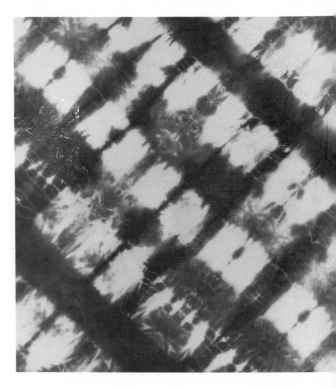

Tie-Dye Details. Nancy Belfer. In (a), the pattern is achieved by diagonal folding and tying. In (b), after the fabric was folded, it was tied and clamped. Clamping may be done by using metal "bull-dog" clamps, clothes pins or heavy-duty paper clips. Photo, courtesy the designer.

Discharge Dyeing (Detail). Nancy Belfer. Discharge dyeing, or tie-bleach, removes the color from fabric. In this sample, the fabric was folded, tied and clamped then dipped into bleaching solution. Photo, courtesy the designer.

Tie-bleach, or discharge dyeing, is related to the traditional tie-dye procedure in that the fabric is bound and tied in very much the same manner. The difference is that, in the tie-bleach technique, color is discharged or *removed* from the fabric rather than added.

The selection of fabric is important. Choose inexpensive intensely colored cottons that are *not* guaranteed color-fast; if the fabric resists the bleaching, it cannot be used. Test a small piece of the fabric to determine the degree of bleaching that will take place before bleaching a larger piece.

1. Fold and tie the cloth as for tie-dye, remembering that there will be *less* bleaching where the cloth is most tightly bound.
2. Wet the cloth completely by immersing it in a basin or sink. (Holding it under a faucet will not wet it completely.)
3. Immerse the fabric in a solution of household (chlorine) bleach and water. (One part bleach, 3 parts water.)
4. Move the fabric about frequently. (Use a stirring stick or wear rubber gloves.)
5. When the desired degree of bleaching is completed, remove the fabric and rinse it thoroughly by immersing it in water.
6. Untie the bindings and rinse again. Wash in hot soapy water to remove the bleach solution. Hang the material and permit it to dry.
7. When the cloth has dried, press it to remove wrinkles. A spray-type starch may be used to add body or "finish" to the cloth. Caution: Do not leave the cloth in the bleach solution too long; excessive bleaching will weaken or "rot" the fabric to the point where it will split and literally fall apart.

Variations: (1) If fabric cannot be found in the color desired, dye a length of fabric with household dye, then proceed to tie-bleach. (2) Experiment with different ways of binding and tying the fabric; use clothespins and paper clips to hold folds in place. (3) Gather sections of the fabric by stitching it and then pulling threads taut. Tie off the ends of thread and proceed with bleaching. Stitch circles, squares, straight lines and zig-zag patterns. (4) The threads used to tie the fabric influence the design: use rubber bands, plastic cord, jute, cotton twine, fishing line and whatever is available for a variety of line patterns on the cloth.

Uses: Fabrics designed by tie-bleach may be used to make clothing such as blouses, smocks, scarves, skirts or other items. Wall hangings, pillows, mats, bags and framed tie-bleach "paintings" can be most attractive when properly finished or mounted. Use tie-bleach fabrics to design soft sculpture, stuffed toys, coverings for lamp shades and other decorative items.

Batik

Batik, one of the oldest techniques for fabric design, can be as simple or as complex as desired. The traditional techniques require special waxes, dyes and tools that are not available in the average classroom; contemporary techniques utilize readily available materials and employ techniques well within the grasp of the beginner. Newer techniques emphasize a freer, more spontaneous approach and account for the renewed interest in batik. The methods described here are simplified and have been found successful for classroom use.

Materials: Wax (paraffin, or 1 part paraffin and 1 part beeswax, for a more flexible wax), dyes (powdered batik dyes or household dyes) and fabric. Choose fairly lightweight fabrics, such as muslin, sheer cottons, sheeting and silk.

Tools include stiff bristle brushes, a glass or enamel container for dye, rubber gloves, stirring sticks, newspaper — in good supply, electric iron and a hot plate, or other heating device for melting wax. Since wax should not be melted directly over heat or flame, provide a water jacket of some type: melt wax in the top of a double boiler or place wax in clean tin cans and place them in a pan of water which can be set on top of the heating unit.

A tjanting needle — the traditional tool for applying wax — is optional. Other types of waxing tools are available, such as the Waxmelter.

The Traditional Method

1. For critical work, fabric should be thoroughly washed to preshink and remove sizing or loose dyes from the material. (For general classroom work, omit this step.)

2. Sketch the design on a piece of paper the same size as the fabric.
3. Transfer the design to the fabric, by tracing if fabric is thin enough to see through or with transfer paper. Designs may also be sketched directly on fabric with tailor's chalk.
4. Place waxed paper under the piece of fabric you intend to use.
5. Melt wax in chosen container and maintain it at an even temperature. Dip brush into wax, press against side of pan to remove excess, then proceed as if painting. When re-dipping brush, allow it to remain in the hot wax long enough to melt congealed wax already on the brush. To use tjanting, fill the metal bowl with wax and pour from spout; if spout clogs, open with a fine wire. Outline large areas of design with tjanting or a small brush, then fill in. Make certain wax penetrates the fabric thoroughly; when the waxing is completed, touch up the underside of the fabric where wax is too thin. Be careful not to drip wax where it is not called for by the design. For unusual effects, brush wax on thinly so that some dye will penetrate to show brush marks; scratch wax with nail or other sharp instrument to obtain a fine line design; gently crush waxed areas for a crackle effect.
6. Dye can be mixed in lukewarm water. To insure complete dissolving of powder, it is preferable to use a small amount of hot water and then add cold. Desired shadings of color are achieved by increasing the amount of powder to be dissolved.
7. For increased fastness, add a fixing agent.
 a. Cotton dyes — add a pinch of plain salt to dyes.
 b. Silk dyes — add a few drops of vinegar to dyes.
8. Dye should be mixed in a container large enough to hold the fabric comfortably. Test dye on a small sample of partially waxed fabric to check the color and to make sure that the wax does not melt; it should hold up to 90°F.
9. Wet fabric so that dye can penetrate immediately. Keep fabric gently in motion, with a stick, to avoid streaks. Rinse thoroughly in lukewarm water; cold water might crack the wax. Blot up excess moisture with old towels or newspaper to avoid streaking when piece is hung to dry.

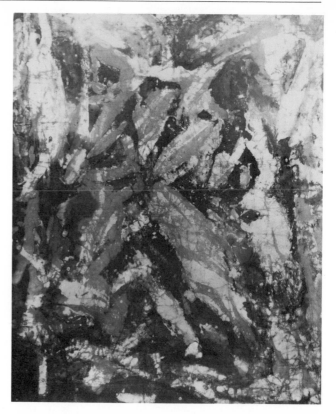

Batik. Student. Fort Lee, N. J. Senior High School. This batik panel, which has been stretched and framed as a picture, illustrates a heavily "crackled" texture. Waxes were applied in a free, spontaneous manner with a brush with no attempt for tightly controlled color areas. Photo, courtesy Joan DiTieri, teacher.

10. When the fabric has dried, remove wax by ironing fabric between sheets of absorbent papers. If newspapers are used, place unprinted papers such as paper towels or newsprint on each side of the batik. Change papers frequently. If fabric is to be used for clothing, have it dry-cleaned to remove all traces of wax.
11. To set the dye after the wax is removed, press the fabric with a vinegar-soaked cloth.
12. Mount for display, if desired.

Variations: (1) Create a design by *brushing* the dye directly on the fabric rather than immersing the fabric. (2) Use found objects such as corks, spools, kitchen gadgets and sticks to *stamp* the wax on the fabric rather than applying it with a brush or tjanting.

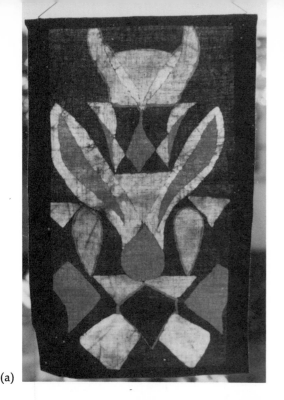

(a)

(b)

Batik Banners. College students. These banners illustrate a variety of approaches to designing with traditional batik procedures involving multiple dye baths. In (a), shapes are simple, bold and clearly defined. In (b), more intricate patterns and a border require more precise control of wax applications. Free-flowing designs and subtle colorations are evident in (c); in (d), the details of (c) reveal cracking and tonal relationships. Photos, courtesy Michael T. Lyon, University of Washington, Seattle.

(d)

(c)

Create lines and dots by trailing or dripping wax on fabric. (3) If a *second* dyeing is planned, permit the first dyeing to dry completely before re-waxing the fabric. (4) Instead of using a white fabric, choose a colored fabric in a light, pastel tone.

Wax Crayon Batik

The following method for batik, developed in the Binney and Smith Studio, New York, involves the use of wax crayons which makes possible a great variety of colors with a minimum of dyeing.

Procedure:

1. Lightly sketch design on cotton fabric which has been washed free of sizing and pressed. (Cotton will give best results; synthetics may resist dyes.)
2. Peel paper from crayon scraps and place them, one color per cup, in a muffin pan. (Brilliant colors work best since dyes tend to dull the darker colors.) Add ½″ cube of paraffin to each cup, so that wax will spread quickly and freely.
3. Place muffin pan in a baking pan filled with boiling water over low heat on hot plate. (Do not put muffin pan over direct heat.)
4. Place cloth on several thicknesses of newspaper or absorbent papers. Brush the melted crayon on the cloth in the outlined areas, leaving spaces between colors. (Newspaper ink that may adhere will disappear later.) To make sure that the wax penetrates the fabric, keep heat constant and work rapidly, before wax can harden on the brush. If wax is too thick, add more paraffin. If color does not penetrate fabric, turn fabric and apply wax to the other side.
5. Let wax dry completely, then crumple fabric gently. The degree of crumpling will determine the extent to which the colors are "cracked" after dyeing.
6. Mix a *strong* solution of any *dark*-color dye, following the manufacturer's label directions. Allow the dye to cool, then place the fabric in the dye for about 10 minutes.
7. Remove the fabric from the dye, set it aside for a few minutes, and then place it on paper toweling, so that excess dye may be absorbed.
8. Place the fabric between fresh sheets of paper toweling and press with a hot iron. Replace paper as the wax is absorbed and continue pressing until little or no color shows on the paper towels. Set fabric aside for fifteen minutes.

Wax Crayon Batiks. Students, Baltimore City Schools. Techniques for this simplified batik process are described in this chapter. (a) Stretched and framed panel. (b) Wall hanging, approximately 3′ x 5′, was a group project.

(a)

(b)

Note: When cleaning becomes necessary, wash the fabric, by hand, in mild detergent and warm water. It should be ironed between sheets of newspaper as was done originally. Do *not* dry clean.

Uses: Wall hangings, scarves, pillow covers, banners, fabric for curtains, clothing. Batiked fabrics may be stretched and framed, as paintings.

Drawn Thread Work

In this simple technique, designs are created by *drawing*, or removing, threads from the ground material. Loosely woven fabrics such as burlap or monk's cloth are ideal because the threads are easily removed and work proceeds fairly rapidly. The looser the fabric, the more open and lacy the finished work. Both vertical and horizontal threads may be drawn to create open or lacy areas that appear to overlap or threads may be drawn in only one direction, depending on the effect desired.

Materials: Burlap, monk's cloth or other loosely woven fabric; string; yarn; felt.

Tools: Scissors; needles. A frame is not necessary but it may be helpful to secure the fabric to a flat work surface for better control. Use thumb tacks or tape at the corners of the fabric; the sides and ends of the fabric must be free so that threads can be drawn.

Procedure: If fabric is wrinkled or crumpled, press it. Attach fabric to work surface and start design by drawing threads. Create "bands" of open spaces by drawing all the vertical or horizontal threads in selected areas. Use short strings to tie some of the loose threads together to create patterns. Experiment by *piercing* the fabric to create openings of various shapes; use a pencil or dowel to create holes. *Shift*

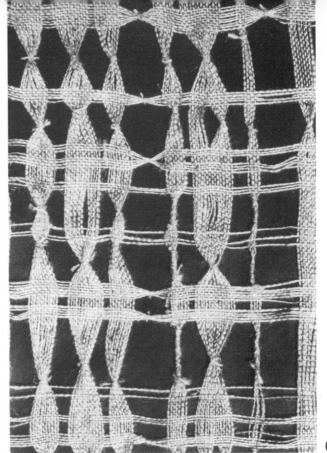

(a)

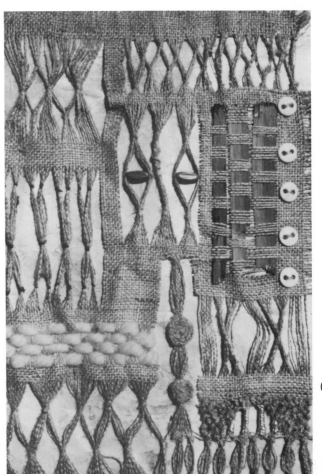

(b)

Drawn Thread Panels. Junior high school students. In (a), an open lacy effect is achieved by removing most of the threads from the burlap, then shifting and tying the remainder. In (b), other fabric techniques are used: some of the threads are bound together, a contrasting yarn is interwoven, buttons and beads provide accents and contrasts in texture. Photos, courtesy Michael T. Lyon, University of Washington, Seattle.

the threads, as the fabric will permit; the more threads removed, the more open and workable the fabric becomes. Create variety in color and texture by weaving a variety of yarns (grasses, ribbons, raffia) into the fabric. Add beads for accents; use felt for appliquéd shapes and for weaving in narrow strips.

To finish, leave edges as they are or fringe and tie. Mount finished work on wood dowel, narrow wood strip, thin metal rod or tree branch, for hanging.

Other uses for drawn thread work include mats, pillow tops and purses, depending on the number of threads removed. Pillow tops and purses should be lined for greater durability.

Patchwork

Patchwork, in the hands of the contemporary designer, is no longer limited to the quilts and coverlets so painstakingly stitched by our ancestors. Although still used in the design of decorative pillows, cushions and other household items, patchwork has become extremely popular for skirts, blouses, coats, handbags and fashion accessories. In the studio and classroom, patchwork is used to create wall hangings, patchwork "paintings," wall quilts and soft sculpture.

Early patchwork makes use of simple, basic shapes such as the square, rectangle, triangle and hexagon to create patterns that copied or suggested natural forms or objects. The "Oak Leaf," "Fan," "Lone Star" and "Wedding Ring" quilt patterns are examples of this type of design, created from tiny shapes cut with templates and joined with the tiniest invisible stitches. The contemporary designer, more concerned with expressive quality, works freely and may combine a variety of shapes and fabrics with stitches that are meant to be seen as part of the design.

Today's patchwork may not be joined by stitches: White glues, spray adhesives and adhesive backings may be used to mount patchwork on rigid board, felt or other fabric.

Materials: The choice of fabric will depend on the nature of the project: a wall hanging, soft sculpture or toy may be made from a variety of fabrics including cottons, tweeds, velvets, satins and whatever else is available. If, however, the patchwork is to be made into clothing which must be washed or cleaned, choose fabrics that will withstand wear and cleaning.

Fast color cottons such as percale, sateen, poplin, muslin, pique and good cotton blends are practical choices for scarves, blouses, skirts and other "everyday" items of clothing. Elegant capes and stoles may be made from velvets, heavy satins and richer, heavier fabrics but it should be noted that heavier fabrics require greater skill in cutting and sewing. Velvet, corduroy, slippery satin and rayon "crawl" under scissors and needle; some rayons fray badly.

Tools: Scissors — fairly small with sharp points; assorted needles and straight pins; chalk (for tracing shapes); electric iron, for pressing. Decorative items such as braids, beads, lace and buttons are optional.

Procedures: Only general guidelines are offered since specific techniques will vary with the project.

1. Light-to-medium weight fabrics are easier to handle and cut when they are slightly stiffened. Use spray starch or sizing and then iron as directed. If the fabric is to be mounted on a wall panel, a thinned white glue may be used since the fabric will not be washed, as in clothing. (Test glue to find if it changes the color of the fabric.)

2. If exactness in design is important or if a number of shapes must fit together precisely, use a template, or pattern, made from heavy cardboard or plastic. Place the pattern on the *back* of the fabric and trace around it with a sharp pencil or tailor's chalk. Do *not* use a ballpoint pen; the marks are almost impossible to remove.

3. When cutting patches, especially when a number of the same shape will be used, remember that the thread of the fabric should run the same way in as many patches as possible. This is especially important in making patchwork for clothing where an even finish is desired. In other projects, such as hangings and "paintings," this is not a critical factor.

4. If new fabrics are not available, use the least-worn, least-faded portions of discarded clothing, drapery and slipcovers.

5. Avoid combining extremely lightweight fabrics with heavier fabrics in patchwork for clothing. They often do not join neatly and will not wear well.

6. To finish: Many patchwork items require a lining, especially those designed to hang. Cut lining the same size as the patchwork and sew it, on

three sides, to the *top* of the patchwork. Turn it inside out, as a pillow case, and press the edges. Close the remaining open end by turning raw edges inside and blind stitching them. Linings may harmonize or contrast with the patchwork colors. Stitchery may be used to enhance selected areas that seem to require it. On wall panels and hangings, acrylic paint may be used to add detail or accents but this technique should be used judiciously.

Uses:

1. *Wall panels.* Apply patches with white glue to a base of Masonite, plywood, bookbinder's board or other rigid support.
2. *Wall hangings.* The hanging may be made completely from patchwork, and lined, or the patchwork may form the positive areas of the design with the base fabric becoming the negative area. Felt, burlap, monk's cloth, linen and similar fabrics are recommended for backgrounds. Upholstery fabrics, often obtainable as scrap, are also excellent for this purpose.
3. *Clothing.* Headbands, scarves, belts, blouses, halter tops, skirts and capes. Decorate with beads, braid, stitchery.
4. *Handbags.* Use sturdy fabrics such as sailcloth, denim and lightweight upholstery fabrics. A variety of tweeds make an especially handsome winter bag. Fashion handles from cord, chain, macrame, leather or cover a rope with harmonizing fabric, stitching it evenly and tightly along the full length.
5. *Stuffed toys.* Choose sturdy materials and join securely. Decorate with appliqué and stitchery.
6. *Soft sculpture.* Stuff the sculpture, rag doll fashion or, if the sculpture is to be mounted on a panel for hanging, stuff or pad parts of it to create relief surfaces. Consider figures, animals and abstract compositions. Lining is necessary if parts are to be stuffed: line with a lightweight fabric or net, then stitch around the part to be padded or stuffed to form a "pocket." Slit the "pocket" on the underside, stuff it with cotton (dacron, old nylon hose), then stitch the pocket closed.

Hand Puppets. Phyllis Dunstan. Machine stitched felt, with yarn, stitchery and button trims. 8″ tall. Photo, courtesy the designer.

Pendant. (Detail) Phyllis Dunstan. Reverse appliqué and stitchery. In reverse appliqué, the fabrics are layered then cut through until the final layer is revealed. Contrasting colors and values are most effective. Photo, courtesy the designer.

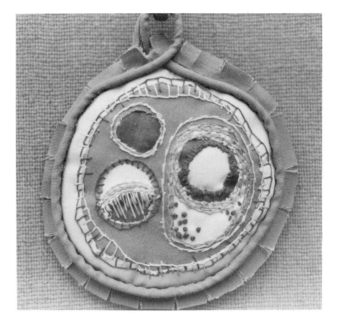

Carved Head. Senior high school student. Baltimore City Schools. Note the contrast in texture on the base.

Carved Plaster. Fort Lee, N. J. Senior High School. The form is mounted on a metal rod attached to a wood base. Photo, courtesy Joan DiTieri, teacher.

Chapter 5
Plaster

Plaster, because of its versatility, has become an increasingly popular material in the art classroom. It may be used in a variety of art activities including sculpture, printmaking, crafts, painting and jewelry making.

TYPES OF PLASTER

There are several different kinds of plaster, each with its own characteristics. Choose the plaster best suited for the project or activity you have planned.

Plaster of Paris

An inexpensive, widely available plaster used in many art classrooms, Plaster of Paris dries hard but is easily carved. Mix in small quantities because setting takes place rapidly, usually in less than 10 minutes. It tends to be slightly lumpy in texture. Popular for use with younger students because rapid setting provides quick results.

Hydrocal

A gypsum cement which may be used instead of plaster. Sets in approximately thirty minutes to a smooth, hard finish. Because of its strength and resistance to chipping and cracking, it is recommended for sand or clay casting and for sculpture. Hydrocal is obtainable in white or gray tones.

Casting Plaster

Casting Plaster mixes easily and dries to a hard, fine-textured surface. It is more difficult to carve than Plaster of Paris but is more resistant to chipping and will not absorb paint as rapidly. Casting plaster sets in twenty-five to thirty minutes.

Molding Plaster

Because it lacks hardening agents, molding plaster is softer and more porous than casting plaster. Surfaces of objects made from molding plaster should be sealed with shellac, clear lacquer or other medium, such as acrylic, before being painted or decorated. Sets in twenty-five to thirty-five minutes.

Pariscraft

Originally manufactured for use in the medical profession, Pariscraft has found wide acceptance in

Reclining Figure. Baltimore City Schools. Carved plaster.

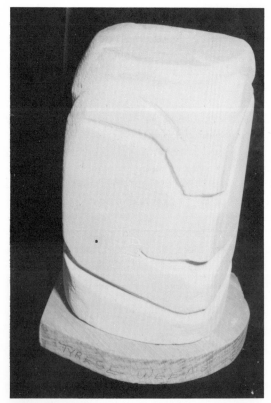

Tree. Baltimore City Schools. Carved plaster. The plaster was cast in a deep round pan.

Plaster Head. Junior high school student. Baltimore City Public Schools. Carved from a plaster block cast in a half-gallon milk carton.

the art classroom. The strips of plaster-impregnated gauze are dipped in water and applied over an armature or form. "Pariscraft" dries quickly and the object produced is very hard. Obviously, preparation procedures and the mess of working with plaster are almost eliminated but, as with all convenience materials, "Pariscraft" is relatively expensive when compared with traditional materials.

SOURCES

Plaster of Paris may be purchased from almost any hardware store. Casting plaster and other so-called art plasters are available from art and school supplies dealers. Lumber and building supplies centers stock other plasters and the aggregates commonly used with them.

MIXING PLASTER

Assemble all equipment and tools needed for measuring and mixing; quick-setting plaster will not wait while one searches for a spatula or bowl. Collect sheet plastic, waxed papers or newspapers to protect work surfaces and to speed cleanup procedures. Slick, non-porous surfaces such as plastic, Formica and glass will clean up readily since dried plaster will chip away from them easily and quickly.

Mixing containers; tools. Bowls or other containers of plastic or rubber are ideal because they are flexible and non-porous. Allow left-over plaster to dry in these containers, then simply bend the bowl from side to side and the plaster will crack and fall away. A large rubber ball, cut in half, provides two "bowls" for mixing small amounts of plaster. Disposable containers such as waxed milk cartons, waxed cups and aluminum foil food containers work well and eliminate many cleanup problems.

Tools for stirring may include plastic spoons, spatulas, clean sticks or strips of wood, old spoons or your own hands. Do not use a tool that is dirty nor one that is likely to disintegrate in the wet plaster since foreign materials interfere with the proper setting of the plaster.

Testing the plaster. If plaster is improperly stored, it will absorb water, becoming lumpy and unusable. Squeeze a handful of the plaster to be used; if it is lumpy, discard it and get a fresh supply. Trying to dissolve the lumps is tedious and rarely successful; objects made from such plaster are likely to be unsuccessful.

Procedures: Use a formula of one part water to two parts plaster. (Formulas for mixing vary with certain plasters but this is a good rule-of-thumb.) Use water that is room temperature; if water is too hot, the plaster will set too quickly and too-cold water will retard the setting process.

1. Pour the measured water into the mixing bowl *first.*
2. Using your fingers, sift the plaster slowly and evenly into the water, discarding any small lumps that are found.
3. Allow the plaster and water to rest and soak for two or three minutes, until the water has had time to wet the grains of plaster.
4. When the plaster appears thoroughly wet, stir the mix gently, using a spatula, spoon or your hands. Avoid a whipping or beating action that would entrap air bubbles. If the mix is too thick, add a bit of water. *If the mix is too thin, do not add plaster, however, since the first plaster has already begun its chemical change.*
5. Mix only until a smooth, creamy consistency is reached, then pour or use the plaster as planned. If "overmixed," the setting procedure is speeded up to the point where the plaster will set too rapidly.
6. If the plaster has been poured into a mold or container, tap the sides of the container as soon as the pour is completed; this will cause any entrapped air bubbles, which might weaken the mold, to rise to the top.
7. About five minutes after the plaster has been mixed, the initial setting process may be observed. The plaster will expand slightly and will feel warm to the touch.

When mixing plaster, keep certain precautions in mind to ensure satisfactory results. Never mix fresh plaster in a container that retains fragments or chips of old, dried plaster since these particles will produce a lumpy mixture that sets too quickly. Use only clean

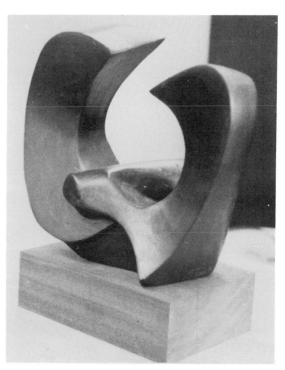

Non-Objective Sculpture. Cicero, N. Y. Senior High School. Combined carved forms mounted on a wood base. Plaster may be finished with waxes, stains, paints, liquid metals and metallic sprays. Photo courtesy Ernest Andrew Mills. Ronald De Penter, teacher.

Bird. Baltimore City Schools. Carved and painted plaster. Intricate patterns were painted on all surfaces after the plaster was sealed with acrylic medium. If not sealed, the plaster will absorb and fade the colors.

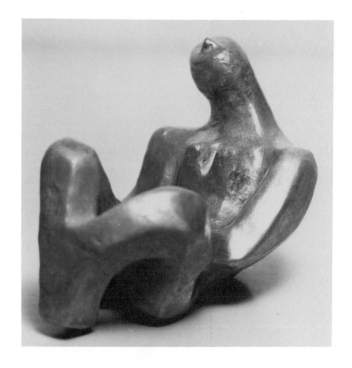

"Sculp-metal" over Plaster. Fort Lee, N. J. Senior High School. The liquid metal is applied in thin layers with each layer being allowed to dry before the next is applied. The surface is polished with emery cloth to achieve a true metallic luster. Photo, courtesy Joan DiTieri, teacher.

containers and tools. Tools used for mixing should be placed in water immediately after use. Sponges used for cleanup should also be placed in water to prevent plaster from hardening inside them.

Control setting time, if required, by changing the water temperature. (See above.) Adding a pinch or two of salt will speed up the setting time; a little vinegar will retard the setting time. (Remember the action of salt when mixing plaster for sandcasting at the beach; plaster mixed with salty sea water sets quickly.)

AGGREGATES

Aggregates may be added to plaster for a variety of reasons. Aggregates alter the texture of plaster, make it harder or softer or, in some instances, more resistant to chipping or breaking.

Vermiculite, perlite, zonolite, sand, sawdust and even used coffee grounds add interesting textures and change the characteristics of plaster. Vermiculite and sawdust produce a rougher, masculine texture and a plaster that is more easily carved. Sand and harder aggregates produce a harder block. A few pinches of soda produces a bubbly texture. Generally, the best rule is to add the aggregate to the dry plaster *before* adding it to the water, although aggregates may be added to a thin mixture if they are stirred in quickly and evenly. When using aggregates, a ratio of three parts aggregate to one part plaster is a sound rule.

For an extra-hard, chip-resistant plaster, reduce water by 50%, substituting a white glue, such as Elmer's. This solution will also help to bind any aggregates used.

It is not always necessary to add aggregates to the basic plaster mix: texture materials may be sprinkled or embedded on the surface of wet plaster. These materials may include fine gravel, crushed stone, crushed glass or marble chips. Be sure, however, that the plaster is wet enough to allow the material to sink into it, becoming tightly embedded in the completely dried surface.

TOOLS

The smooth, white surface of plaster lends itself to a wide variety of textural changes: it may be roughened by scraping, gouging, cutting, carving or even drilling, depending on the effect desired. Before the plaster has completely hardened, it may be combed, gouged, cut away or scraped. (If it is necessary to keep the plaster slightly damp during the texturing and cutting, place the plaster in a plastic bag or wrap to retard drying.)

Special rasps, knives and gouges designed for the professional artist are available but completely adequate tools may be found in the classroom, in the kitchen gadget drawer or home workshop. Experiment with paring knives, awls, compass points, pastry wheels, corkscrews, nails, paper clips, metal hair clips, thin strips of metal and other found objects. As bits of plaster are dug up from the surface, wipe them away with a sponge to keep incised patterns sharp and clear.

FINISHING TOUCHES

The finish applied to plaster will depend entirely on the function of the piece and the effect desired. The original stark white surface may be desirable and, if so, a sealer is all that is required. Suitable sealers include acrylic medium, plastic spray, a mixture of equal parts of water and white glue, clear lacquer or clear epoxy spray finish.

Porous plasters should be completely dry and sealed before paint finishes are applied; otherwise paint is too quickly absorbed and apt to flake off, after drying. (Use any sealer listed in preceding paragraph.) Oil paints, acrylic paints, glazes, enamels or metallic paints may be used for subtle or bold effects. Acrylic paints are especially recommended since they incorporate color and sealer in one application. Fabric dyes may be sponged on or brushed on.

For an antiqued metallic quality, apply silver bronze or copper tone paint and allow it to dry. Apply an all-over coat of black paint and, before it completely dries, wipe away most of it from the high points, leaving it in incised lines and recessions. The effect is strikingly rich. Seal or wax the surface, depending on the paint used. (Acrylics require no sealant.)

Colors may be added to the plaster itself, of course, as it is being mixed: add *dry* colors to the *dry* plaster; add liquid colors to the water used. Cement colors (hardware store) are more permanent but tempera color or acrylic colors from the art classroom can be used satisfactorily. For a marbled effect, add bits

of powder color as the plaster is mixed. Mix only until trails of colors appear; a too thorough mixing will spoil the effect.

USES FOR PLASTER

Plaster-block Prints

Collect shallow box tops to serve as molds for the blocks. Coat the inside of the box tops generously with Vaseline or liquid wax for easy removal, then pour in plaster to depth of 1″. Place on a level surface and allow to harden twenty-four hours. Remove hardened blocks from box tops and, if surfaces are slightly uneven, smooth with the sharp edge of a ruler or strip of metal. Seal the surface of the block with shellac or 1:1 mixture of water and white glue; this makes the blocks less absorbent and produces better prints.

Carve designs directly into the blocks, using nails, knives or other improvised tools. Linear designs are simplest and, with younger students, most satisfactory. Apply inks with a brayer, cover the inked block with paper and print by rubbing the block with the bowl, or bottom, of a spoon. Use oil base ink, water base ink or, if neither is available, tempera paint with a bit of glycerin added to retard drying.

Printing blocks may be formed by pouring plaster into other molds including jar lids, the irregular forms of foil food trays or in cut-down waxed cartons or cups.

Prints may be used to produce repeat patterns, combined with lettering on greeting cards or posters or may be matted. Use a variety of papers including kraft paper, wallpaper, newspaper and tissue. Experiment by overlapping and printing off-register.

Sculpture

Plaster lends itself to many sculptural activities including pieces in-the-round (seen from all sides) and relief sculpture (attached to a flat base or background from which they extend).

Pieces designed in-the-round may be carved from a single block (the substractive method) or may be built up over an armature (additive method) of wire, wood, screen or other materials.

From the Block. Mix the plaster of the desired type and pour it into the mold; waxed milk cartons pro-

vide a good-sized block for beginning projects. Add aggregates or coloring matter as desired. After the plaster has set, but not completely dried, peel away loose bits of paper.

Plan a design on paper if that will assist you in visualizing the completed form or, if you prefer, sketch your ideas on the plaster form itself, indicating where grooves or hollows will be. Turn the plaster as you sketch, keeping in mind that the form will be viewed from all sides and that lines and shapes should be unified, in a rhythmic movement.

Using gouges, knives and other tools, begin cutting away to achieve the forms your design indicates. Turn the piece as you work; make changes, if necessary, creating contrasts in movement, textures and shapes.

When the form is completed, smooth with sandpaper, texture with rasps or files, if desired, then set it aside to complete drying. When completely dry, finish by sealing, painting or staining the piece to enhance the total design.

On an Armature. As you build an armature or support, bear in mind that the finished piece will only be as sound and sturdy as the armature on which it is built. If the piece must stand upright, the armature cannot be wobbly. The armature, providing a hollow core, also permits the form to dry more quickly. Larger, more varied forms can be built over an armature than can be designed from solid blocks of plaster.

Use wire, wood strips, metal screen, cardboard tubes and cartons, Styrofoam, twigs, balloons, papier-mâché, chicken wire, or other scrap materials to build the armature or framework. These may be free-standing or attached to a base of wood. Use fine wire or string to bind joints securely; wire coat hangers are easily obtained but are sometimes difficult to bend. If hangers are used for basic lines, use lighter weight wire to add strength and volume to the figure.

If plaster will not adhere directly to the armature, dip strips of cloth — old sheeting or muslin is ideal — into liquid plaster to build up shapes and masses. (Mix white glue with plaster for better adhesion and strength.) Add plaster with spatula and smooth into final finish coats. When the piece has dried, sand and apply finish or texture as desired.

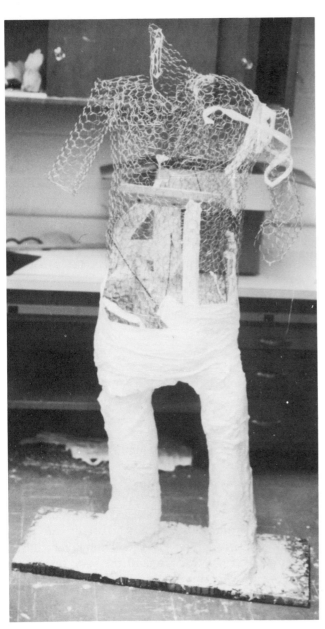

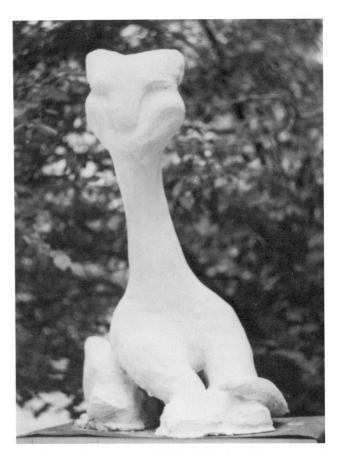

Big Cat. Baltimore City Public Schools. Plaster-dipped fabric over an armature of wire and wood.

Plaster-Dipped Fabric. Baltimore City Schools. A sturdy armature was constructed from chicken wire and wood which was covered with plaster-dipped strips of old sheeting.

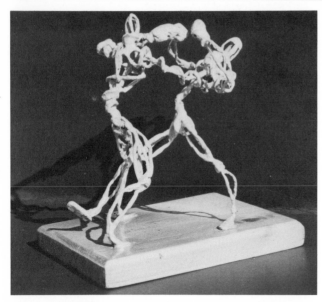

Boxers. Lutheran Senior High School, Los Angeles. Plaster on wire sculpture. The addition of white glue to the plaster makes a stronger, chip-resistant finish. Photo, courtesy Gerald Brommer, teacher.

Toy Chest. Clifton, N. J. Senior High School. "Pariscraft" on a balloon armature; finished with paint, fabric and scraps of foam rubber. A student's solution to an assignment to design "funky furniture." Photo, courtesy Laurence Goldstein, teacher.

Building From Cast Units. Use egg cartons (coated with Vaseline or wax), muffin tins, lids, small milk cartons or other small containers to produce a number of identical forms — the number to make will be determined by the design that is planned. Join these shapes by gluing them together, by using wet plaster, or by drilling holes through them and joining them with a thin metal rod.

Sandcasting

Sandcasting with plaster is an always-popular activity in the art classroom and with good reason: the technique is simple and, with variations in materials, the results are always exciting. Sandcasting out-of-doors, particularly at the beach, provides the added element of just plain, good fun.

Materials and Tools: Sand (coarse builders' sand is best); plaster of Paris; cardboard box; plastic bowl and spoon, for mixing plaster; chicken wire, for reinforcing larger panels; wire, to make a hook for hanging.

Procedures: A design may be sketched and cut from paper or the design may be drawn directly in the sand. In any case, bear in mind that the design will be reversed in the sand, as a "mirror-image."
1. Fill the box with sand to a depth of three to four inches. (If sandcasting on the beach, a box is not needed: simply hollow out the sand to create a "box" or an irregular form, if desired.)
2. Level and smooth the sand with the hands or a stick. Moisten the sand with water.
3. Outline the design with a pointed object.
4. Scoop out or depress areas that will be in relief, or "stand out," on the finished panel. Use found objects to create patterns and textures: spools, sticks, corks, shells and wood scraps make excellent tools.
5. Mix plaster to a creamy consistency, stirring until smooth but no longer than three minutes.
6. Pour plaster mix slowly and carefully over the sand. Do not pour in one spot or unwanted indentation will result. Smooth the surface of the plaster and embed a prepared wire hook, if one is required, before it sets.
7. Allow the plaster to stand until it has completely hardened, then lift it carefully from the sand.
8. Remove excess sand by brushing the casting with with a soft brush.

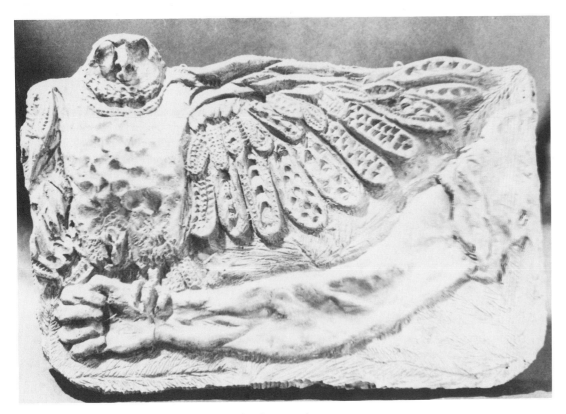

Cast Plaster Panel. Rye, N. Y. High School. Cast from modeling clay. Photo, courtesy Ernest Andrew Mills. Joan Vedy, teacher.

Sand Cast Panel. Baltimore City Public Schools. A beverage can and other found objects were pressed into the sand before the plaster was poured. The procedure is described in this chapter.

Variations:

1. Before pouring plaster; shells, pebbles, bits of glass, buttons or other small objects may be pressed loosely into the sand.
2. The plaster may be tinted or colored as it is mixed.
3. To re-inforce larger panels: pour half the plaster, then place a piece of chicken wire which has been cut slightly smaller than the panel on top of the wet plaster. The wire hook for hanging should then be attached to the chicken wire at a point approximately one-third down from the top of the panel. (The hanger should be long enough to extend above the second layer of plaster.) After the hanger is attached, pour the *second* layer of plaster.

Uses for Sand-cast objects:

1. The sand-cast panel may be used "as is" or it may be mounted on a hardboard panel such as Masonite, plywood or barn boards. Use a strong cement, such as epoxy.
2. Use the sand-casting technique to create a mold for making ceramics. (See chapter on *Clay,* for procedures.)
3. Consider substituting other materials for plaster: cement produces a harder, more durable casting material and may be used to create garden sculpture, a top for a patio table or tiles.
4. Create a sand mold for making candles: press gelatin molds, bowls, cups or other containers into the sand to create a depression, then set the wick and pour in wax.

Plaster Jewelry

Plaster may be used to design novelty pins, earrings and pendants that are both attractive and inexpensive.

Plaster of Paris will work well but Hydrocal, which is harder and stronger, produces a more durable result.

Materials and Tools: Hydrocal plaster; container and tools for mixing plaster; paints, for decorating (acrylic paints are best); white glue; jewelry findings (pinbacks; earscrews; rings for pendants). Molds, for making basic shapes: plastic ice cube trays or small muffin tins work well. Oil or Vaseline, to coat mold.

Procedures:

1. Coat the mold with a thin application of oil or Vaseline so that the plaster can be easily removed.
2. Mix plaster and pour it into the mold to a depth approximately ¼". Set aside to harden.
3. Remove the plaster shapes and spray lightly with fixative or brush with acrylic medium or water-thinned white glue. (Sealing prevents over-absorption of color.)
4. Paint designs on shapes, as desired, and seal with acrylic medium, thinned glue or varnish.
5. Attach appropriate jewelry finding with strong white glue.

Variations:

1. To create free-forms, pour plaster on plastic film. (A thicker plaster mix works best; if the plaster is too thin, the shape cannot be controlled.)
2. Create designs with bits of colored tissue in a collage technique. Experiment with other paper cutouts, bits of lace dipped in acrylic medium or white glue or watch parts.
3. Experiment with metallic colors and fluorescent colors for unusual effects.

Chapter 6
Glass

The recent revival of glass crafts — particularly the art of stained glass — may be attributed directly to the development of new adhesives and the techniques related to their uses. The new plastic resins and epoxies have, in a sense, liberated stained glass from the limitations of the traditional techniques of leading and have made possible the introduction of stained glass into the classroom and studio.

Craftsmen have applied new thinking to glass as an art form and, through extensive experimentation, have discovered techniques unknown to the traditional craftsman who was limited, primarily, to "church art" of windows and mosaics. Even the outright beginner can now learn the processes of *fusing, bonding, laminating, casting* and, if he chooses, the traditional techniques of *leading*. The new techniques are used to create stained glass jewelry, panels, mosaics, constructions, mobiles and dozens of decorative objects limited only by the imagination and skills of the designer.

CHARACTERISTICS

Before starting to work with glass, it is well to understand some of its characteristics and how they influence the kinds of things that can be done. Glass is a somewhat capricious material: one can never be *exactly* sure just how it will behave while being cut, fused or otherwise treated. This characteristic exists because of the nature of glass and has to do with molecular structure, chemistry and other factors unfamiliar to the layman. Simply put, the best guide is to remember that all glasses are *not* alike: they vary in hardness, thickness, texture, melting points and, with stained glass, in the chemistry that produces the glittering array of colors. Some glasses are compatible and may be fused, or fired, together; others are not and despite all precautions, crack or break apart. *Because of this unpredictability, pre-test all glass that is to be fused or fired.* As pieces of glass are cut, note that some glasses cut easily while others seem to be "tough" or unusually hard to cut.

TYPES OF GLASS

Stained glass, sometimes called cathedral glass, is softer than other types of glass and requires less heating for melting. Do not, therefore, attempt to

fuse stained glass with ordinary window glass, which is much harder; they will break apart when cooled. Certain colors — notably the warm reds, oranges and pinkish colors — often will not fuse with other colors. If stained glass is to be fired on a blank of clear glass, use the clear glass made by the stained glass manufacturer. If the surface of the glass is textured, cut it with short, varying strokes of the cutter rather than with the single stroke recommended for smooth glass.

Window glass is available in single and double strengths. Use single-strength for jewelry, panels, mobiles and lamination; use double-strength for larger panels and heavier projects.

Picture glass is thin, brittle and lightweight. Use it in making glass ornaments, wind chimes, jewelry and similar projects where light weight is desirable.

Plate glass fires successfully but tends to break irregularly when cut. Expensive except when obtained as scrap.

Crystal cuts easily and may be fused with moderate heat. It is expensive, however, particularly for classroom use.

Other glass may include preformed glass such as dime-store ash trays, plates, bowls, bottles, vials and other glass containers. These glasses are often improved in appearance by firing and results can be surprising and exciting. Experiment by placing bits of colored glass or enamels inside bottles and vials, then collapsing the bottle by firing it in the kiln. The bits of materials will then be laminated within the bottle.

Marbles, beads and *buttons* of glass may be used "as is" when set or caged as "jewels," or they may be crushed or fired whole for use in jewelry, mosaics or decorating box lids, frames or other craft items.

SOURCES

Stained glass is obtainable from manufacturers, glass studios — especially those specializing in the design of architectural glass — and from arts and crafts suppliers. (Check the Yellow Pages for nearby suppliers or order from sources listed in Sources for Materials and Tools.) Stained glass is available in *dalles* (slabs, 8″ x 12″), *sheets* and *cullet* (nuggets). Generally, it is sold by the pound but special units may be arranged with the distributor or manufacturer. Prices vary, with the reds, oranges and other warm colors being the most expensive.

Novelty shapes, or preformed glass jewels, are available from several stained glass manufacturers. They are available in a variety of basically geometric shapes including the *roundel*, a spun or pressed round form containing whorls of color. These "jewels," often used as accents within larger panels, may also be leaded as individual hanging forms. Glass globs are little lumps of solid glass, flat on one side and available in a variety of colors. They may be used in mosaics and in decorative applications on jars, bottles, boxes and jewelry. Spaces between globs may be grouted or filled with metal paste or liquid lead.

Roundels and jewels are expensive and are sold individually; glass globs are comparatively inexpensive and are sold by the pound in mixed or single colors. (Globs can be made by firing bits of glass in an enameling kiln. See "Firing Glass.")

Some manufacturers will make up special packages of scrap glass, at reduced prices, for school use. Scrap may sometimes be obtained cost-free; inquire to find what is available. Since stained glass is comparatively expensive, it should be used economically with even the smallest fragments saved for "jewels."

Glass bottles, jars, vials and other glass containers can be collected as discards from home, school, the school cafeteria — the city dump! Colors are apt to be limited to brown, green, blue and amber but these are useful, nevertheless, and should not be overlooked. Use available funds to purchase reds, oranges and other colors rarely found as discards; scrap red glass usually fires black; only red stained glass can be expected to *remain* red if fired.

Sheet glass can always be purchased, but inquire at department stores, shops and at manufacturers of display shelves to find if cracked or otherwise damaged glass shelves may be obtained at little cost.

Broken ware may be obtained as scrap from the showrooms or outlets of companies dealing in decorative glassware. Ask.

Marbles, buttons and *beads* may be purchased—or collected from home sewing baskets, dresser drawers

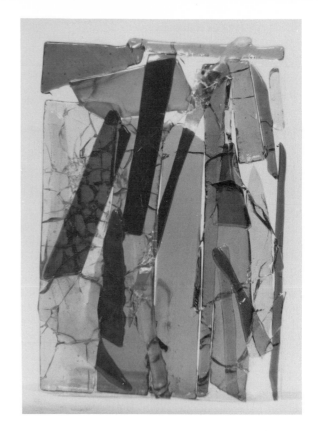

Fused Glass Panel. Student, Fort Lee, N. J. Senior High School. Scraps of stained glass were placed on a small window pane and fired in a kiln. Photo, courtesy Joan DiTieri, teacher.

L'Escargot Amiable. Chris Lemon. Stained glass, wire and screen. Scraps of stained glass are leaded on a wire framework. Photo, courtesy the artist.

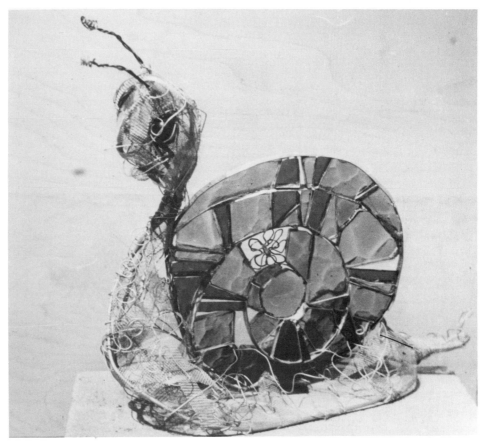

and from clothing manufacturers who have odd lots they can no longer use.

Mirrors, broken and otherwise, may be used in a variety of glass projects. Small mirrors from purses or compacts are easy to obtain; ask about scrap from dealers who sell plate glass and mirrors. (See Yellow Pages.)

HANDLING AND STORAGE

Glass should be carefully handled to avoid painful cuts; even the smallest fragment of glass can cause serious injury to hands, face or eyes.

1. Store glass carefully. Panels of glass should not be propped carelessly against a wall. Store vertically, in a rack, if possible. An *open* shelf, turned on its side, makes a satisfactory rack; use a metal phonograph record rack for small pieces. Store small pieces in excelsior or shredded newspaper.

2. Use gloves to handle, or "sort through," quantities of glass. Dull pointed edges with a file.

3. Keep work areas clean. Use a brush or cloth to sweep working surface clear of small bits of glass. NEVER USE BARE HANDS TO CLEAR A SURFACE!

4. If glass must be broken or pounded, place it between a thick padding of newspapers or burlap. Some type of face shield should be worn.

5. Clean glass before attempting to cut it; any soil on the glass or oil from the hands will cause the cutter to skip, producing an uneven cut. Clean by washing with detergent or denatured alcohol. After the glass has been cleaned, avoid unnecessary handling. To manipulate small pieces, use tweezers or attach bits of transparent tape to the edges of the glass so that it can be lifted without handling.

CUTTING GLASS

Glass is not actually "cut." It is scored with a cutter; scoring weakens the glass so that breaking can be controlled or directed. Straight cuts are easy to make; arcs, "S"-curves and circles require care and practice. Special cutters for cutting circles are available from glass craft supply houses.

There is no absolute rule for the right way to hold the cutter; hold it in the manner that is most comfortable for you. Remember, however, that the cutting wheel should be held perpendicular to the glass, otherwise a beveled edge will result. Great pressure is not needed; a firm *even* pressure that produces a continuous white line on the surface of the glass is sufficient for proper scoring. After the glass is scored, turn it over and apply pressure with the thumbs to the scored line and the glass should separate. If it does not separate readily, tap the reverse side — directly under the scored line — with the ball end of the cutter. Tapping is usually required for thicker sheets of glass.

A straight-edge or ruler may be used as a guide in making straight cuts. A paper or cardboard pattern is helpful in cutting curved lines. Whatever shape is cut, leave a margin of glass one to two inches wide around the shape for easier removal. This is especially important when cutting circles or other curved shapes: score radiating lines from the shape to the edge of the sheet of glass. Remove the margins in sections rather than attempting to remove it in one piece.

Tips on cutting: (1) The working surface should be level and well-cushioned with sheet cork, firm carpeting or a thick pad of newspapers. (2) Be sure that glass is clean; wash with detergent or denatured alcohol. (3) To remove minor irregularities, smooth with an abrasive (carborundum stone); a very rough edge can be smoothed with a coarse rubber abrasive wheel. Do *not* use a stone wheel; shattering may result.

DRILLING GLASS

Some projects such as jewelry, mobiles, hanging forms and ornaments require the drilling of holes in the glass through which wire, cord or thread can be passed. With practice, the following procedure is successful: Place the glass on a well-padded surface and clamp it securely so that it will not shift under the drill. (Use spring clamps, with padding between the clamp and the glass.) With the point of a file, make a small pit in the glass to receive the point of the drill. (A small hand drill, of the "egg beater" type, is adequate.) Set the drill in the pit, being sure that the drill is held vertically; turn the handle. When a white powder (ground glass) appears, add a drop of kerosene in the drilled depression to cool the drill bit and

the glass. Do *not* drill all the way through; when the drill bit is almost to the bottom of the glass, turn the glass and re-clamp it to the work surface. Drill again, setting the drill directly over the point where the drilling was stopped. Turn the drill until a clean hole is made.

If the glass is to be fired, the hole must be plugged or filled to prevent its closing during the firing. Make a paste of the separator (kiln wash, talc, Mold-coat) and fill the hole with it. This filler can be easily removed after the glass is fired.

TECHNIQUES AND PROCESSES

Working with glass does not require a host of hard-to-get materials, tools and equipment. While glass firing and the techniques related to it require a kiln and basic firing equipment, many exciting activities and projects can be carried out with much simpler, less expensive materials and tools.

The techniques described here are those found to be practical in the classroom or home studio. Some of them require a kiln; others require little more than the glass itself and an active imagination.

Whatever technique is used, keep these facts in mind: glass appears at its sparkling best when light is permitted to pass through it, unobstructed. Therefore, if glass is to be mounted on an opaque backing such as wood or Masonite, cover the backing with a metallic paint, foil which has been crumpled, then smoothed — or a coat of bright, white paint. Stained glass may be mounted on mirror. Be sure that the adhesive used for joining glass is one recommended for *non-porous* materials; epoxy cements are the most reliable. Choose clear-drying adhesives that are unobtrusive in the finished design. Certain adhesives advertised as "clear-drying" are actually milky upon drying. Pre-test your adhesive, following the manufacturer's directions meticulously. Glass, even in small quantities, is surprisingly heavy and a strong adhesive bond is essential.

Firing Glass
Melted and fused glasses provide exciting, challenging materials which can be used in designing mosaics, jewelry, panels, stabiles and many other crafts items. Various kinds of glass can be used including stained glass, scrap glass of all types, marbles, beads, bottles and jars. (Since red, orange and yellow glasses are difficult to find as scrap, stained glass is suggested for projects requiring these colors.)

Because kilns and glasses vary, experimentation provides the best guide as to the "correct" temperature and firing time. In an enameling kiln, slumping occurs around 1350°F. and fusing around 1450°F. In a ceramic kiln, 1450°F. and 1500°F. are corresponding points in firing. Use an 016 cone in a ceramic kiln. In either type of kiln leave the lid slightly open until 1000°F. is reached, then close the kiln. Ventilation prevents frosty, cloudy glass. Watch the kiln carefully and when the edges of the glass start to round, shut off the kiln. The glass will continue to melt for a short while after the heat is shut off; therefore, it is best to shut off the kiln a bit ahead of time. There are two absolute rules to observe: (1) Start with a cold kiln and (2) permit the kiln to cool *completely* before removing the glass.

Fired Glass Mosaics: Although procedures for mosaics are described, the fired glass "globs" may be used in jewelry making, mobiles and in creating decorative effects on jars, boxes and bottles, as described earlier in this section.

Tools and Materials: Assorted glass, white glue or transparent cement, detergent or alcohol for cleaning glass and kiln wash (whiting, clay flour, talc, plaster of Paris, Mold-coat) to prevent glass from sticking to shelves. Glass cutter, hammer, wire cutters and, if desired, tweezers. Mounting boards (for mosaics) of Masonite, plywood or other non-warping hardboard; paint boards white or silver or cover them with foil for greater light reflection. A mirror provides an excellent background. *Attach a hanger and a lath frame, if desired, before the mosaic is laid; attaching either later will disturb the mosaic.*

Procedures: These procedures are for the use of an enameling kiln; if a ceramic kiln is used, note earlier information on temperatures and cones.
1. Break glass for firing by placing the glass between thick folds of newspaper to prevent glass particles from flying. Small pieces of glass are more effective. More regular shapes may be cut with a glass cutter if sheet glass is available. Cut on a padded surface.

2. Arrange glass on kiln shelves which have been coated with kiln wash. Provide adequate spacing to prevent fusing and fire to temperature between 1450°F. and 1500°F. (See preceding notes on firing.) Experiment with kiln for desired results. *Underfiring* gives variety in texture and pieces retain the original shape; sharp edges are slightly rounded. *Overfiring* causes bubbles and sharp edges as the glass starts to flow when it reaches a liquid state. Correct temperature should give rounded edges and bead-like shapes.
3. Draw design lightly on mounting board which has been painted white, silver or covered with foil. (Glue foil to board, using white or clear glue.)
4. Arrange and glue glass pieces over the design using white glue or transparent cement. Place pieces about ⅛" apart; wider spaces are disturbing, especially if foil is used to cover the mounting board. If foil shows through and is disturbing, consider grouting the design or place pieces closer together.

Suggestions for Variations
1. Designs or patterns may be applied to the pieces of glass with copper enameling powders, lumps or threads. These may be applied before the first firing, or may be fired in a second firing.
2. Ceramic underglazes can be used very effectively between layers of clear glass that are to be fired.
3. Copper and silver wire can be used to make hangers or decorative lines. Silver wire does not change in firing; copper wire turns black. Nichrome wire is a special wire which will not flake under high temperature; it is used for embedding in glass. Buy it at a hardware or electrical supplies' store.
4. Copper, brass and aluminum foil can be fired between layers of glass for various effects. Experiment with available foils: copper foil turns black, brass bubbles slightly, and aluminum burns out. Mica flakes produce bubbles between layered glass. Mica flakes are available at building supplies stores.
5. Glass mosaics may be left ungrouted or grouted with regular mosaic tile grout. For most effective results, use no grout, but place glass pieces close together.
6. For stained glass window effects, surround solid color glass areas with liquid solder, metal paste or black aquarium cement. (Hardware store, or see Sources for Materials and Tools.) Avoid getting any of these "grouts" on the surface of the glass; spills should be wiped up immediately.

Notes:
1. Fire stained glass in a separate firing because of its lower firing temperature.
2. Fire only one color on the kiln shelf to keep colors separate for storage and for easier color separation.
3. Use triangles or tile setters between shelves to load kiln with 5 or 6 shelves. (Ceramic kiln.)
4. Allow kiln to cool before removing shelves from kiln; glass will then be less apt to shatter or come apart, if fused. Important!
5. Wire hangers for a glass mobile may be fused to the glass pieces in one firing. (Nichrome wire is best.) Place the wire on top of the glass and tape a very small piece of glass over the end of the wire, where it will become fused, to hold it in place. The tape will burn away in the firing. Shape the hanger before the firing, if possible, since firing stiffens the wire.
6. *Unfired* glass may also be used for mosaics. Smooth edges with a carborundum stone or rubber wheel and adhere to the mounting board as described earlier. Grout or a substitute, as listed, may conceal unattractive edges.
7. Glass mosaics may be mounted on a clear plastic panel, such as Styrene or Lexan, instead of hardboard, for total transparency. If the mosaic panel is to be suspended, leave a margin or space where a hole may be drilled for a hanger. If it is to be mounted in a frame, leave at least ¼" margin on all sides so that the panel can be slid into the frame.

Sagged Glass
Sometimes referred to as "slumped" glass, sagged glass is another firing technique. Generally, a glass blank is placed over a mold of clay or soft firebrick and heated until the glass sags, or slumps, taking on the shape of the mold.

Molds of various types and materials may be purchased from glass craft supply houses or they may be made from clay (regular or terra cotta) or from soft firebrick.

Make *clay molds* by draping slabs of clay over bowls, dishes, or small trays. (Cover the form with

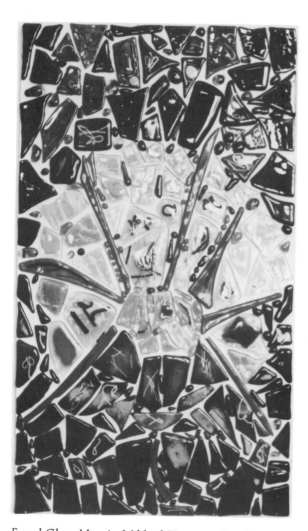

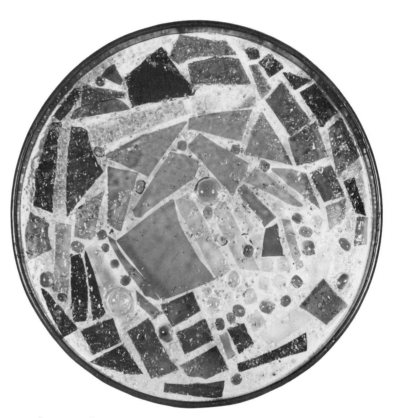

Laminated Panel. The author. Stained glass and polyester casting resin. The frame is a discarded rim from a drum, 17" diameter. The simple, quick process is described in this chapter.

Fused Glass Mosaic. Mildred Vanatter. Random shapes of scrap glass were first fired in a kiln until their edges rounded. After cooling, the shapes were adhered with clear cement to a white-painted hardboard. Photo, courtesy the artist.

plastic wrap or tissue paper for easy removal of clay.) Shape the clay carefully and trim. Permit the clay to dry until it will stand alone, then remove it. Refine the shape, being sure that edges or rims are smooth and even. Fire the clay.

Make molds from soft firebrick by hollowing out the desired shape with a spoon or other tool. If one firebrick is too small, join two bricks by cementing with kiln cement. Coat the mold with kiln wash to seal the porous surface, then coat with a recommended separator such as clay flour or Mold-coat, before placing glass over it and firing.

Precautions:

1. Ceramic molds should be dried slowly, *upside down*, with a weight on top, to assure even edges. Before firing the mold, *upside down*, drill small holes, approximately 1/6″ diameter, through the mold about half way down the side; the holes will permit gases to escape from the mold cavity during firing.
2. The bottom of the mold cavity *must* be flat or the finished glass will rock.
3. Do not make *undercuts* in ceramic or firebrick molds.

Cast Glass Panel. Junior high school student, Baltimore City Schools. Epoxy resin binds and frames the glass in one easy pour. The finished panel is free of interior supports; the dark lines which show in the photograph are part of an existing window against which the panel was photographed. Courtesy Laurence Vickers, teacher.

4. Apply the separator (kiln wash, clay, Mold-coat) smoothly; bumps and other irregularities will be duplicated in the glass.
5. Glass blanks should not extend over the edges of the mold.
6. *Underfire* the ceramic mold — 2 to 3 cones lighter; the mold will then be less apt to crack with repeated use. If the mold cracks, brush both cracked surfaces with *sodium silicate*, dry, apply a second coat and then bind both pieces together with wire. Permit to dry forty-eight hours, then scrape away excess sodium silicate (water glass, from ceramics supply company.)
7. Glass blanks may be decorated before firing with glazes, enamels or stains.
8. Sag or "stretch" bottles by *suspending* them in a ceramic kiln. Suspend by forming wire loops on the necks of the bottles, then attach the bottles to a "clothesline" wire stretched tautly across the top of the kiln and attached, *outside* it. The kiln lid will rest on the wire. Heat the kiln slowly; watch carefully through the peep-hole until the bottles have "stretched" to the shape desired. Bottoms of bottles should *not* touch the bottom of the kiln; allow space for the sagging.

Lamination

Briefly stated, lamination refers to layering; and, many materials including wood, leather, plastic and others may be laminated. Here, the discussion will pertain to the layering or lamination of glass. In the basic technique, decorative elements are "sandwiched" between two glass sheets. The glass "sandwich" is then fired or fused until the parts are unified.

Experiment with the following materials to create designs for laminations. Apply the materials to the bottom blank, except where otherwise indicated, and fire on a shelf that has been coated with a separator.

1. *Copper enamels.* Use ground enamels, lumps or threads. (Avoid very large lumps.) Instead of using gum tragacanth or other commercially prepared binder, use baby oil which is less apt to discolor the glass. Brush it on lightly, then apply enamels. Use stencils, or apply freely, as design requires.
2. *Ceramic underglazes.*
3. *Stained glass.* Use finely *crushed* glass to avoid fractures and cracks.

4. *Fiberglas screen and threads.* Use "as is" or color it with underglaze.
5. *Metal.* Copper, aluminum or brass screen are most successful. Sheet metal, even in small pieces, can cause the glass blanks to shatter upon cooling.
6. *Metallic foils.*
7. *Miscellaneous. Metallic overglazes* on the *upper* blank; dry overnight. *Liquid glass glaze,* on the *upper* blank.

Notes:
1. Use baby oil, applied with the fingers, on the bottom glass blank to position dry materials.
2. Permit underglaze to dry before firing.
3. Experiment with ways of applying enamels and glazes: Use stencils, screens and brushes. Scratch into powders with toothpicks or wires; twist and shape wires to create distinctive linear patterns. Cut bits of screen to shapes desired.
4. Laminated glass can be fired flat or, if *rigid* materials such as screen and wire are *not* included, sagged or slumped. (See preceding section.)
5. Small laminated panels may be incorporated into larger panels and projects. Join with frames or cement with epoxy, or other heavy duty adhesives, to glass or plastic bases in designing room dividers, candle screens or lamp bases.
6. Other projects: Bowls; trays; mobiles; jewelry; paperweights; suspended designs to "catch" light. Cement designs to window panes.
7. Laminations in epoxy and polyester resins do not require firing and, since the techniques relate primarily to the resins, are discussed in *Plastics,* the section which follows.

Leaded Glass

One of the oldest glass crafts — and one of the most exacting in terms of skills required — *leaded* glass is enjoying a revival in crafts design, particularly in decorative accessories and lighting fixtures.

Large leaded glass projects such as windows and wall dividers demand considerable skill in cutting glass to exact sizes and shapes; the soldering of dozens of joints requires both skill and patience. The time demanded for acquiring these skills is seldom available within the normal school schedule and, consequently, activities in leaded glass are limited to comparatively small projects such as jewelry, mobiles and candle screens.

The projects outlined here require the leading of only a few pieces of glass which may be combined to create a stabile, mobile or, on a small scale, a piece of jewelry. The materials, for the most part, are obtainable at the hardware store, with the exception of *lead came.* Lead came is simply a strip of lead that is shaped to fit along the edges of glass. It is available in "U" and "H" shapes: the "U" shape fits around an outside edge; the "H" shape (turned on its side) can have glass inserted on either side. Came is extremely flexible; it is shaped around the edges of glass and soldered at joints and corners.

Materials:

Glass — use scraps or cut shapes, as desired. *Glass-cutter. Soldering Iron. Lead solder* (60-40). *Flux,* containing oleic acid. *Small bristle brush,* for applying flux. Thin *wire,* for hangers. (Jump rings and cord or chain for jewelry.)

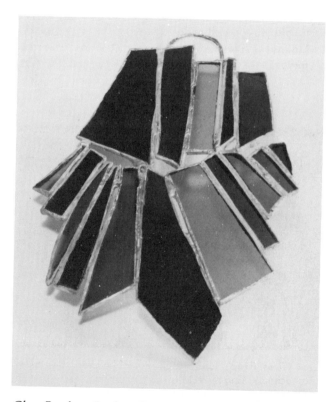

Glass Pendant. Student, Fort Lee, N. J. Senior High School. A jump ring and chain are all that are needed to complete a unique design for jewelry.

Procedure:

1. Decide what is to be made: a pendant may require only one piece of glass; a mobile or stabile will require more, possibly 5 to 7.
2. Consider scrap pieces available or cut new shapes that are more pleasing. Experiment with arrangements; a sketch may help.
3. When design is determined, bend a piece of "U"-shaped lead came neatly around the first piece of glass. Cut it cleanly, with a sharp knife, so that one end neatly abuts the other. Press the lead down firmly on the glass.
4. Following procedures in 3, fit lead around all remaining shapes.
5. Using the small bristle brush, apply flux at the point where the two ends of lead meet; use a short scrubbing stroke, rather than a dabbing motion.
6. Touch the hot tip of the soldering iron to the joint and, simultaneously, touch the solder to the tip of the iron. The solder will flow across the joint, sealing it together.
7. Following procedures in 6, solder the joints in all remaining pieces.
8. If a pendant is designed, solder a ring at the top for the attachment of findings — a jump ring and a cord or chain are needed.
9. For a stabile: solder pieces together, at angles, so that they stand. If a mobile is designed, the pieces must be balanced on metal arms and suspended. (Use a springy wire for maximum movement; coat hanger wire is too stiff.)

Soldering Hints

1. Be sure that joints to be soldered are clean. Use a wire brush to clean areas to be joined or scrape away soil; do *not* clean with acid.
2. If the lead came melts, the soldering iron is too hot.
3. If solder runs off the tip of the iron, the iron is too hot or the soldering tip needs cleaning. To clean an iron tip, run it over a wet cellulose sponge while it is hot. To clean and *re-tin* a copper tip: scrape away soil and oxides with a file; do not destroy original shape of tip. When tip is clean, heat it, apply flux and run solder over the entire surface of the tip.
4. If sharp pointed ends show on the joints, the iron is not hot enough. Solder should flow smoothly.

The Copper Foil Method

Developed during the great era of Tiffany glass designs, this method makes possible delicate, elegant designs not possible with the bulkier less manageable lead cames. It may, of course, be used to join glass in simple constructions but is used most effectively in more intricate designs where a thinner, more delicate line is essential. In a project of this type, each piece of glass is cut from a pattern and must fit, with all other pieces, into the total design. The copper foil method makes possible the joining of this glass jig-saw puzzle without the heavy obtrusiveness of lead came. The edges of glass are wrapped, *individually*, in thin strips of copper foil and the ends are soldered together. The pieces are then placed over a pattern or mold (as for light fixtures) and soldered together. When the soldering is completed, the copper foil should not show.

Materials:

Copper foil. (Available in light, medium and heavy weights; sold in strips which are 6" wide.) *Solder* and *flux* as listed for lead. *Scissors* or *razor blade*, for cutting foil. *Soldering iron*, with a *thin* or ¼" *semi-chisel* tip. Cut pieces of glass.

Procedures:

1. Cut a strip of foil slightly longer than the length required to wrap the edge of the glass; this will allow for a short lap and a neat cut. The foil should be 3 times as wide as the thickness of the glass.

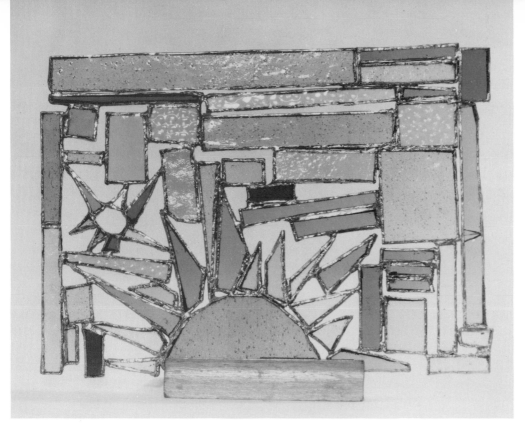

Stained Glass Constructions. Students, Fort Lee, N. J. High School. Note that the slotted wood bases are unobtrusive and simple, providing ample support without obstructing the elements of the designs.

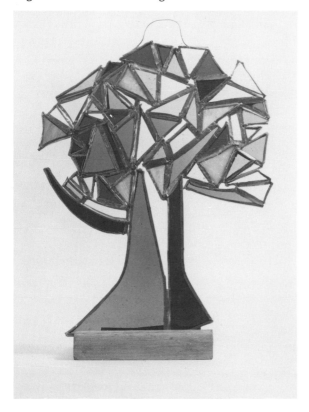

Beginner's Projects. Leaded stained glass. Simple projects such as these involve a minimum of leading and the glass "globs" may be purchased or formed in the kiln, from scrap. Courtesy Glass House Studio.

Stained Glass Sconce. The sun-like arrangement of glass projects outward, on wires, from a mirrored back. Between the glass and the mirror, a small brass cup, soldered to the projecting wires, holds a votive candle. The foil method was used to lead the glass since is it too thick (½") for traditional lead came. Collection, the author.

Sir George. Chris Lemon. Wire is used to add pattern and details. Note that the shape of the base relates to the stance of the figure and repeats some of its angles. Photo, courtesy the artist.

Leaded Glass Flower. Student, Fort Lee, N. J. Senior High School. The method used is the copper foil method described in this chapter. Forms such as these lend themselves to jewelry or may be used as decorative hanging forms. Photo, courtesy Joan DiTieri, teacher.

2. Bind the edge of the glass, pressing the foil tightly against the edges. Press down and around at the same time. If the foil tends to pull away, rub a tiny bit of Vaseline on the edges of the glass.

3. Cut the foil, being sure that the ends abut.

4. Flux the joint, then solder. Use only a tiny bit of solder. If it is easier, pick up the glass and touch the joint to the iron, rather than applying the iron to the joint.

5. Continue in this manner until all pieces of glass are wrapped and soldered.

6. Lay all the pieces of glass over the pattern; place tacks around the outer edges of the design to hold the pieces together.

7. Solder all pieces together at the corners, so that the panel is held together securely. Remove tacks.

8. Solder the entire panel, being sure that *all* of the copper is fluxed.

9. Turn the panel and solder the reverse side.

10. The final application should cover all the foil, and, ideally, appear as a rounded ridge.

11. Bind the edge of a panel with "U"-shape lead came and solder the joint. Solder on a wire hanger, if one is required.

The process just described is painstaking and demanding, particularly for the beginner. Keep beginning projects on a small scale: mini-panels, tiny candle screens or hanging "light catchers" can be completed in a fairly short time. Small panels may be mounted in an existing window, with tacks, tape or thin wood moulding.

Casting Techniques with Slab Glass: Panels

Casting techniques using 1″ thick stained glass were first developed in France, shortly after World War I. The technique has been refined in America where the development of epoxy cements and mortars has provided strong, more versatile binding agents.

Glass may be cast in binders of plaster, concrete, epoxy mortar or polyester resins. With a few variations, the procedures for each are basically the same: A retaining frame, which may or may not become part of the finished design, is placed on a working surface that has been covered with a material which will *resist* the mortar, concrete or resin to be poured into it. Glass shapes, random or precut, are arranged on the working surface, within the frame. Spaces into which the binder will be poured are left between the pieces of glass and between the glass and the sides of the frame. The binder is then poured or trowelled between the pieces of glass and allowed to set and harden. The frame may or may not be removed, depending on the use to which the design will be put.

If *both* sides of the finished panel will be exposed (as in a room divider or screen) two pourings — one from the front and one from the back — make a more attractive, "finished" surface. If the panel will be viewed from only one side — perhaps in a lighted "shadow box" frame — only one pouring is necessary.

The effect created in casting is that of thick "jewels" of stained glass set in a wall, or bed, of opaque binding material. Light passes through the glass; the binding material acts as a foil, shutting out the surrounding light and accenting the jewel-tones of the glass. The technique has become increasingly popular, replacing the more traditional leaded glass techniques employed in creating much ecclesiastical art.

Cast glass panels are quite heavy; beginning projects should be kept small, perhaps 12″ x 18″. Maximum size should not exceed 3′ in either dimension.

Glass Cast in Plaster

This technique is the simplest and, in terms of materials, the least expensive for classroom use: Arrange pieces of slab glass inside a simple mold (waxed paper tray, aluminum frozen pie-pan). Mix plaster of Paris to a creamy consistency and pour around the pieces of glass; do not cover glass. (White glue added to the plaster will make it stronger and less likely to chip.) When half the depth has been poured, insert a wire hanger (through the side of the mold), then finish pouring. Let the plaster harden completely, then tear away the mold. In a variation, cast the glass in a sandcasting technique: Push the glass into wet sand which has been packed into the bottom of a cardboard box. Pour the plaster and set aside to harden. Lift out the casting and brush away the excess sand; the glass will stand out from the plaster.

Casting in Concrete

Materials necessary for casting in concrete include scraps of thick *slab glass*, a bag of pre-mixed *concrete*, *sand*, *wire*, for reinforcing the concrete and *wood strips*, for making the retaining frame discussed earlier in this section, *waxed paper* or acetate, to

separate the concrete from the working surface. (Freezer paper is ideal.) A *working base* to which the frame will be nailed can be made from a sheet of wallboard or other hardboard; it should be at least ½" thick.

1. Prepare a sketch for the design, indicating the placement of glass and colors to be used. Use this as a guide.
2. Cut a piece of waxed paper that is approximately 3" larger, on all sides, than the design. Place on the working base and tape it at the corners.
3. Nail wood strips (1" x 1½") on *top* of the waxed paper to make a rectangular frame the same size as the design. *Wax the inside of the frame.*
4. Place glass within the frame and sprinkle dry sand into the frame, *around* the glass, to a depth of ½". Sprinkle water on the sand to dampen it evenly.
5. Cut lengths of wire and criss-cross them, on the sand. This will reinforce the concrete.
6. Mix concrete according to directions and pour it carefully between the glass until it is within ¼" of the top of the glass pieces. Be sure that it touches the frame at all points. Level the concrete with whatever tool will fit between the glass — a small spatula, trowel or knife.
7. Permit the panel to cure for three days.
8. Knock away the wood frame and turn the panel over, on the working base, exposing the back side.
9. Replace the wood frame and pour concrete into the spaces, as the front was done.
10. Set aside to cure, as before. Remove frame; clean the glass.

Notes:
1. Keep the working base level.
2. Avoid spilling concrete on the glass; wipe up spills immediately.
3. Cure the panel in a cool, damp place or cover with dampened burlap; too rapid curing will cause the panel to crack.

Variations:
1. While the concrete is still wet, sprinkle it with sand, gravel, bird gravel or marble chips to create a textured surface.
2. To strengthen concrete, add a binder such as liquid latex. Substitute latex for the water required.

(White glue may be added if latex is not available.)
3. *Casting in plastics.* The procedures for casting in plastics are essentially the same as those used for casting in concrete. Since the slight differences in procedures relate specifically to the characteristics of plastics, please see *Plastics*.
4. *Slab glass constructions.* With a glass hammer or mason's hammer, shape scraps of slab glass so that they can be joined together with epoxy cement, silicone adhesive or glass glue. Make a sketch, if a guide is needed, or simply build the design by placing one piece of glass on top of, or adjacent to, another until a pleasing arrangement is achieved.

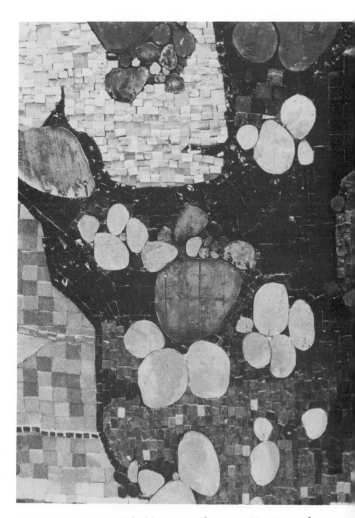

Mosaic (Detail) Reinhold P. Marxhausen. Venetian glass tile, smalti and stones. Photo, courtesy the artist.

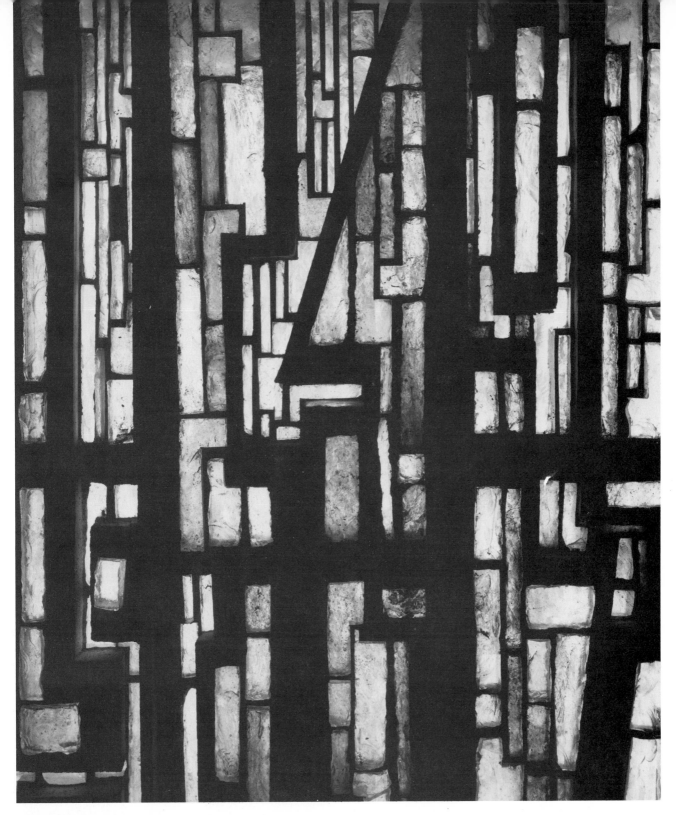

Sculptural Screen. (Detail) Faceted stained glass in con-
crete. Designed and constructed by Roger Darricarrere for
Lytton Savings and Loan. Photo, courtesy the artist.

Notes:
1. To cut slab glass: place a cold chisel, bladeside up, in a vise and secure it firmly. Place glass on the blade of the chisel and strike it with a hammer at a point directly over the blade.
2. *Faceting* the glass provides greater brilliance. To facet, or chip, the edges of glass: hold the piece in one hand and with a cutting (mason's) hammer strike the edge on the face side of the glass. A chip will fly off.

GLASS PAINTING, STAINING

Glass may be painted or stained and the degree of permanency varies with the type of paints or stains used; those that require firing are formulated to resist corrosive effects of the atmosphere and last indefinitely. Their use, however, involves a great degree of skill on the part of the craftsman and more time than is generally available in the classroom. The needs of the student and beginning craftsman can be met with fewer, more readily available materials and simpler, less time-consuming techniques.

Glass paints and stains which require no firing are available from a number of manufacturers (see "Sources for Materials and Supplies"). The stains are more widely used and are comparatively inexpensive. In general, they require no mixing or grinding of colors; the stain is premixed and is simply brushed on glass that has been thoroughly cleaned with detergent or denatured alcohol. Extenders and various media accompany the stains and directions for their uses are provided on labels and brochures.

To achieve a more realistic simulation of leaded glass, lead strips or lead tape may be adhered over the stained design. A special adhesive for attaching the tape is available. The tape is easily shaped and, overall, the effects obtainable are quite handsome. Colors resist the effects of light, they withstand washing and only a strong abrasive will remove them from the glass.

Use the staining technique to design panels, lamp shades, jewelry, decorative containers, mobiles and glass constructions.

Chess Set. Glass "globs" are combined to design the playing pieces and leaded glass squares make up the board. Courtesy Glass House Studio.

SIMPLE PROJECTS

The following projects and activities may be completed quickly and with a minimum amount of materials.

1. *Small glass panel:* Create a design on a piece of window glass; draw it on the glass or place a sketch under the glass. Fit pieces of stained glass over the design, adhering them with epoxy cement or glass glue. Leave spaces between the glass — approximately ¼″ wide. After the adhesive has dried and the glass pieces are securely set, fill in the spaces with liquid solder, metal paste — or even black aquarium cement — to create a leaded glass effect.

2. *Tiles.* On a glazed wall tile — white is best — arrange scrap colored glass. Fire to 1450°F., in an enameling kiln, following the procedures outlined in *Glass Firing*, this section.

3. *Bottles, tumblers, candle glasses.* Select a container that is simple in shape; clear glass provides the best results. Be sure that the container is sparkling clean. Starting at the bottom, adhere small pieces of colored glass (scrap, cut, melted globs) with epoxy or glass glue. Leave small spaces between the glass and finish it, as outlined in 1, above, with liquid lead, etc. Apply an even band of the liquid lead or metal paste to finish the tops and bottoms. Smooth the edges. Use as decorative holders for flowers, weeds, branches and candles. (Candles are especially effective.)

4. *Jewelry or trinket box.* Apply glass as in 1, above. Glass may be applied to all surfaces of the box or only on the lid. Mix tiny pieces of mirror (cut with glass cutter) with the glass for an ornate effect. For greater reflection, first paint the surfaces with silver metallic paint or cover them with foil. (Crumple the foil slightly, then smooth it and apply with a strong glue.) Use cigar boxes, wooden cheese boxes or boxes purchased at hobby shop.

5. *Jewelry.* Set glass jewels on a bracelet made from papier-mâché. (See *Papier-Mâché.*) Cage a glass glob in wire (copper, silver) and suspend, as a pendant. Fuse 3 or 4 globs, and "lead" the outside edges with liquid solder, metal paste or colored *silicone sealer.* (Tube. Hardware store.) Use the copper foil method to join glass globs, if glass is thin.

6. *Mirrored panel.* Using a clear-drying glass glue or epoxy, mount scrap glass on a backing of mirror. Over-lap and over-lay pieces of glass to blend colors, to create light and dark areas. Cover the mirror *entirely* except for a margin that may be necessary for framing or hanging. Use this technique to create mobiles, a decorative top for a box, a candle screen, small pieces of jewelry, a hair ornament, a splash board for the bathroom, a jeweled construction, or a wall panel. (Bond's "527" adhesive is especially recommended. See Sources for Supplies.)

Brooch. Ramona Solberg. Cut mirrors glued on stiff cardboard and "grouted" with liquid solder. From *Inventive Jewelry Making,* by the artist.

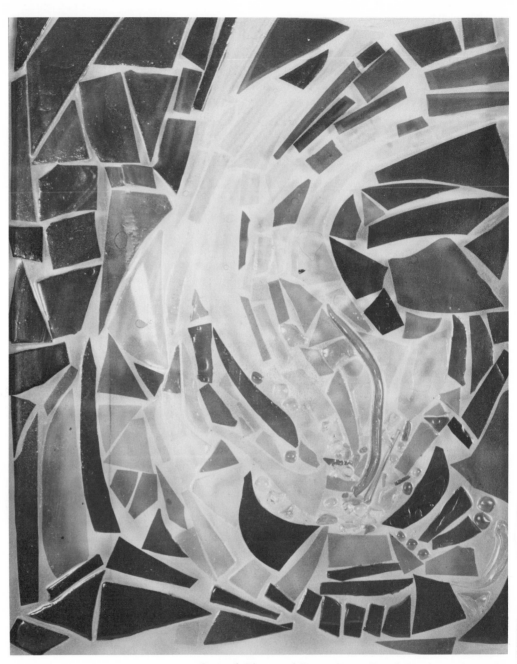

Stained Glass and Epoxy Resin Panel. By the author. The only support for the glass is the cured epoxy resin; a backing of glass or plastic is not required. A single pouring of the resin binds both the glass and the frame. The process is described in this chapter.

Chapter 7
Plastics

Plastics, products of the chemist's laboratory, provide the newest and perhaps most challenging media for art expression. Contemporary craftsmen have discovered that, while this new and vital material can be used in creating traditional art forms, plastics possess unique characteristics and that they, indeed, have a place of their own in the field of design. Unlike conventional, so-called "natural" materials such as wood, stone and glass, plastics are *created* and their characteristics can be controlled by formulation.

The beginning craftsman or student exploring the uses of plastics soon discovers that all plastics are *not* alike; materials that *appear* to be similar behave quite differently when he attempts to saw, bend, join or otherwise use them. There are approximately 20 or 30 different *basic* types of plastics, each with its own characteristics that limit or expand its uses. Furthermore, many kinds of plastics are designed for industrial use only or require expensive materials, tools and equipment that exceed the limitations of the studio or classroom.

Plastics are a comparatively expensive art material and for this reason are not widely used in school programs. The aims here are to discuss those plastics most commonly available at lower costs or those obtainable as scrap materials.

TYPES OF PLASTICS

There are two basic types of plastics: *thermoplastic* materials that soften when heated and harden as they cool, and *thermo-setting materials* that are hardened by *chemical* heat. *These differences are important to keep in mind.* Polystyrene (styrene), for example, can be softened by physical heat, shaped and, if necessary, reheated and reshaped; polyester resins and epoxies cannot be treated in this manner. They will simply disintegrate in various ways. Most plastic containers, often used in scrap plastics projects, are thermoplastic, as are acrylics, and may be softened by physical heat.

Some general guidelines should be observed when working with plastics:

1. Follow the manufacturer's directions meticulously, especially the safety precautions listed.
2. When working with an "unknown" scrap plastic do not attempt to heat it in an oven or kiln; fumes

from certain plastics are highly toxic. Do not attempt to dissolve it with whatever solvent is at hand; toxic fumes or a caustic material may result.

3. Always work in a well-ventilated area.

4. Avoid undue exposure of the skin to plastic resins and their solvents; some persons are allergic to specific plastics. Use disposable tools, materials and gloves if the latter are recommended.

5. Pre-test unknown plastics before attempting to use them in designing a project.

Plastics are available in various forms including powders, liquids, pastes, solids and films. Solids may be sheets, slabs, tubes, rods or pellets. (Every type of plastic is not available in all of these forms, however.)

Plastics most commonly used in the classroom include the following; many are referred to by brand names:

1. *Slabs* of expanded polystyrene foam such as Styrofoam (Dow) or Dy Plast (DuPont). *Polyurethane*, commonly used as an insulating material, is also available in slabs. Some slabs are formed of compressed pellets, such as "Gen-a-lite". The polystyrene foams tend to be crisp; incisions and cuts can be made cleanly and neatly. Others, particularly the types made from compressed pellets, tend to be softer and cuts must be made carefully to avoid ragged, uneven edges. Their resiliency, however, is an advantage when the material is used for a printing block; it does not break or crumble under reasonable pressure.

2. *Epoxies* are available as coatings, paints, pastes, adhesives and casting resins. In the classroom, they are commonly used as *adhesives*, especially for joining "unlike" materials and when an extremely strong bond is required. *Epoxy resins* are being used more widely because of the recent revival of the art of stained glass; the epoxies have been found to provide an ideal material for casting and joining slab glass. They are also used in casting, laminating and mounting jewelry. The material comes in two parts — a resin, plus a hardener, or catalyst. Epoxy materials are expensive but because of their extraordinary strength and versatility are inexpensive in *use*; only small amounts need be used to bond or cast materials that are quite heavy.

3. *Polyester resins*. These versatile liquids are available in great variety from many manufacturers.

Like the epoxies, they come in two parts — resin and hardener. They may be colored by the addition of dyes made especially for that purpose. They may be used in casting and laminating; fiber glass sheets — among other "fillers" — are used in the laminating process. They differ from the epoxy resins in that they are more vulnerable to light and atmospheric conditions, shrink to a greater degree and are more apt to crack or shatter. Their adhesive qualities are less reliable; materials embedded in polyester resins should be fairly small and lightweight. Polyester resins are most effective in producing small cast forms for jewelry, mosaics and mobiles; they are *not* recommended for outdoor installations for reasons noted earlier. Some polyester resins have an extremely short "shelf life"; purchase them shortly before anticipated use to ensure freshness and do not store for extended periods of time.

Owl. Gerald F. Brommer. Plastic casting resin. Height, 9", without base. The owl was first made in ceramic and a rubber mold made from the original. The mold was then filled with casting resin and allowed to harden. The surface was finished with colored lacquers. Photo, courtesy the artist.

Polystyrene Puppet Heads. Egg shapes of Styrofoam form the bases for the heads; the necks (finger stalls) are formed by pushing cylinders of stiff cardboard into the base of the head. Modeling of the facial features is completed with papier-mâché; smoothly applied tissue covers the entire head. "Hair" is added with fur and yarns. Acrylic paints are recommended since they are self-sealing; shellac or other sealer is not necessary. Photo, courtesy Polly Culpepper and Lily Mills, Shelby, N. C.

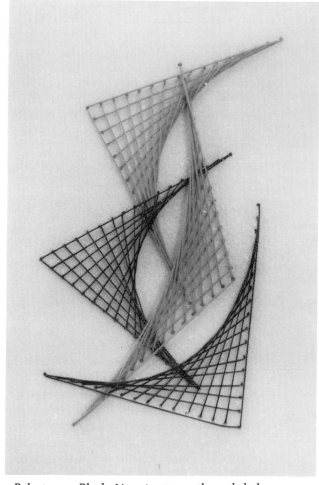

Yarn on Polystyrene Block. Yarn is strung through holes that are punched through the block. Because they are lightweight and easy to display, Styrofoam boards are an ideal base for displaying visual teaching aids, as shown here. They may be covered with stretched fabric to display stitchery or other textile designs. Photo, courtesy Polly Culpepper and Lily Mills, Shelby, N. C.

4. *Thermoplastic pellets; tiles.* The procedures for working with these materials are similar. *Pellets* are placed in a retaining mold (Pyrex, metal, metal foil) and melted or fused in a kitchen oven or portable broiler; they fuse at approximately 330°F. Foreign materials including papers, glass beads, foils, threads and wires may be embedded in them and colorants may be added. The tiles, although obviously intended for mosaics, may also be melted or fused in the same manner as the pellets. Pellets and tiles are available in a variety of colors and may be used in designing jewelry, mosaics, hanging forms, trays and decorative items. The tiles may be mounted on a variety of backings including sheet plastic, glass and hardboard.

5. *Acrylics*, available in solids of sheets, blocks, rods and tubes, are most commonly obtained as scrap. (Brand names include Plexiglas and Perspex.) Uses include printmaking (incised sheets), constructions, and jewelry. Acrylic *painting media* include paints, acrylic medium, gesso, gels and paste which are used, in addition to painting, in collage, printmaking, papier-mâché and jewelry techniques.

7. *Scrap plastics* may include almost any type of plastic: vinyls, silicones, acetates, polystyrenes — whatever is used to package, contain or protect. Broken household utensils such as plastic bowls, cups, plates and plastic toys, costume jewelry, hair curlers — all may show up in the scrap box. Experiment — safely — to find the best adhesive or the most imaginative uses.

SOURCES

Plastics, like all art materials, may be purchased from a variety of sources. In addition to school and craft suppliers, hardware and building supplies companies stock an amazing array of plastics. (See Yellow Pages — and check all categories under the general heading of "Plastics".) Ask for discards and scrap, especially from the manufacturers of *finished items*; manufacturers of the basic plastic material rarely have scrap. Collect scrap plastic items from home and school cafeteria: plastic foam food trays, berry baskets, bottles and jugs can be transformed into print-

ing plates, collages, constructions and — when all efforts fail — water containers!

TECHNIQUES

Plastics can be cut, glued, melted, fused, carved, laminated, cast and formed in various ways that are limited only by the nature of the material and the craftsman's imagination. Practically all areas of art can be explored through the use of plastics: puppetry, printmaking, collage, construction, sculpture, interior design, painting and jewelry making.

The techniques described here are related directly to specific types of plastic; the related materials and tools are those commonly found in the art classroom.

Polystyrene Slabs (Styrofoam)

Related Tools, Materials: For cutting: sharp knives, single-edge razor blades or a Styrocutter; for joining: white glue, wire hair pins; a separator for cast forms: Vaseline petroleum jelly; for coloring: poster paints (add liquid soap or white glue), acrylic paints, printing inks. Optional: For cutting lines, a wood burning pencil or pencil-type soldering iron; for impressing shapes and lines: cookie cutters, jar lids, nails.

1. *Printmaking.* Create a design on a plastic slab by impressing, cutting or burning lines and shapes. Ink with a soft brayer or apply paints with a brush and print by placing the block, face-down, on the paper and applying even pressure. If prints are not distinct, dampen the printing paper, cover with *dry* paper and print by rubbing with the bowl of a spoon. (The solvent in some permanent-type felt markers will dissolve lines in Gen-a-lite; use the markers to incise lines.)

2. *Constructions.* Cut shapes from slabs to design three-dimensional standing forms. Join individual shapes by tongue-and-groove or by pinning them together, then glueing with white glue. Remove pins after glue is dry. Shapes may be mounted on wood dowels and attached to a base or may stand alone. Add color, if desired.

3. *Bas-relief panel.* Create design by cutting shapes, as in (2), and attach with glue to a plastic slab or hardboard. Spray with plain or metallic paints,

as desired. (Pre-test spray paints for compatibility.)

4. *Casting with plaster.* Pack dampened sand into bottom of a box with walls at least 4″ high. Cut shapes from plastic slabs; create textures and patterns on blocks then coat the surfaces that will be exposed to plaster with Vaseline. Press blocks into the sand, at different levels; set blocks with design-side up. Pour creamy plaster into the mold and permit to set until thoroughly hard, then lift up plaster cast, remove plastic blocks and brush away sand. If a hanger is used, insert before plaster is set. Use screen wire reinforcement if the cast block is very thick or large.

5. *Puppet heads.* If plastic foam is available in egg-shapes (Styrofoam), use as a base for shaping a head for a puppet. Create depressions for eyes, build up nose and other features with bits of foam or papier-mâché. For a smooth surface, dip the head in gesso (acrylic recommended) or thin plaster to which white glue has been added. Paint and finish as desired.

6. *Armatures.* Build armatures for animals, figures or other forms from plastic slabs. Finish by filling out or building up with papier-mâché, metal paste or plaster-dipped fabric.

7. *Jewelry.* With a sharp knife or single-edge razor blade, create a shape from plastic slab. Invest the shape in plaster then pour in hot metal, such as pewter. The plastic will volatize and the metal will replace it. (This might be called a "lost-plastic" casting.) Use crisper, harder plastic slab, such as Styrofoam, for jewelry designing; shapes will be cleaner, sharper. Finish by filing, polishing.

8. *Working Hints.* *Always* test adhesives to be used on plastics; some cements dissolve the plastic. *Both* sides of a plastic printing block may be used for incised or cut designs; use scraps of plastic block for scrap prints. Use *foam packing materials* as you would foam slab, depending on shapes and sizes available; join shapes, as found, or cut to desired shape.

Epoxies: Cements and Resins

Related Tools and Materials: For mixing and stirring: disposable, clean sticks, jars, cans; for making forms for casting: wood strips, hammer, saw, nails; for separating resin from work surface and frame: wax, acetate or other plastic film or commercial mold release; to make modeling compound: metal powder (aluminum, bronze, steel). Optional colorants for resin: use *only* those recommended by the manufacturer.

Cements. Generally sold in tubes, the cements come in two parts — the cement and a hardener. *Mix according to manufacturer's directions.* Use to join unlike materials such as glass to wood, wood to metal, ceramic to leather, etc. Especially recommended for use in jewelry where a strong, unobtrusive joint is required, and for use in projects combining many different kinds of materials such as assemblage and "junk" sculpture.

Casting in epoxy resins and mortar. The basic technique for casting stained glass slabs is described in the preceding chapter on *Glass.* (See "Casting Techniques with Slab Glass".) Follow the procedures outlined there for building the retaining frame, for the use of separators and for pouring. There are a few variations that should be noted; some relate to working procedures and others to the nature of the materials and the quality of design.

1. In preparing the working surface, cover the surface with a sheet of white paper that will extend two or three inches beyond the retaining frame *on all* sides. (Colors of glass are more readily identified against the white background.) Cover the white paper with a sheet of clear acetate (or other plastic) that will extend beyond the frame; this will prevent the resin or mortar from sticking to the paper. Set the frame on top of the acetate. Don't forget to wax the inside of the frame *if it is to be removed.*

2. If a resin of a syrupy consistency is used, seal the outside of the frame *tightly* so that the resin doesn't leak out of the frame. Use plasticene modeling clay or masking tape. If a heavier, mortar-type epoxy is used, the chances of leakage are lessened but the edges should be taped as added "insurance."

3. Thick cast panels — especially those cast in mortar — do not require a frame after completion. Thinner, lighter-weight panels cast in resin are often framed. If the latter is desired, do not build a rough retaining frame but, instead, use the "finished" frame to retain the work. In this case, do

not wax the interior edges of the frame; the epoxy will bind the frame to the work and no other framing is necessary. If this short cut is used, cover the frame with masking tape or paper to protect it from accidental spills and splashes; epoxy is all but impossible to remove!

4. Use resin for thin sheet glass; epoxy mortar (available in colors) is better for the thicker slab glass but the resin will bind it if poured at least ⅛" thick.

5. It is not necessary to pour a thick layer of resin; a pour that is only ⅛" thick will bind heavy materials.

6. It is not necessary to pour both front and back of the panel, especially thin resin-cast panels. Two pours of mortar may be desirable depending on how the panel will be viewed. (See notes on *Casting in Concrete* in the preceding chapter, *Glass*.)

7. When pouring resin-cast panels, use different forms of glass: cullet, sheet, rods, *small* pieces of slab glass and preformed glass (marbles, beads, glass rings cut from bottles, fired glass globs).

8. Experiment with *laminating*, by building the panel in layers: overlap colors and shapes for greater subtlety and depth.

9. Other uses: With small, or left-over, amounts of resin, cast small shapes for jewelry. Use plastic ice-cube trays or "found" forms — but remember to add a separator. Embed bits of glass, shells, marble chips or other colorful and textured materials. Drill holes for pendants; attach pin backs with epoxy cements.

10. It is *essential* that epoxies be thoroughly and evenly mixed, especially the heavier, thicker mortars. In mixing resins, avoid whipping in air which will cause bubbles. Large amounts of resin generate heat as they are mixed; therefore, do not mix in containers that are deep and narrow. Use shallower plastic bowls or disposable buckets. Containers should be scrupulously clean to avoid contamination that can interfere with proper mixing and curing.

11. For clean-up, a good grade of lacquer thinner is safer than acetone. Avoid clean-ups by using disposable tools.

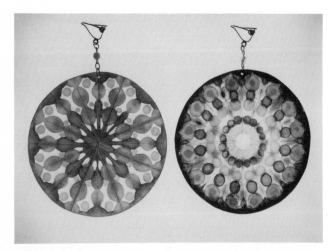

Earrings. Folded rice paper was dyed with vegetable dyes then laminated between clear polyester casting resin. From *Inventive Jewelry Making*, Ramona Solberg.

Pendant. Sally McCorkle. Silicone bathtub sealer was squeezed from a tube to form the pendant. Color was added by dipping the dried form in "Dippety-Glas", a colored liquid plastic. From *Inventive Jewelry Making*, Ramona Solberg.

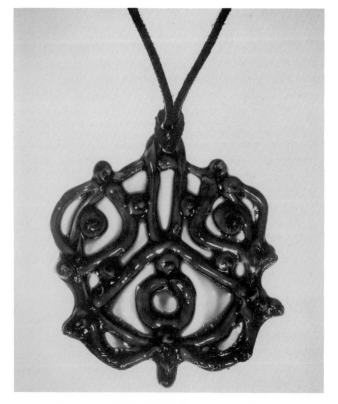

Polyester Resins

Although varying somewhat in their basic characteristics, polyester resins may be used in techniques *similar* to those described for epoxies. They cannot, however, be used in casting slab glass. *Other differences, described earlier in this chapter, should be noted before projects are planned.*

Related Tools and Materials for Lamination: Fiberglass cloth or mat; *thin* materials for embedding (wire, pressed grasses, string, yarn, powdered enamels, paper, cloth, lace, confetti, decorative tapes), waxed paper; brayer. (Materials for casting with polyester resins are listed separately in material that follows.)

Working Procedure:
1. Have a plan for the design — and the embedding materials to create the design — readily at hand.
2. Spread waxed paper on the working surface. Cut two pieces of fiberglass cloth of the same size and lay one of these on top of the waxed paper.
3. Mix the catalyst with the resin, following the manufacturer's directions carefully.
4. Spread the resin evenly on the single sheet of fiberglass cloth that was placed on the waxed paper. There will be enough resin on the cloth when it turns clear.
5. Carefully place the embedding material, according to design, on top of the resin-filled cloth.
6. When the arrangement is completed, place the other piece of fiberglass cloth on top of the design and again spread with resin.
7. Place a piece of waxed paper over the total layered arrangement and, using a small brayer, roll the surface smooth.
8. Allow to set and harden before removing the waxed paper.
9. Fiberglass-reinforced plastic panels may be used in designing trays, room dividers and screens. Experimentation will suggest other uses such as bowls and other three-dimensional structures.

Related Tools and Materials for Casting: Frames of wood (ready-made, found or constructed from strips); a separator for the working surface (acetate, waxed paper, clear Contac paper), mold release, as recommended by the manufacturer. Materials for embedding or casting: *small* pieces of sheet glass for panels;

glass cullet; colored tissue; beads; watch parts; ribbon; string.

Working Procedure:
1. For a panel, prepare the frame according to procedures for casting in epoxy. Set the frame on top of a separating sheet.
2. Arrange materials, within the frame, on top of separating sheet (acetate, waxed paper, etc.). Do not use large, heavy materials.
3. Pour resin and allow to set.
4. Resins differ; one brand may adhere to the frame unless it has been coated with a separator, another may not. *Pre-test the material*, mixing it according to the manufacturer's directions.
5. Molds for casting resins may be shaped from heavy-duty aluminum foil. Be sure that the sides of the mold are deep enough to contain the resin and any materials (glass "jewels," watch parts, colored tissue) that are added to it. These cast pieces may be used in a variety of ways: make holes in pieces with a hot wire or hot ice pick and suspend them, singly or in groups, from a thin nylon fishing line or fine black thread; use use them in assemblages or constructions. Make small cast pieces to utilize leftover resin from larger cast pieces.
 Very small amounts of "leftover" resin may be dribbled or poured over wood, Masonite or sealed hardboard to create a printing plate. Permit resin to dry thoroughly before inking and printing.
6. Experiment with using found objects as molds or frames; be sure there are no undercuts to make removal of the cast form difficult or impossible. Apply mold release.
7. Follow safety precautions, as recommended, for ventilation, handling and use of solvents.

Thermoplastic pellets and tiles
Related tools and materials: Molds, bases or retaining forms: foil; Pyrex pans; cups; metal forms; "found molds". Decorative materials, as described for polyester resins. Colorants, as recommended by the manufacturer.

Working Procedures:
1. Separators and mold releases are not required.
2. Sprinkle pellets, or arrange tiles, on a base until the surface is evenly covered.

(a)

Mobile in Thermoplastic Pellets. This mobile fish (a) is made from individually shaped sections fused in a portable broiler at 350°. The process is described in the photos which follow. (b) One of the sections is shaped from a stainless steel stripping which is flexible and reusable. (c) The frame is placed on a cookie sheet and filled with plastic pellets. (d) The filled frame is placed inside the preheated broiler. (e) Plastic tile, to be used as accents of shape and color, are cut while the pellets are heating. (f) The bits of tile are arranged on the partially fused pellets and returned to the broiler for complete fusing. (g) The fused section is removed from the oven, allowed to cool, and the retaining frame is pulled away. The process is repeated for as many shapes as are necessary to complete the design. From *Plastics for the Craftsman,* Jay Hartley Newman and Lee Scott Newman.

(b)

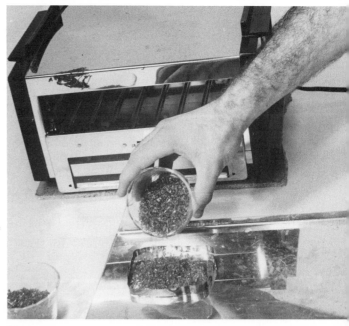

(c)

(d)

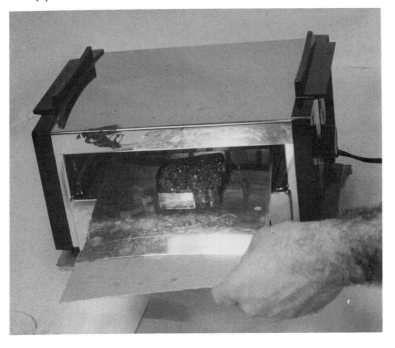

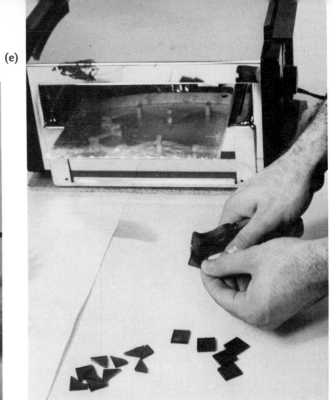

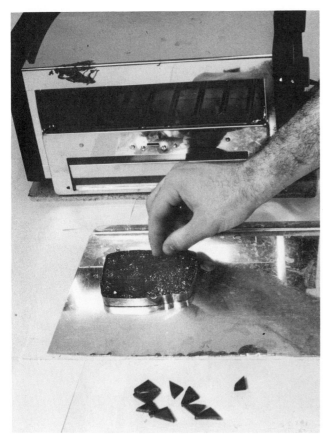

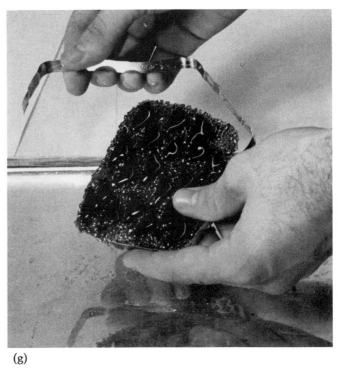

(g)

(f)

3. Embed decorative materials to add color, texture and variety of shapes. Cover the embedded materials with pellets.
4. Place in kitchen oven or portable broiler and watch carefully until the fusing temperature is reached. Degree of fusing can be controlled; experiment. (Read manufacturers' directions carefully; brands vary.)
5. Make foil molds to create shapes to be used as decorative hanging forms, paper-weights, jewelry and forms that may be incorporated in weaving, stitchery, macrame and assemblage.
6. To suspend forms, make holes with a hot ice pick or needle. Thread with nylon fish line, cord or thread. Use watchband cord and make pendants. Attach jewelry findings with clear-drying cement.

Acrylics

Since acrylics are available in many different forms including painting media and solids — in the forms of sheets (Plexiglas," Perspex), blocks, rods and tubes — these categories will be treated individually.

Acrylic painting media, available from several manufacturers, generally include the paints (jar or tube), acrylic medium, acrylic gel medium, modeling paste, gesso and a matt medium. They are quick drying, retain their flexibility, may be combined with a variety of other water-soluble media and, when dry, are impervious to water. Sizing and priming are not necessary except to seal porous surfaces. The paints and related media are adhesive and will adhere to almost any surface with the exception of glass, metal, plastic and oily or waxy surfaces.

Uses of Media

1. Thin *colors* with water or medium.
2. *Acrylic medium* is used to thin paints, to mix glazes, to seal a painting surface, to varnish; it may also be used as an adhesive in collage and papier-mâché.
3. *Gel medium,* the pure acrylic emulsion, is used to increase the "body" of jar or tube colors, to create textures and impastos. Dries clear and provides an excellent glaze vehicle. May be used to adhere collage or other additive materials to the painting support. Used to extend the drying time of paints. (To further extend the drying time, spray the paint surface with a fine water mist.)

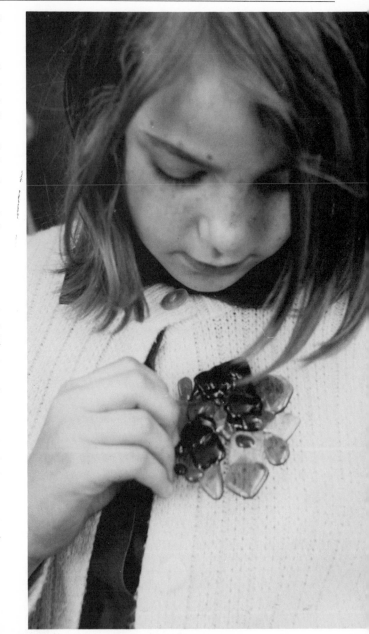

(a)

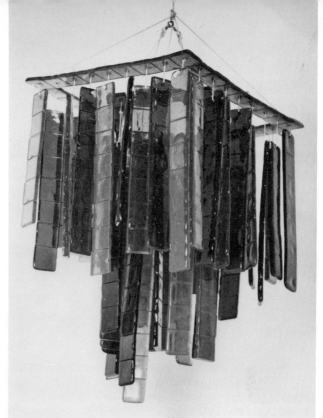

Thermoplastic Tiles. Thermoplastic tiles, like thermoplastic pellets, may be fused at 350°. They may be used as is, or may be fused to create a variety of designs. In (a), only a few tiles are needed to create a colorful brooch. Attach pinback or other findings with two-part epoxy cement or other compatible adhesive. The wind chime (b) is made by fusing tiles into strips of varying lengths. Holes for stringing can be made with a heated awl or ice pick. A panel (c) is composed of overlapped tiles and prefused odds and ends of plastic. Photos, courtesy Poly-Dec Co., Bayonne, N. J.

(b)

(c)

107

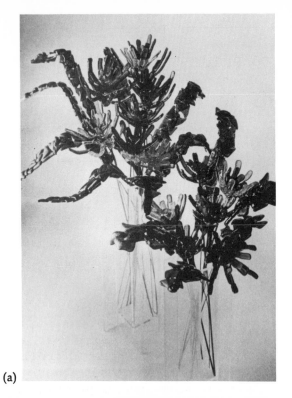

(a)

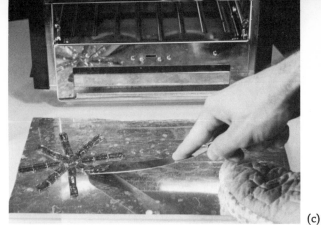

(c)

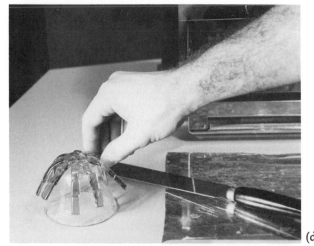

(d)

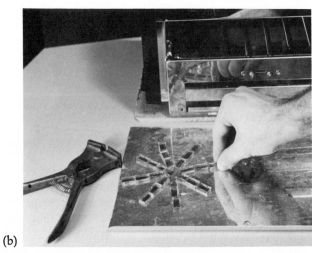

(b)

Thermoplastic Tiles. The flowers and leaves (a) were designed and shaped by fusing tiles in the same method described for fusing pellets. In (b), cut tiles are arranged on a cookie sheet. An extra tile is placed at the center to ensure fusing. After the tiles are fused, (c), they are removed while still quite warm, with a spatula. In (d) the still flexible form is placed over a Pyrex bowl to sag into the desired shape. (Smaller forms were sagged *inside* the bowl.) A heated wire, (e), is pushed into the base of the cooled flower to form a stem. Leaves are made in the same manner and may be shaped in hand if an oven mitt is worn. From *Plastics for The Craftsman*, Jay Hartley Newman and Lee Scott Newman.

108

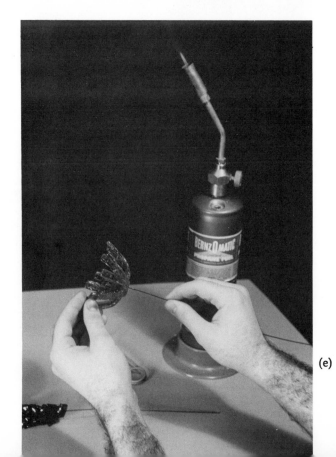

(e)

4. *Modeling* (*molding*) *paste* is composed of finely ground marble. Used to build impastos — alone or in combination with paints. May be shaped, modeled or textured. When dry, it may be carved, cut, sanded or filed.

5. *Acrylic gesso* is extremely white and remains pliable. One application will cover canvas; rigid, darker supports may require several thin coats. Sand, gravel or other additives may be adhered to a rigid support with gesso to provide a textured painting surface. May be mixed with modeling paste; may be tinted.

6. *Matt varnish* serves as a protective coating wherever a matt finish is desired. Use flat, soft brushes and avoid over-lapping strokes. Use *acrylic medium* for a gloss finish. (Some manufacturers produce a gloss medium.)

Techniques. The amazing versatility of acrylic media makes for an almost unlimited range of experimental problems. Remember that the paints and the related media will adhere other materials in mixed media techniques.

1. Dip thin, lightweight fabrics (cheesecloth, muslin, etc.) in acrylic medium to create relief surfaces on Masonite or pressed board.

2. Saturate vermiculite or zonolite in acrylic medium and press it firmly on a wet paint surface or dry ground. (vermiculite or zonolite from builder's supply house.)

3. Impress bits of colored glass, marbles or pebbles into acrylic modeling paste to create mosaic-like accents on panels, bottles. (If used on bottles, first coat bottle with gesso.) Press deeply to ensure adhesion.

4. Press colored magazine "ads" or illustrations onto a surface made wet with acrylic medium or acrylic paint surfaces. Lift "ad" before it dries on the surface to obtain a transfer. (Experiment first to determine proper time to lift illustrations from surface.) Try varied surfaces: canvas, muslin, shade cloth, etc. Use transfer as an element in painting or collage.

5. Spread a thin ⅛" to ¼" layer of acrylic modeling paste on a rigid backing. Experiment with texturing it with vegetable grater, old comb, hair rollers, spools, pastry wheels, etc. After surface is dry, brush thinned paint or colored glazes over the paste, then rub lightly with cheesecloth to leave highlights. Consider using metallic paints.

6. Use left-over acrylic paints to create colored papers for collage. Simply brush over any paper — even scraps — and permit to dry. The range of colors provides more interesting, varied collage elements.

7. Use thinned acrylic paints (1 part paint, 1 part water) as batik dyes are used. Brush them over previously waxed areas. The colors are washable.

Collage with Acrylic Media

Acrylic media, including paints, medium, paste and gel medium may be used in almost unlimited ways in collage-paintings. They provide excellent adhesives for joining a variety of materials including paper, fibers, fabric, cork, wood and foils. *Procedure:* Use a fairly rigid board as a base or support to lessen danger of warping. If transparent colors are used, coat the board with gesso or flat white paint. Dilute acrylic medium with an equal amount of water and use to adhere papers (foils, maps, grasspaper, wallpaper), to the support. Apply acrylic gel to selected areas of the design. Permit gel to dry. Experiment by applying acrylic paint in glazes and scumbles. Stained glass effects are produced when a color glaze is brushed over dried impasto gel applications. For accents, rub fluorescent paints over selected areas of collage; use sparingly, wiping away most of the paint with a soft cloth.

Papier-Mâché with Acrylic Media

The substitution of acrylic medium for wheat paste in the preparation of papier-mâché makes an unusually strong, water-resistant finished product. *Procedure:* Soak paper strips in water until they are softened. Drain off water, then dip strips in acrylic medium which has been diluted with an equal amount of water. Apply strips in the usual fashion to an armature or to a model of plasticene, wood or plaster. (If a plasticene model is used, permit the mâché to dry for several days, then slice the shell with a sharp knife, removing it in two sections. Join the sections with additional strips of paper which have been saturated with acrylic medium.) For a smooth finish, sand lightly and coat with acrylic gesso or thinned acrylic modeling paste. Finish with acrylic paints. If a high gloss is desired, brush on acrylic gloss medium.

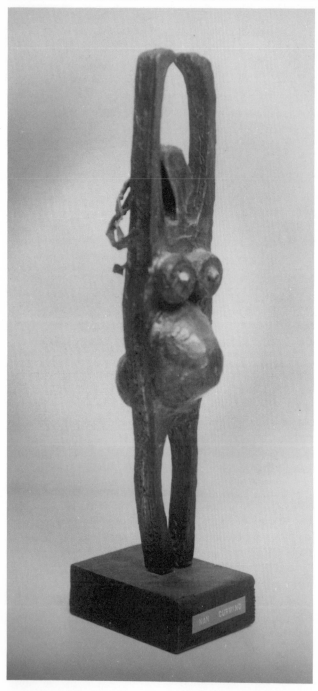

Sculpture. Student, Fort Lee, N. J. Senior High School. Acrylic modeling paste over an armature. Armatures or bases may be made from wood, clay or hardboard; the dried paste may be finished with liquid metals, paints, or various metallic sprays. For an "antiqued" effect, glaze with thinned oils or acrylic colors. Photo, courtesy Joan DiTieri, teacher.

Acrylic Paste Jewelry

Acrylic modeling paste, dropped in free forms on waxed paper, can be used as the base for simple jewelry. Press stones, cord, beads, etc. into the wet paste. Finish with acrylic colors and gloss medium. Attach findings with epoxy cement or strong glue.

Solid Acrylic Forms

Sheets, tubes and *rods* of acrylic are usually obtained as scrap and, despite the limitations of shape, size and color that usually accompany scrap materials, can be used in a variety of ways.

Sheet acrylic may be used to create printing plates, jewelry, constructions and small pieces may be incorporated in collage, weaving and assemblage.

Materials and Tools for Printmaking:
Clear plastic sheet (or colors, as available); oil base inks; papers; brayer; printing press; needle or other sharp tool for etching the design.

Procedures:
1. Plan a design on paper and place it under a piece of clear plastic. Using a needle or other sharp tool, incise a design on the surface of the plastic plate. Produce varied line effects by scratching deeply in some areas and lightly in others.
2. Apply ink to the plate by rolling with a brayer. Using a piece of soft cloth, rub the ink into deeply incised lines. Remove ink from some parts of the design to produce interesting value variations in the resulting print.
3. Place the plate face down on the printing paper and print on the press.

Materials and Tools for Jewelry:
Acrylic sheets, as available; saw; adhesive for plastics; file, sandaper; buffer. (Power tools such as a belt sander and drill press make the work easier.)

Procedures:
1. Use a commercially prepared adhesive or make your own by dissolving bits of *clear* acrylic (for best appearance) in *ethylene dichloride*, which is obtainable where plastics are sold.
2. *Laminate* the sheets by spreading the adhesive between them and then placing the laminate in a vise; use moderate pressure.

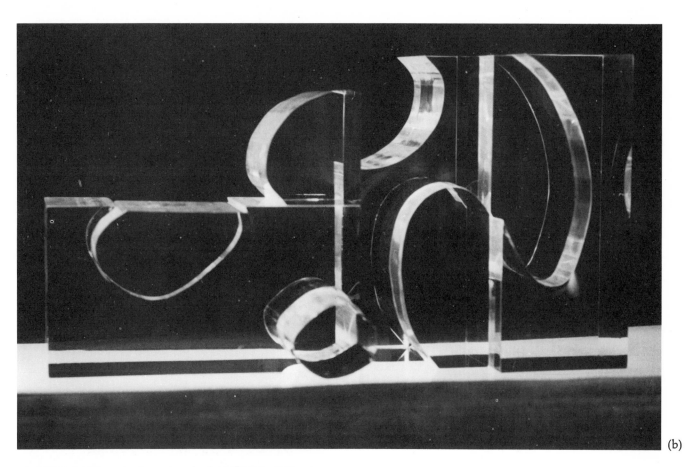

(b)

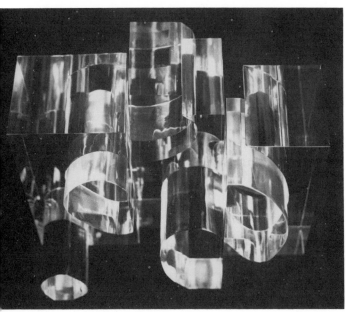

(a)

Involvement Construction No. 2. Thelma Newman. Carved acrylic block. Height, 10", width, 12". Parts can be re-ordered in many combinations by the viewer. (b) A re-ordering of the parts. Photos, courtesy the artist.

Acrylic Paintings. Students, Fort Lee, N. J. Senior High School. The versatility of acrylic paints is illustrated by the varying uses in the paintings shown here. The paints may be thinned to a wash, brushed in a flat, smooth manner similar to tempera or applied in a heavy impasto.

3. When the plastic sheets have formed an integral, solid block, shape with power or hand tools to make rings, earrings, pendants, hair ornaments.

4. To *drill* plastic, use a metal drill bit on a drill press; *shape* on a belt sander; *polish* with an electric buffer charged with tripoli and white rouge.

5. Handle ethylene dichloride carefully under all circumstances and do *not* use it in projects with very young students; it is toxic.

6. Use epoxy cements to join acrylics and dissimilar materials such as metal, glass, wood and for attaching jewelry findings.

7. Acrylics may be softened at 275°F. and bent into desired shapes; this is an easy technique for shaping bracelets.

Miscellaneous Uses:

1. Cut or otherwise shape sheets, rods and tubes to create a design. Mount on backing of hardboard that has been coated with a flat white paint. Use epoxy or other strong cement that has been tested.

2. Weave acrylic *rods* or tubes into wall hangings (weaving, macrame.)

3. Saw acrylic *tubes* into short lengths to use as beads in combination with other materials in jewelry projects.

4. Use *scrap acrylic* as mosaic tesserae. For greater reflection, back with foil.

Scrap Plastics

Discarded containers; scrap lots; "found" plastics from packing cases; broken toys, household objects.

Tools and Materials: Scissors, saw, adhesives, threads, drills.

Procedures:

1. Experiment with adhesives; some will work, others will not, depending on the type. Read labels carefully. Epoxies are the most reliable.

2. Use lightweight materials in mobiles, "junk" sculpture and assemblage. Use broken bits for mosaic tesserae.

3. Before attempting to melt an unknown plastic, try to find out what it is. Fumes *can* be toxic!

4. Use plastics to create a surface to be printed as a collagraph. Mount on bookbinder's board or other non-warping board, ink the surface and print.

5. Arrange scrap on a panel to create a relief design. Spray with a *compatible* paint.

6. On a cookie sheet (or other sheet metal) arrange scraps of acrylic or polystyrene to form a panel. Heat in a kitchen oven or portable broiler until the plastic softens. Remove from oven and create patterns on the softened plastic by texturing it with found tools such as nails, screws, corrugated metal fasteners and kitchen gadgets. The panel may be suspended, used as a printing plate or may be mounted on a backing or base.

Plastic Bracelet. Plastic cottage cheese carton melted and cut to form a bracelet. Cap from a toothpaste tube was melted into place on the front. The bracelet was removed from the oven while still warm and formed around a bottle. From *Inventive Jewelry Making*, by Ramona Solberg.

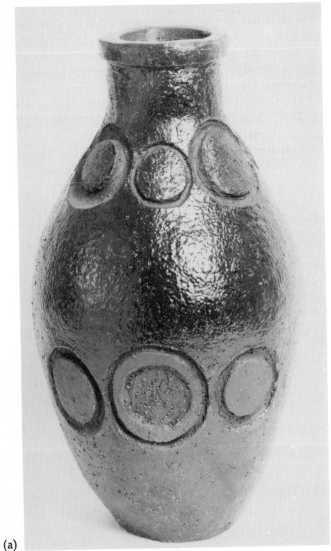

(a)

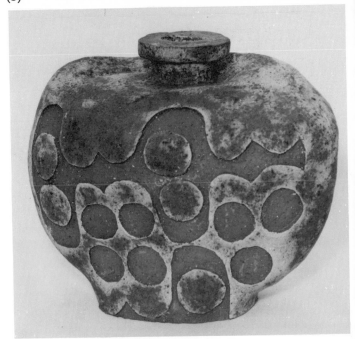

(b)

(c)

Ceramic Pots. Senior high students, Fort Lee, N. J. Senior High School. A variety of forms may be created from coils. Note, too, the variety of surface treatments. In (a), the heavily grogged clay and the glossy glaze require only the simplest incised design, in (b), positive and negative shapes enrich the surface, in (c), a patterned band of clay has been added. Note how the spouts harmonize with the over-all shape of the pot. Photos, courtesy Joan DiTieri, teacher.

Chapter 8
Clay

Art activities in clay are popular with all ages and grade levels; from the simplest "push-pull" modeling to the building of complex forms from hand-built and wheel-thrown pieces, clay techniques provide something for everyone.

The concern here is to describe basic *modeling* and *building* techniques — "push and pull" modeling, pinch pot, coil and slab — and the equipment, materials and tools required for their completion. Simple press molds and slip casting are also described.

TYPES OF CLAY

Clays selected for use depend on the age or grade level of the students and the purpose of the specific activity. There are three basic types of clays: *non-hardening* clays, *self-hardening* or air-hardening clays, and *firing*, or potters' clays.

Non-hardening clays have an oil base and, since they do not harden, may be used repeatedly. They are used, primarily, for modeling activities with very young children and, with older students in building forms to be cast and in making armatures. *Because of their oily bases, these clays should not be painted and they cannot be fired.*

Self-hardening clays, generally, are made of potters' clay, water and chemical additives which activate the setting or hardening process as the clay is air-dried. These clays are produced under several brand names and the compositions vary with manufacturers; the best guide to their uses is to follow the manufacturers' directions. Generally, the clays are packaged in a dry form and water is added at the time of use. Several brands are advertised as being suitable for modeling, casting and carving techniques; again, follow manufacturer's directions for best results. If a kiln for firing is not available, use self-hardening clays instead of painting firing clays to simulate fired glazes; the latter technique is a misuse of materials since the clay must be fired to become durable enough for normal handling and use. *Do not, under any circumstances, use compounds containing asbestos; research has proven that asbestos is a cancer-producing agent when free particles are inhaled into the lungs.*

(a)

(b)

Techniques for Self-Hardening Clays. In (a), the head is built over papier-mâché which was covered with a coarse fabric to grip or hold the clay as it was applied. In (b), puppet heads and hands are shaped over crushed paper, and (c) is cast. To mount heavy pieces on wood or other backing, use epoxy cement for best results. The product used in these projects is "Sculptamold". Photos, courtesy American Art Clay Co., Indianapolis, Ind.

(c)

Firing, or potters', clays are natural clays that have been washed and refined to remove foreign materials and prepare them for use; they are packaged in dry or moist forms. They will dry to the consistency of hard plaster or chalk and, in this state, are often painted to simulate glazes despite the fact that results are often disappointing; colors do not adhere well and the form chips easily under even normal handling.

Firing clays are available in several varieties: pottery clay may be gray *stoneware* or *terra cotta* clay; the stoneware clay will fire to a light buff tone and is recommended when lighter, brighter glazes are to be used; terra cotta fires to a darker reddish-brown which darkens glaze colors applied over it. Fired terra cotta is handsome in itself and glazes are not really required. Sculpture clay when purchased ready-mixed, contains *grog* (ground fired clay) which strengthens it. Sculpture clay may be prepared from regular potters' clay by adding grog — about 20% by weight. Fine grained *white clays*, requiring lower firing temperatures, may be purchased for making jewelry and other small items where strength and rigidity are not prime requirements.

Egyptian paste, a firing clay which is a combination of clay and glaze, may be purchased ready-mixed or may be mixed from various formulae. It is somewhat limited in use in that it does not lend itself to coil, slab or wheel techniques. It is, however, most effective in designing jewelry, buttons and other small objects. Since it requires special handling, Egyptian paste is discussed separately at the conclusion of this chapter.

Because both self-hardening and firing clays contain water, some general guidelines may be followed in working with both of them: keep the clay moist until the project is completed and do not permit the finished object to dry too rapidly or it will crack; solid pieces should be hollowed out. Firing clays will crack if modeled over a solid armature; see manufacturers' directions for use of non-hardening clays over armatures; some are suitable, others are not.

EQUIPMENT

Special equipment is not required for using non-hardening or self-hardening clays. The equipment listed below is that required for firing clays: *A kiln,* for firing. (See manufacturers' catalogues for types, sizes, prices.) *Kiln furniture,* to support ware being fired; *kiln posts* and *shelves,* to provide more firing space within the kiln, to fire "layers" of objects; a *wedging board,* on which to condition the clay; a *damp box,* for storing clay to prevent its drying out. (A damp "box" may be improvised: use a large stone crock or plastic trash can, with a lid.)
Optional: A *pug mill* to recondition clay; *decorating wheels; tile setters.*

Materials and Tools
Glazes; wax (for resist techniques); *plaster,* to make bats and molds; *kiln wash,* to protect bottom of kiln and shelves; *grog,* to add to clay for greater porosity, less shrinkage. Tools should include: a variety of clay *modeling tools,* brushes, assorted; ruler; rolling pin, for rolling slabs; *wire; grinding stone,* to smooth edges from fired objects. *Oilcloth* or *sheet plastic,* to cover and protect work surfaces; *syringe* or *dispenser bottle,* for slip trailing; *knives,* to cut and trim clay; metal and rubber *pallets,* to smooth or scrape clay, glazes.

Note: The majority of materials and tools listed here are designed and manufactured for use with clay;

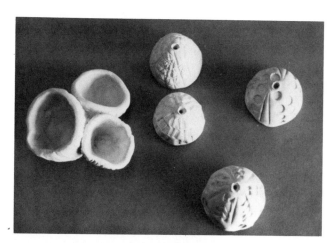

Pinched Forms. These little "pots" may be used in a variety of ways: they may be textured or smooth and may be used singly or joined. The textured pieces shown here have holes punched in the bottoms; these could be mounted on wire stems, after firing, or be incorporated in a macrame hanging.

however, tools that, in many instances, are equally suitable may be found or improvised. A broomstick or large wood dowel may be substituted for a rolling pin; tools for *texturing, carving* and *modeling* may include table knives, forks, spoons, nails, hairpins, sticks and old combs. To make pallets for smoothing and scraping, cut rectangular and half-moon shapes from scrap metal or coffee cans. A strip of tin bound and cemented to the end of a pencil or dowel to form a loop may be used for cutting, scraping and trimming.

Materials and Tools for Non-hardening and Self-hardening clays

Use *modeling* tools, as listed above, for both non-hardening clays and self-hardening clays. Additional materials for self-hardening clays are those used for finishing (paints, lacquers, metal pastes, varnishes) and for making armatures or molds if they are built up or cast (wire, plaster, wax).

PREPARATION OF CLAY

Non-hardening clay requires no special preparation; the warmth of the hands will soften it as the clay is worked, or place the clay near heat (radiator) so that it can warm *gradually*. If the clay is still unworkable, add a bit of glycerin, working it *thoroughly* into the clay.

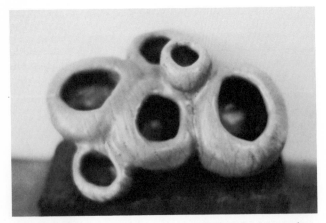

Joined Pinch Pots. Forms such as these can be used to design planters, candle holders, weed pots or abstract sculptural forms.

Self-hardening clays should be prepared according to the manufacturers' directions. Read labels or brochures carefully.

Preparation of *firing clay* requires the use of two simple pieces of equipment — the plaster bat and the wedging board (or tool).

Plaster bats are simply slabs of plaster that are used to support a piece while it is being worked and to control the rate of drying. The bat is made wet by sprinkling water over it or by soaking it. To make bats, mix plaster to a creamy consistency and cast it in cardboard boxes or pie pans. (Coat cardboard with Vaseline for easy removal. Refer to chapter on *Plaster*, for mixing techniques.) Bats of pie-pan size should be at least 1″ thick. Bats of larger size should be proportionately thicker.

Wedging

The purposes of *wedging* the clay are to remove air bubbles which would explode in the firing process and to distribute moisture evenly. The clay is wedged by slicing it in half with a tautly held wire, then slamming the two halves on to the wedging table or *board*. This process should be repeated until the clay is uniform in consistency and all air bubbles removed. A wire wedging tool may be made by attaching strong handles to both ends of a 12″ length of steel wire. The wire, stretched tautly to its full length, is pulled through the mass of clay, slicing it. This simple tool is adequate for preparing a small amount of clay — a long, sharp knife could be used — but a *wedging board* is essential for preparing large amounts of clay, for a class. Unwedged clay should not be used: clay that has been stored, although appearing workable, should be wedged before use.

The preparation of *firing clay* purchased in a moist state is simpler than the preparation of clay purchased in dry powder form. The moist-pack clay, however, usually requires the addition of water to achieve a workable consistency and should, of course, be thoroughly *wedged*. If the clay is too stiff, wedge or knead it on a wet cloth or, if the clay is too hard to knead or wedge, break it up into chunks and put it into a large plastic bag (crock, plastic trash can) and pour in water. Set aside to permit the water to be gradually absorbed into the clay. The amount of water needed depends on the stiffness of the clay; experience is the only reliable guide. If too much water has been added and the clay is sticky, spread

it on a *dry* plaster bat and turn it repeatedly until excess moisture has been absorbed. If still stiff, wet the plaster bat or knead the clay on a wet cloth, as described earlier. When a smooth, pliable consistency is achieved, wedge the clay and store it. (See Storage of Clay, which follows.)

To prepare dry powder clay, spread the powder in a container large enough to hold the powder and enough water to mix the clay to a thick molasses-like consistency. (A flat, shallow container will speed evaporation; a narrow, deep container is unsuitable.) Mix the clay powder and water until they are smoothly combined and free of lumps. When the water has evaporated and the clay has reached a slushy stage, pour the clay on dry plaster bats to dry until it can be wedged. Scraps of dried clay may be re-conditioned by the same method but additional time is required since the dried clay must soak until it has absorbed enough water to become workable.

Prepare *slip* by adding water to clay powder, moist clay or dry, scrap clay. (The latter procedure requires time for the clay to absorb water.) Add enough water to achieve a heavy creamy consistency then strain the mixture through a 36 mesh sieve. (Ceramics supply store.) The addition af a small amount of sodium silicate — a teaspoon full — will make the slip easier to pour and reduce shrinkage. Store slip in a closed container — a wide-mouth plastic jar is ideal — and stir it thoroughly before use.

STORAGE OF CLAY

Clay should be stored in a closed container to prevent its drying out. *Damp boxes,* lined with galvanized metal, are available commercially but any of the following may be used: A large (5 to 10 gallon) stoneware crock or jar with lid; a plastic trash can with lid or a laundry tub of galvanized metal or plastic. If neither of these is available, use a heavy-duty plastic bag to hold the clay and set it inside a cardboard box to protect the bag from accidental tears. Close the top of the bag with a stout rubber band or plastic twist-tie. Wet cloths may be placed over the clay as additional insurance against drying.

The "right" consistency for clay is determined by the project at hand: for modeling and pottery making, the clay should be quite soft and pliable but not "gooey"; sculpture projects require a firmer clay

that will not collapse from its own weight. If the clay shows fine cracks it is either too dry or overworked. As work progresses, keep the plaster bat wet and, if the work must be put aside, wrap it in damp cloth and place it in a damp box or plastic bag.

WORKING HINTS

1. If cracks have developed in a still-wet piece, fill the crack with clay of the same consistency of the work in progress. Fill it from the bottom up or an air pocket, which is likely to explode during firing, will be formed.
2. If cracks have formed in a piece that is completely dry, fill the crack with heavily grogged slip that has been mixed with vinegar instead of water.
3. If a part has broken off a piece of work that is leather-hard, moisten the clay *slowly* with a damp sponge. Too-rapid moistening will cause extensive cracking. Score or scratch the broken area, add slip, then rebuild the missing part with soft clay.
4. Avoid thin, fragile or angular projections, sharp edges and corners. They may dry too rapidly and, consequently, crack off.
5. If it is necessary to add parts, scratch the surfaces to be joined, brush on a bit of slip and carefully weld the parts together.
6. Before drying sculpture, hollow out the center of the clay if it is thicker than 1½". A supporting wall ½" thick should be retained. Hollowing will allow the piece to dry more rapidly and will lessen the dangers of cracking.
7. To smooth the surfaces of a finished piece, sponge it lightly or burnish the surface with a metal pallet or improvised tool such as the bowl of a metal spoon.

BASIC TECHNIQUES

Push-and-pull modeling is the most elementary modeling technique and is recommended as an introductory activity at all grade levels. The emphasis should be placed on visualizing the object as a whole, without adding on parts. For best results, the clay should **be formed in the** *basic* **shape of the object to be** modeled: a sphere, a block, a cylinder or an egg-shape.

The object is then created by pushing in parts of the clay and pulling out others. In modeling human or animal forms, arms and legs should be made thick and sturdy and placed close to the body. Overall, the object should be fairly compact; a broad interpretation of the subject is more successful than tedious attention to insignificant details.

Clay of all types may be used in this method; thick pieces should be hollowed.

Pinch pots are enjoyed by all age groups; there is a kind of fascination in building a tiny pot, using only one's fingers as tools. Roll soft clay into a ball that can be held comfortably in one hand then, with the thumb of the other hand, push evenly and firmly into the center of the ball. The walls of the pot are formed gradually as the ball is turned in the hand. Work from the bottom up, pressing with the thumb on the inside and the fingers on the outside to shape walls that are uniform in thickness. Care should be taken at the point where the wall joins the base; it should not be too thin. In the average pot, the walls should be about ¼" thick. The base can be formed by tapping the bottom on a plaster bat where the pot should be placed for the finishing of the rim. Do not pinch the edge until it is dangerously thin; keep it rounded and uniform in thickness.

The finished pot should be basically round but, for variety, the edges may be turned inward or outward, or a tiny lip may be formed by pinching and pulling it outward. A number of small pots may be formed, then joined to create a nest of pots. If this procedure is followed, all of the pots must be kept soft for successful joining. Scratch surfaces to be joined, add slip, then weld the joints. If self-hardening or firing clays are used, small handles may be added.

Finishing may consist of a simple glaze, or a decorative texture may be incised or carved into the surface while it is still soft or even leather-hard.

Coil building is one of the oldest and most popular methods for building with clay. This simple technique may be used to build pots, bowls and hollow sculpture. Either self-hardening or firing clays may be used. Only one modeling tool is required.

The building of a cylindrical vase is recommended as a beginning project; this simple form allows concentration on the basic skills of forming and joining the coils. If a more complex shape is planned, make a full-size drawing of the pot and trace its profile on a piece of heavy cardboard. Use this cardboard profile as a *template*, or pattern, for checking the contour as the shape is built.

To make coils, roll a lump of soft, thoroughly wedged clay into a cylinder about five inches long and ¾" in diameter. (Work on a damp surface to avoid rapid drying of clay.) Working only with the *fingers*, continue to roll the cylinder, with light pressure until it is 10" to 12" in length. Keep the thickness uniform and the surface even. Cover the completed coil with a damp cloth and make additional in the number required.

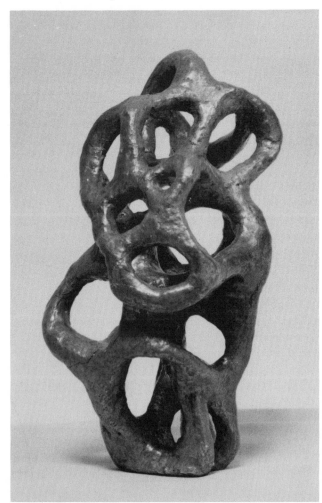

Coil Sculpture. Fort Lee, N. J. High School, Joan DiTieri, teacher. Coils may be used to build abstract sculpture. In this piece, Sculp-metal was applied over fired clay.

Make a *base* by patting a ball of clay into a slab about ½" thick. Use a pattern or compass to mark a circle on the clay, then cut it out with a knife. To begin building, scratch or roughen the *edge* of the base with a sharp tool then lay the first coil carefully along the edge. Weld the coil securely to the base on the inside and, where ends meet, cut them *diagonally*. (The diagonal cutting makes for a neater, cleaner joining of the ends without causing bumps in the wall of the cylinder.) It is essential that coils be welded together carefully as work progresses or the piece will crack: the coils may be welded together on the inside *and* the outside or, if the texture of the coils is to be retained, only the *inside* surfaces are welded and smoothed. Welding and smoothing the inside coils must be done as coils are added because it is difficult to get the hand inside a narrow pot *after* it is built to its full height.

If a *template* is used, check the contour of the piece after adding two or three coils. If walls appear to be sagging from the weight of the coils, set the piece aside to allow the clay to stiffen a bit before adding additional coils.

When the piece is completed, it may be finished in one of several ways: if the coils are not welded on the outside, simply glaze and fire. If the outside walls have been smoothed, they may be glazed or, before glazing, the surface may be textured by scratching, carving, slip trailing or by adding very thin coils to create a relief pattern. (The latter technique is called *sprigging*.)

Slab techniques make possible the building of a great variety of ceramic forms: tiles, plaques, vases, boxes, abstract sculptural forms, jewelry and slab animals and human figures. Self-hardening or firing clays can be used successfully in slab techniques.

The success of the slab technique depends greatly on the proper preparation of the slab itself. As in all instances, the clay should be thoroughly wedged and pliable. The work surface should be covered with a damp cloth because it is difficult to remove a wet slab from a smooth, dry surface without tearing or stretching the clay. Burlap or canvas may be used to cover the work surface and add their own interesting textures to the back of the clay slab.

Slabs may be formed in several ways: simply pound a lump of clay into the desired thickness and

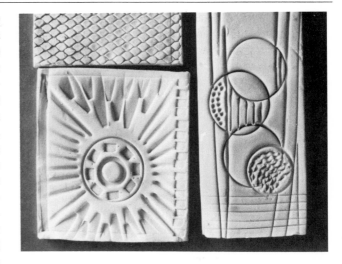

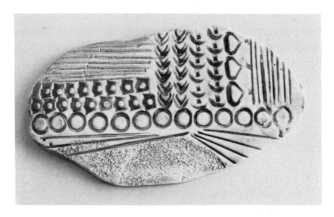

Textured Slabs. Helen Speck. Found objects were used to create a variety of textures: scissors, wire mesh and metal tubing were some of the tools used. Slabs such as these may be used as tiles, or in designing ceramic wall panels, pots and weed plaques.

then cut it to the desired shape. This method is satisfactory when only one slab is needed and when a smoothly sliced surface is neither required nor desired. Another simple method is to pound the clay into a shallow box lid of the required size. The most popular method, however, is rolling. Place the clay on a damp cloth between two sticks of the same thickness. With the sticks as guides, the clay is rolled with a rolling pin (wood dowel, broom handle). This method assures a smooth surface and the uniform thickness essential for many projects. The "proper" thickness depends on the project: ashtrays, bowls and

dishes should be approximately ⅜", depending on size; for jewelry, small animals and figures, ¼" thick; wall plaques and medium-to-large slab sculpture, ⅜" to ½" thick.

Free-form shapes may be cut directly into the clay but paper patterns should be cut for pieces requiring more exact fitting and joining, such as boxes or vases. Experiment with paper sculpture techniques in planning *slab animals* or *figures*.

When the shapes have been cut from the slab, set them aside and allow them to stiffen somewhat before attempting to join them; a too-soft slab will collapse. If textures are to be *impressed* on the slab, however, the texturing must be done while the clay is still soft: a leather-hard surface may be *scratched* or *carved*.

To join slabs to each other or to a base, scratch the surfaces to be joined, moisten them with water or slip, then press them firmly together. To reinforce inside seams: roll thin coils of clay, place them along the seams and weld them with the fingers or a tool.

Figures, animals and sculptural pieces made of joined slabs may need to be supported until the clay stiffens. Cut supports from corrugated or other strong board and use them as props.

Draping Slabs. Slabs can be draped over forms of plaster, pottery, plastic, bisque-fired pottery, cardboard or other "found" shapes that have first been covered with a damp cloth. When the clay has stiffened enough to hold its shape, remove it from the form and trim the edges where needed. If the surface is to be treated by cutting, carving or adding relief decoration, this must be done while the clay is still wet. In making bowls or trays by this method, add a base while the clay is still draped over the form and while it is still wet. The base can be made level by sanding it after the piece has dried completely.

Cylindrical forms may be made by draping the clay (¼" to ⅜" thick) around cardboard tubes (mailing tubes, cardboard cores from tissue rolls, oatmeal boxes). First, cover the cardboard forms with plastic wrap or waxed paper for easy removal of the clay, then roll the clay around the form; the clay should not be stretched. Weld and smooth the seam. Set the forms aside until the clay has stiffened enough to hold its shape, then *very carefully* pull out the cardboard form. These clay cylinders may be used in

several ways: add a bottom to a single cylinder to make a simple vase; weld cylinders of various diameters and heights together to make a weed bottle or vase; use the cylinders as parts of an animal or figure. Slice the cylinders horizontally and weld the resulting "rings" to a slab wall plaque. Experiment!

Sandbag armatures are easy to make and provide a quick interesting method for making hollow forms. To make a pot, fill a plastic bag with sand and tie it at the top; leave about 3" of the bag *above* the tie. Drape a slab, approximately ⅜" thick, around the bag, leaving the tied top *above* the clay. Add a piece to form a bottom or, if the pot is to be small, simply set the sand-filled bag on the slab and pull the slab up around it. Press the clay around the bag, patting or beating it with a stick to shape and texture it; be sure that the base is **securely welded. Impress** textures, if desired. **Set the clay-covered bag aside** until the clay has stiffened enough to hold its shape, then untie the bag and pour out the sand. Gently remove the plastic bag. Add a top, lip, rim, base or feet as needed to complete the design.

Consider using these hollow forms as bases for creating amusing figures or animals; apply coils and cut out shapes to create detail. Long, narrow bags make long, narrow shapes; larger, wider bags make large, wide forms. Experiment with bags of different sizes. In this same method, drape the clay over *paper bags* stuffed with shredded or crushed newspapers.

Hammock molds are used to shape clay slabs that are to be made into platters, plates or curved shapes for sculpture. The materials required are a cardboard box, thumb tacks and a piece of cloth soft enough to drape easily and cut slightly larger than the top of the box. The procedure described below is for making a platter.

The method is quite simple. Spread the cloth on the work surface, taping or tacking the corners to prevent slipping and wrinkling. From thoroughly wedged clay, roll out a slab about ¼" thick (larger platters should be slightly thicker). Cut the clay into the desired shape and remove the cut-away scraps. Lift the cloth — a helper is needed — and lower it into the box. Secure the cloth in a "hammock" position by tacking it on the outside of the box. A taut, high cloth will make a shallow platter; a low-slung cloth produces a deeper platter.

Allow the clay to damp-dry *slowly* to avoid warp-

(a)

(c)

Slab Built Pots. Fort Lee, N. J. Senior High School, Joan DiTieri, teacher. Three quite different applications of the slab technique. A shape such as (a) can be built by draping a slab around a sand-filled bag. The thin, flattened shape of (b) can be designed by forming an "envelope" of clay around a core of newspaper; necks and lips are made of tubes of clay which are welded to the body. (c) For this kind of design, the clay slabs must be stiff enough to hold their shape. Wadded newspaper may provide a temporary support as the pot dries. In all examples shown, the surface treatments of the clay are related to the overall shapes and serve to enhance the total design.

(b)

ing and cracking. When the clay is stiff enough to hold its shape, remove it from the cloth. Sponge the edges smooth. Feet or a base may be added at this point. Decorate, as desired, by texturing, burnishing, incising, etc. Glaze and fire in the usual manner.

Jewelry. Cut shapes from a slab about ¼″ thick; shapes thicker than ¼″ are apt to appear heavy or awkward. Make a neat hole for the insertion of a jump ring or cord in a piece to be used as a pendant; holes in beads should be made slightly larger than the cord to be used to string them since the clay will shrink somewhat as it dries. Thin shapes for jewelry must be dried with extreme care to avoid warping and cracking: place them on a damp bat and cover them with a damp cloth for a day for even, gradual

Pendants. Sherry Charles. An inventive approach to ceramic jewelry. Flattened pats of clay are textured with found objects and stamps from an old printing set. Photo, courtesy Ramona Solberg.

drying. Do *not* dry them on a non-porous surface; the top will dry more rapidly than the bottom, causing the piece to warp or crack. (*Tiles* should be dried in the same manner.)

Other Uses for Slabs. Make mosaic tiles from a ¼″ thick slab: cut free-form tiles as well as the conventional square or rectangular tiles. Design special shapes or "accent-pieces" for use on a ceramic panel. Experiment with textures and glazes. Make ceramic weed plaques from free-form textured slabs. Make holes, or slots, to hold weeds and grasses by pushing a pencil or sharpened dowel into the clay. Or make holes in a separate, narrow slab and weld it to the plaque. Matt-finish, earth-colored glazes are recommended for weed pots; a highly colored gloss glaze overpowers the dried grasses and weeds.

Fire left-over scraps of slabs to make a clay "collage". Cement the fired "left-overs" to a wood panel.

Simple Mold Techniques
The following techniques involve the use of simple, one-piece molds. (For more advanced techniques, consult references listed in the Bibliography.) Although simple to make, the following molds for casting and pressing clay may be used to design jewelry, tiles, pottery, bowls, figures and animal shapes.

Slip casting
The following procedures describe how to make a one-piece casting mold quickly and economically.
1. Build a positive model and tape it down with gummed tape to the bottom of a cardboard box. Coat the model with Vaseline or cooking oil.
2. Mix enough plaster to cover, with three or more inches over the model.
3. Take the plaster mold out when hardened and dry. Use it as casting mold.
4. To cast a ceramic piece:
 a. Prepare a liquid mixture of clay, or slip, in a uniform thickness, similar to thick milk shake.
 b. Fill the casting mold with the slip, then shake it lightly to help the air bubbles escape to the surface. Wait a few minutes, then pour the slip out into another bowl; wait about ten minutes before repeating the process.
 c. Repeat the previous process about six times, with ten-minute intervals, until desired thickness is reached.

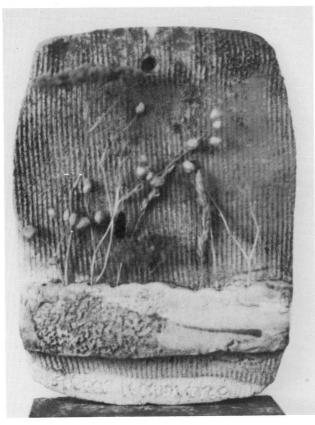

Weed Plaque. The weeds are held in holes in the clay strip which has been welded to the larger slab. The larger slab has a combed texture; matt glazes in subdued earthy tones complete the decorative details.

 d. After the last pouring, wait until leather-hard, then carefully remove the mold.

 e. A new form or design can be arranged at this time by cutting the edge or by twisting and pulling to create a new form or shape.

Note: (1) Large, thick plaster molds should be built up in layers and should be allowed to dry for approximately one week before use. (2) Avoid *under-cuts* that prevent easy removal of the clay from the mold.

Press molds

Press molds are generally used to make small forms such as jewelry or small tiles. The process for making a press mold is essentially the same as described for slip casting; it is usually done on a smaller scale, however, and thick molds are not necessary. To make a press mold for jewelry and tiles:

1. Make a *positive* model from non-hardening clay or wax and place it in the bottom of a small box about 2″ high. Allow 1″ on all sides of the model. (Avoid undercuts).
2. Mix plaster to a creamy consistency and pour it about 1″ thick — or 1″ from the top of the box.
3. When the plaster has hardened, tear away the box and remove the clay. Non-hardening clay (or wax) is easy to remove. The mold is now ready for use.

Whether making jewelry or tiles, the procedure is the same: press thoroughly wedged clay firmly into the mold until the clay stands slightly above the mold. Scrape the clay to an even surface with the metal edge of a ruler or similar tool. If making jewelry, impress the finding (pin back, clip, ear screw) on the back of the clay before removing it from the mold: this impression makes for a neater attachment of the finding with cement or glue after the piece has been fired.

Permit the clay to set for about 15 minutes then tap the mold to release it. If it does not fall out readily, press a piece of fresh clay against it and pull.

Dry the clay shape slowly, then glaze and fire.

Note: A press mold may be made by carving a design into a pre-cast plaster slab. Cast small slabs in box lids, waxed paper cups and waxed food containers. Remember: you are making a *negative* pattern.

Sandcasting

This mold technique is closely related to those described in *Plaster*. (See Chapter 5.) It is a press mold used to create *one-half* of a hollow form which may be joined with another half to create a pot, or perhaps a hollow-figure. Sandcasting is fun at the beach but, of course, may be done inside. The only materials required other than ceramic materials are sand and plaster. Use beach sand or coarse builders' sand from the hardware store. To make a pot by this method:

1. Build up a positive model with wet sand, remembering that the model is half of the pot to be made. *Keep the sand wet to avoid crumbling.*
2. Smooth and flatten the sand around the base of the model.

3. Pour a thin layer of creamy plaster over the model. Do not "dump" it on one area; pour it carefully to avoid disturbing the contours of the sand.

4. Permit first layer of plaster to set briefly, then pour additional layers until the plaster shell is two or three inches thick. When it is *hard*, remove the plaster mold and allow it to dry for several days.

5. Press well-wedged clay into the mold until a uniform thickness of approximately ½" is reached.

6. After the clay has dried in the mold for about 30 minutes, remove it and set it aside to stiffen.

7. Repeat the entire process to form the second half of the pot.

8. Join the halves by scratching the edges, wetting them with slip and pressing them together firmly. Smooth or weld the seam with a tool. Hold the two sides together firmly until the slip starts to dry.

9. Add a base, if desired, or a top. Make these from thick coils of clay and weld them to the body.

10. Permit pot to dry slowly then glaze and fire as desired.

Note: This technique may be used to design a hanging garden lantern, planter, candle holder, bird bath, or the basic form for sculpture.

DRYING CLAY OBJECTS

A common cause for cracking or warping in clay is improper drying. Some general guidelines should be followed.

1. *Water must not evaporate from the surface of the object faster than it can be replaced from the interior.* Slow the drying rate to prevent the surface from cracking.

2. Fine grained clays — especially the "jewelry clays" — must be dried slowly; coarse grained clays can be dried more rapidly. For example, grogged clay has less clay particles and, consequently, shrinks less.

3. Slabs placed on a marble or metal surface will not dry at a uniform rate since moisture will evaporate more rapidly from the exposed top, causing warpage. Dry on a porous surface and turn frequently.

4. Ensure equal distribution of water in the clay and, consequently, more uniform drying by thoroughly wedging clay before use.

SURFACE TREATMENTS

After a clay object has been formed, there are two basic ways of decorating it: the surface of the clay can be textured or it may be glazed. The techniques may be combined, of course, or either may be used to treat only *parts* of the object.

Texturing is used to provide variety on the surface of the clay and may be achieved by stamping or impressing, carving, scratching, burnishing or beating. *Relief* surfaces may be created by adding coils, slabs, impressed shapes or bits of clay.

Clay Stamps Stamps for texturing soft clay may be made from wood, plaster, clay or found materials. In a very simple method, plaster is poured in an improvised mold and allowed to set. (A waxed paper cup makes a good mold.) As soon as the plaster has set but before it has completely hardened, the cup is peeled away. The design or motif is carved into the bottom of the plaster with a sharp tool. Have a slab of clay nearby so that the stamp can be tested as the cutting proceeds. After the plaster has hardened, it can be sealed with thinned white glue, P.V.A. or shellac. For a more permanent, long-lasting stamp, make the design in clay and fire in the usual manner.

Other stamps may be made by glueing found objects to spools; the spool makes a comfortable handle.

In *sgraffito*, a sharp tool is used to scratch into a dried glaze to reveal the clay body or a previously applied glaze. Use "found" materials such as nails, screws, clay stamps, sticks, kitchen gadgets, pencils, dowels to add textures and to create patterns on soft or leather-hard clay. Scratching or carving may be done on leather-hard clay; to take impressions or stamps, the clay must be softer. *Remember: the texture should enhance the basic form, not dominate it.*

Slip trailing is achieved by filling a syringe or dispenser bottle with clay slip and literally trailing it over the surface of leather-hard clay. The clay must not be too dry or the slip will crack off as it dries. Colors may be added to slip.

(a)

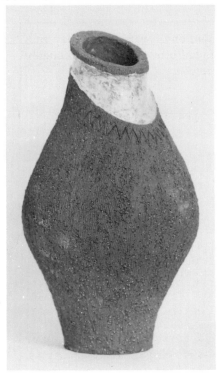

(b)

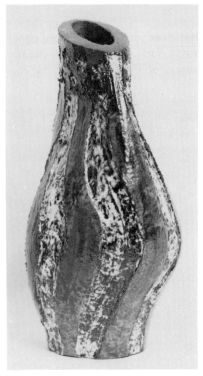

(c)

Surface Treatments and Glazes. Fort Lee, N. J. Senior High School. The pots shown here illustrate a variety of forms and a careful consideration of surface treatments. Note that although (a) and (b) are similar in shape, each pot reflects a different character because of the varying glaze treatments. In (c), the characteristics of clay are exploited in the rough texture. Glazes applied to (d) follow the contours created by the "folded" top of the pot. The deeply incised designs of (e) require no further treatment. Photos, courtesy Joan DiTieri, teacher.

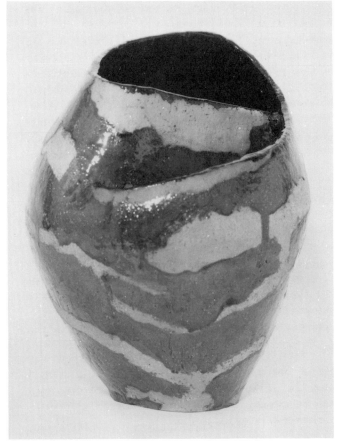

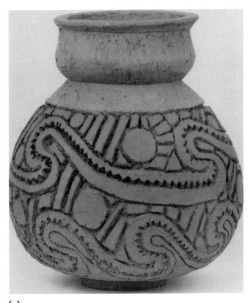

(d)

(e)

127

Wax-resist decoration is quite effective and the method is simple. Melted wax (paraffin, candle wax) is brushed on dry clay or bisque ware to create a design or texture. When glaze is applied, it will run off the waxed areas, permitting the color of the clay body to show through. Or, a piece may be covered completely with glaze, then "decorated" with wax. The piece is then given a second coat of glaze of another color. The wax burns away in firing, revealing the color of the glaze first applied.

GLAZING

Generally, clay objects are bisque-fired before glazes are applied. The bisque-firing makes the clay harder and, therefore, less fragile but leaves it porous enough to accept or absorb the glaze.

Glazes are available in great variety: clear, opaque and textured in matt or gloss finishes.

The kinds of glazes used will depend on the type of clay to be fired. It is recommended that clay and glazes be purchased from the same source, whenever possible. Glaze and clay should have the same firing temperature — they should "fit." Otherwise, the glaze may peel off or crack during firing. The glaze, however, can be fired in lower temperatures than the clay body.

There are four basic methods of applying glazes: *brushing, pouring, dipping and spraying.*

Brushing is the method most widely used in the classroom since it does not require large amounts of glaze. Use a soft, wide brush to apply several coats of glaze, each in a different direction, for even coverage. *The thickness of the glaze should be that of thin cardboard.* Glaze the inside of the object first, then work on the outside.

Pouring is the technique used when a pot is too large to dip or when there is not sufficient glaze for dipping. Glaze is poured into the pot which is then twirled until the interior is properly coated. The excess glaze is poured out into a container and then used to pour over the outside.

Dipping requires a large amount of glaze — more than is normally available in the classroom or home studio. The clay pot or object is literally dipped and turned until the total surface is covered. If small areas are "missed," they may be glazed with the brush.

Spraying gives an even coating but has some disadvantages: it wastes large amounts of glaze and must be done in a spray booth equipped with an exhaust fan (or out of doors), since many glaze materials are toxic.

Regardless of the glaze or technique used, remember: the *outside bottom, or base, of a ceramic object should not be glazed because glaze surfaces stick to kiln shelves.* Clean the bottom of the piece thoroughly before firing or coat it with melted wax *before* glazing. The wax will burn off during the firing process.

FIRING

Firing is necessary to transform clay from a plastic to a hard, durable state. During the firing process, the clay is exposed to prolonged intense heat which changes the nature of the clay body, making it stonelike.

Kilns for firing may be heated by gas, oil, wood or electricity but the type of kiln most commonly used in the classroom is the electric kiln which is compact and simple to operate. The purchaser has the choice of either a front- or top-loading kiln; other options include a pyrometer (temperature gauge) and an automatic cut-off device.

Pyrometric cones are used in determining when the temperature in the kiln has reached a certain point. The cones are available in two sizes: small and large. The small cone is used in the automatic cut-off device; the large cone is used when the kiln is cut off manually. Cones are numbered, the number indicating the temperature at which that particular cone will melt. For example, an 09 cone will melt at 1751°F., an 06 cone at 1873°F. (Small cones, Orton scale.)

If the automatic cut-off device is used, it must be set before the kiln is loaded; follow the manufacturer's directions for setting the device. When the automatic cut-off is *not* used, push the base of the large cone into a pat of wet clay and place it on a kiln shelf so that it can be seen through the peephole. Check the position of the cone with a flashlight.

Glaze Firing

After the ware has been bisque-fired, brush it with a soft brush to remove clay dust or loose bits of clay.

Apply glazes, as required, taking care to see that the footing or base of the piece is free of glaze which would cause the piece to stick to the kiln shelf. Permit to dry completely.

Load the kiln, allowing adequate clearance between the *individual* pieces, and between the pieces and the walls and heating elements of the kiln. Start the firing at low temperature, with the kiln lid propped open for approximately one hour. When the heat from the kiln is no longer moist, close the lid and turn to high temperature.

After the cone bends, cut off the heat and allow the kiln to cool sufficiently for safe removal of the fired pieces.

EGYPTIAN PASTE

Egyptian paste takes its name from the fact that it was used by the Egyptians prior to 4000 B.C. The beads, scarabs, tiles and tomb sculptures which have been excavated from Egyptian tombs and exhibited in our museums, were probably made from this ceramic clay body.

Egyptian paste is unique in that it is neither a clay nor a glaze, but a combination of the two. The ingredients are inexpensive and easy to obtain. It is completed in one firing. Formulae vary; some pastes fire to a matt finish, others to a high gloss.

The following is an easy-to-mix formula that will provide enough paste for beads and several sets of earrings. This particular paste produces a matt finish.

Silica	4 tablespoons
Bentonite	4 teaspoons
Soda Bicarbonate	2 teaspoons
Copper Carbonate	½ teaspoon

All measurements are level. Combine the ingredients and sift them together or put them through an 80-mesh screen. Add enough water to form a thick paste. The paste will thicken rather quickly but can be restored to a working consistency by the addition of a few drops of water.

Uses: Egyptian paste is limited in plasticity and, therefore, cannot be cast or thrown on the wheel. It

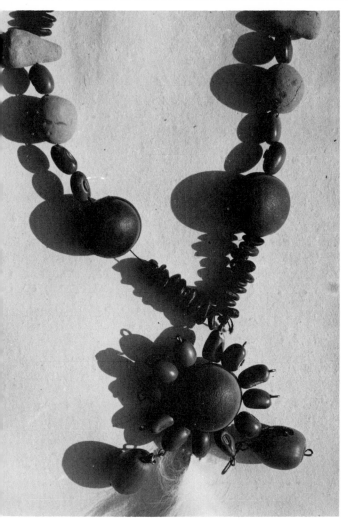

Necklace. Senior high school student, El Camino Real High School, Woodland Hills, Ca. Mud beads with found objects. The "mud" is any type of garden earth, sifted, formed with water and baked in an oven, from 350° — 500°. This assignment is a "beginning" project. Photo, courtesy Caroline Tupper, teacher.

Bisque Firing

To bisque fire, dry the ware slowly and stack it in the kiln. Pieces may touch or rest on each other in this stage since they are unglazed. Do not, however, place heavy pieces on top of lighter-weight pieces. Start with a low-firing temperature for one to two hours, with kiln lid open, then close the lid and turn to *high* temperature. Bisque ware should be fired to approximately 1750°F., or cone 09.

is best used for jewelry, buttons, tiles, knobs, handles, ornaments or small bits of abstract sculpture.

Color: The traditional color of Egyptian paste is turquoise. The above formula results in a light, delicate blue. If the copper carbonate is omitted, the paste will be an off-white. A teaspoon of Naples yellow added to the white will result in a light yellow. Purple tones may be obtained by adding ¼ to ½ teaspoon of manganese dioxide. Regular glaze colors may be substituted. Experimentation may be done to obtain other colors.

Firing: The firing range is wide and results vary. Cone 08 to 05 or 04 may be used; 06 cone is generally recommended. Beware of overfiring! Thin pieces tend to warp at higher firings. Pastes producing a matt finish may touch each other during firing; gloss pastes will stick together and pieces should not touch.

Handling: Mixing is best done on a clean sheet of glass or plastic. (Porous materials tend to extract some of the color.) A spatula or flexible knife blade makes an excellent tool for blending the dry ingredients with the water. Place moist paste in an air-tight, plastic bag 24 hours before using.

Simple plaster press molds made in small pans or lids may be made for shaping. As soon as the paste begins to pull away from the walls of the mold, invert it and gently remove the casting to a flat surface. If the paste is left too long in the mold, some of the color will be extracted. Since the paste is rather fragile at this point, further trimming or shaping should not be attempted. Once the paste has completely dried, small fragments can be smoothed. Do not sponge pieces before firing.

The paste may be pressed into a small slab or cake and shapes cut from it. Simple designs may be added with a modeling tool or stick. Permit to dry slowly and completely for best results. Cover with damp cloth to slow drying.

Beads of the gloss-type paste may be shaped and fired on a nichrome wire which has been cut into short lengths. These wires may be arranged "clothesline" fashion on firebrick or placed in the holes of setter posts. The wire will support the beads during the firing process and will prevent their sticking together. Or, fire beads on a shelf which has been coated with kiln wash.

Egyptian paste, in a variety of colors, may be obtained premixed in a dry form, from commercial sources.

Chapter 9
Wood

Wood as a medium for creative expression retains its centuries-old appeal for the craftsman and artist that newer more modern materials neither duplicate nor replace. The newer, man-made materials such as plastics are, in many instances, more durable, more easily worked and more predictable, but wood maintains its old appeal for the artist. The irregularities of grain, texture and color that mark wood as a once-living material invite touching and handling; the warmth of wood surfaces cannot be duplicated in the chemist's laboratory.

Wood is a responsive material that lends itself to the needs of the classroom: even the youngest student can be involved in constructing a wooden "design," using only hammer and nails. Depending on interests and manipulative skills, older students may be introduced to *incising, carving* and *assembling* and to the myriad possibilities for designing with wood.

TYPES OF WOOD

There are hundreds of different varieties of wood, each with its own unique characteristics of weight, grain and color; a complete description of any of these is not within the scope of this discussion which is concerned, primarily, with projects and techniques that are possible with woods generally available in the classroom. Because they are easy to work and comparatively inexpensive, the woods most appropriate for student work are the *soft woods* such as balsa, basswood, soft pine, yellow poplar and soft maple. *Plywood*, made up of layers, is useful for many projects and is available in fir and a variety of other woods. These, along with scrap wood, provide variety and challenge in student projects. Other types of wood are available, of course, and should be considered for special uses when they are obtainable or affordable: hard maple is good for turning; cypress, cedar and redwood are good for outdoor projects; cherry, mahogany and walnut are very beautiful — and very expensive.

SOURCES

Woods can always be purchased, of course, but their costs often exceed the limits of school budgets. Except for balsa, basswood and dowels, woods used in the

art classroom are most often obtained as scraps, discards or donations. Home and school workshops provide odds and ends of boards, laths, moulding and plywoods. Other sources in the community may include a cabinet maker's shop, lumber yards, building sites, toy manufacturers, furniture manufacturers — in short, any place where wood is sold or used extensively. Scraps may be obtained at little or no cost: cabinet doors, toy parts, turned wood (spindles, chair legs, lamp bases) and wood handles may be bought as "seconds" whose tiny flaws are unnoticeable — or even attractive — in a wood assemblage or fanciful wood sculpture.

The weathered textures of driftwood, bark and "beach wood" exhibit textures that defy duplication by hand or tool: look for wrecked lobster pots, wood floats and the scorched wood from beach fires. Set these aside to dry in the sun, remove sand, debris or ash with a wire brush — then apply imagination and ingenuity!

"Ready-mades" in wood may include wooden spoons, bowls, boxes, spools, discarded toys and furniture, picture frames, knobs, handles and paint stirring sticks from the paint store or hardware store. These may be painted, carved, cut and assembled to create panels, totems, figures, animals, assemblages, jewelry — the possibilities are limited only by the imagination of the artist.

Trees that are being trimmed or removed may provide wood for a variety of projects: branches can be used as "looms" for weaving or supports for wall-hangings; sections of the trunk may be carved or cut into parts which may be re-assembled. These unseasoned woods will crack or "check," in time, but these characteristics are not a vital concern, particularly for the beginner. If logs are collected well in advance of use, however, seal the ends with shellac and set the wood aside. Do *not* remove the bark; the bark will prevent the rapid drying that takes place once the wood has been brought inside.

TOOLS AND MATERIALS

The number and variety of tools required for working with wood depend, of course, on the project at hand. Many special wood tools that make work easier, or more "finished" in appearance, are available and may be purchased if funds permit, but the tools *essential* for classroom projects are few and readily available.

Cutting tools should include two kinds of saws: a carpenter's *handsaw* for general use in cutting boards and thicker woods and a narrow-bladed saw, such as a keyhole saw, for shaping contours and making *interior* cuts. To make interior cuts: a hole is first bored into the wood, then the narrow tip of the keyhole saw is inserted in the hole and sawing is completed. A coping saw is useful for sawing and notching thin sheets of wood.

Shaping tools are used to define contours and to texture the wood. *Knives* and *chisels* are the most versatile and basic tools. Knives may include pen knives, utility knives, craft knives — almost any type available can be used. Chisels are available with narrow or wide blades and both types should be provided. The chisel should be held at an *angle* as it is struck with the mallet, to avoid splitting the wood. Both cutting and chiseling should be done gradually, to remove chips rather than chunks of wood.

Files, rasps and *rifflers* are used to shape wood by abrasion. Files may be convex, flat or round and produce cuts that are fine or coarse. Files are used to shape larger masses, as in sculpture; finer detailing is achieved with rasps and rifflers. The latter is especially useful in shaping delicate contours and in working in cavities or depressions. Files are used first, then the finer rasps and rifflers.

Incising may be accomplished with *gouges* of the type used for printmaking; special *wood gouges* are available for shaping masses. If gouges are not available, nails, screws or other found tools may be used to incise lines and textures.

Hammers and mallets for nailing and pounding are essential.

C-Clamps are useful for holding together pieces of wood that are being glued and for securing wood to a work surface while it is being gouged, textured, or otherwise treated.

A carpenter's vise, with wood jaws, will hold wood securely without marring it. Pad the jaws of a metal

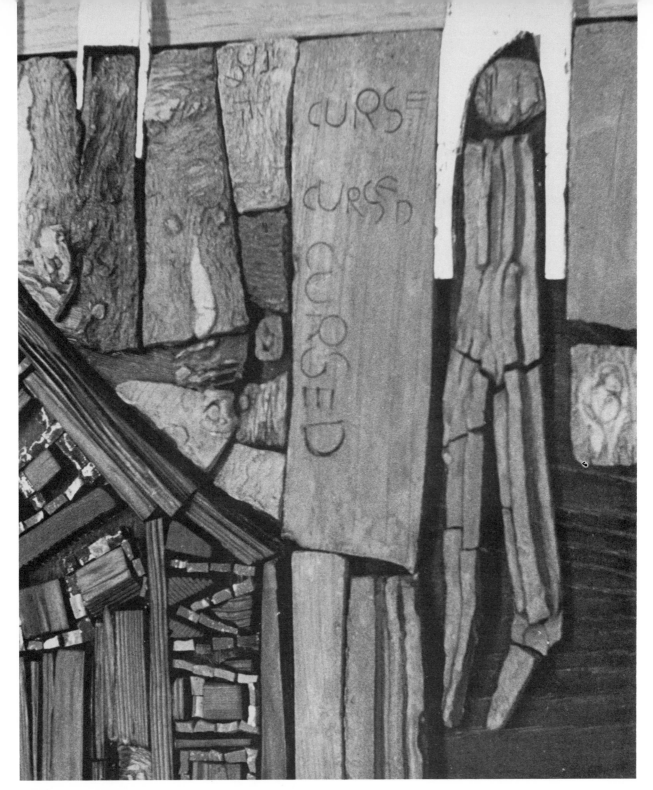

Wood Mosaic (Detail) Reinhold P. Marxhausen. Note the
variety of woods used, some of which retain their bark.
Words are formed from glass mosaic tesserae; spaces
around the letters are filled with small pieces of wood.
Photo, courtesy the artist.

vise to avoid marking the wood if a carpenter's vise is not available.

Smoothing tools and materials should include metal scrapers (which may be improvised), and coarse and fine sandpapers. The *scraper* is used by holding it at right angles to the wood surface, then pulling it firmly. Coarse sandpaper is used before fine. To achieve an extra fine finish: sand with fine sandpaper, sponge the surface lightly with water, then finish with *aluminum oxide paper. Always sand with the grain of the wood.*

Brushes are needed for applying stains, paints and other finishes. Provide a variety of types and sizes.

Joining materials include *nails, screws, corrugated metal fasteners* and *glues.* Quick-drying transparent cements are recommended for balsa projects. Synthetic resin adhesives are the most widely used, but special types of adhesives may be required if a nonporous material such as metal or glass is joined to wood; in the latter instance, two-part epoxy cements are the most reliable.

FINISHES

Wood may be unfinished except for the application of a *sealer* to protect it from soil and atmospheric conditions which would cause changes in color or deterioration of the wood itself. This simple procedure is recommended for special types of wood, such as redwood or driftwood, where the addition of color or gloss would detract from the natural beauty and color of the natural wood surface.

From Schoodic Point. 33" x 18", by the author. Driftwood, on a plywood base. The only finish used was thinned acrylic medium to seal the surface of the wood. Thin stains of acrylic colors or oil colors could be used if additional colors are desired.

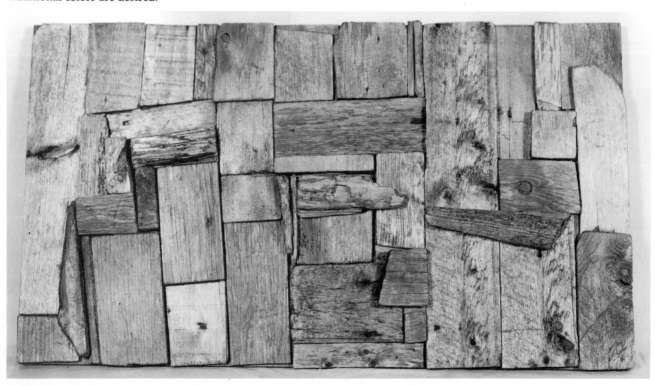

Polyurethane finishes provide an especially durable finish that resists stains and wear. *Varnishes* and *shellacs* are also used to seal surfaces. Surfaces to be shellacked or varnished should be clean and dust-free. These finishes may be brushed or sprayed.

If a white base coat is desired, coat the wood with *gesso*. Apply at least three thin coats and permit the wood to dry thoroughly before applying colors.

Coloring may be added by applying stains, enamels, acrylic polymer paints, artists' oil colors, combination wax-stains, spray paints in flat, gloss or metallic finishes, wax crayons, oil pastels, dyes, inks and "household" paints. (Even shoe polishes may be used.) The wood may be "antiqued" by applying a base coat of color then, after it has dried, dry-brushing or daubing on a stain made from thinned burnt umber. The stain is applied overall and then wiped to produce the "antiqued" effect.

Waxes may be applied to raw wood or used over a stain or other color. *Paste wax* or a clear, liquid *floor wax* may be used; the former produces the finer finish but requires considerable buffing for best results.

Oils may be used to emphasize or enhance the grain of wood and to preserve it.

Notes on Finishing:

1. Paints cover and obscure the natural beauty of wood: use only for decorative purposes, to finish unattractive scrap wood or to unify a design made up of odds and ends of wood that are not harmonious in color, texture and grain.
2. Before applying a stain, prime the wood with equal parts of raw linseed oil and turpentine.
3. If flat wood pieces such as planks or panels are to be coated with shellac, paint, gesso or other finishes, coat *all* surfaces, including front, back and edges of the wood. This procedure will lessen the possibility of warpage.
4. *Stains* do not wear well: for greater durability, seal with shellac, varnish, polyurethane finish or wax with liquid or paste wax.
5. Inks and dyes will run, or "bleed," on wood and their colors tend to fade. For best results, first seal the wood before applying inks or dyes; to pre-

serve colors, coat with a clear-drying sealer or liquid floor wax. (Felt marking pens work well.)
6. For best results, apply *wax* or *oil crayons* over wood that has been waxed or gessoed: if the color and grain of the wood are to be preserved, use wax; if the color and grain are to be covered, use gesso. Finish crayoned surfaces by rubbing or buffing with a soft cloth and seal with liquid floor wax for greater durability. Oil crayons or oil pastels may be blended by rubbing or by going over colors with a brush that has been dipped in turpentine.

Decoupage

In decoupage, decorative papers or cut-out paper shapes are adhered to the wood surface. Traditional techniques involve the application of numerous layers of varnish and much sanding to produce a durable glossy surface. The discovery of new adhesives and finishes has provided many short-cuts and laborious, time-consuming procedures are no longer necessary. *Arcylic polymer medium* is especially recommended for decoupage techniques since it adheres, seals and produces a deep glass-like finish that is tough and durable. P.V.A. (polyvinyl acetate emulsion) or a thinned white glue may be used but results are not as effective as those produced with acrylic medium. Mediums designed especially for decoupage are available from general art and crafts supply houses.

Papers commonly used include patterned gift-wrap papers, wallpaper, tea papers, marbled papers and shapes or figures cut from a variety of sources including colored advertisements, greeting cards, playing cards, paper lace, old magazines, calendars, stamps and decorative paper seals.

The entire surface of the wood may be covered with paper — particularly if the wood is unattractive — or a single paper shape or figure may be applied over a painted, stained or sealed surface where it serves as the central theme or accent. In either case, the procedure is essentially the same: apply the medium and, while it is freshly wet, position the paper carefully and press it firmly onto the surface. If a large sheet of paper is to be applied, smooth the paper over the medium by rolling it with a clean, dry brayer. Roll from the center, outwards, to avoid air bubbles. Permit the medium to dry, then brush on a thin second coating. Three to five coats

should be applied, depending on the depth and gloss required.

Burning

Burning, or charring, softens raw edges of wood and emphasizes the grain. Contemporary artist Robert Pierron uses this technique extensively and effectively in wood panels, sculptures and assemblages.

The technique is fairly simple and effects vary with the degree of charring and the type of wood used: the wood is charred with a propane torch and, when the degree of charring desired is accomplished, the wood is doused with water. The charred surface is then brushed with a stiff wire brush until all loose particles of ash are removed and the clean, unscorched wood is exposed. The grain of the wood will be emphasized by the darkening produced by the burning. The wood may then be sealed, waxed or treated with thin stains of oil or acrylic colors.

This technique is especially effective on plywood panels which have been designed in relief. Wood shapes may be pre-cut then charred and assembled in various ways: mount them on a panel which has been stained or painted in a contrasting color or suspend them on a nylon cord or chain. The possibilities are endless: char a wood mask, wood sculpture, or pieces to be used in wood jewelry. A thin stain, wax or sealer is sufficient; opaque finishes which would obscure the wood grain should be avoided. WHEN CHARRING WOOD, ALWAYS WORK OUT-DOORS; KEEP BUCKETS OF WATER HANDY.

TECHNIQUES

Wood lends itself to a variety of techniques and processes including printmaking, sculpture, construction, painting, crafts and the designing of objects or "things" that defy precise definition. The wood itself may suggest a use: a knotty, paint-stained scrap from a garage workshop can be used to make a handsome print; an ample supply of fine woods may suggest an in-the-round carving; a discarded wood handle can be transformed into an elegant wood pendant. The design or use should be suited to the characteristics of the wood at hand.

The techniques and projects suggested here are geared to the types of wood commonly available in the classroom or home workshop: plank-grained boards and scrap or "found" woods.

Prints

1. *Scrap prints.* Collect a variety of scrap: woodshop scraps, bark, short lengths of boards or beech wood. Clean the wood to remove dust, loose particles or other foreign matter that might interfere with the application of ink or successful printing. Apply ink with a brayer if the wood is relatively smooth; if the wood is rough (bark, weathered boards) apply ink with a brush or dauber. Print by placing the paper over the inked surface and burnishing it with a baren or the bowl of a metal or wooden spoon. Very small pieces of wood may be printed by stamping. Do *not* apply pressure by standing on the wood: bark and weathered boards are apt to split. Oil base inks work best; if water base inks or tempera paints are used, add a bit of glycerin to retard their drying.

 Experiment by using two colors, by overlapping the image and by printing on a variety of papers (kraft paper, wallpaper, classified sections of newspaper). Prints may be made on tissue paper if pressure is applied with a brayer or by stamping; tissue is apt to tear if burnished.

2. *Woodcuts.* Use a length of board or a discarded cabinet door; soft to medium-hard woods are most appropriate, particularly for beginners. Wood that is warped will not print successfully but slight warpage can be cured by wetting the wood and placing it under a heavy weight until the warp disappears.

 Develop the design, using a brush or felt-tip marker to achieve the strong, bold characteristics desirable in a woodcut. Transfer the design to the block with a felt-tip marker and blacken those areas that are to be printed — the *positive* areas. This procedure lessens the dangers of cutting away the wrong areas as work progresses.

 To cut the block, use *knives, gouges* and *linoleum cutting tools.* Other cutting and texturing tools may include a *flexible shaft drill, nails, screws* and other *"found"* tools: to produce a variety of textures place nails, screws or metal screen on the surface of the block and pound with a hammer. Cut *with* the grain of the wood to avoid splintering and crushing; in cutting across the grain, use a sharp knife and work slowly and carefully. *Avoid undercuts.*

 Apply ink with a soft brayer and print on a press or by burnishing. Use a press only if the block

Woodcut on Irregular Scrap. 14″ high. Lutheran High School, Los Angeles. Note how the design is planned to fit the shape of the scrap.

Printed Scraps of Wood. Lutheran High School, Los Angeles. The varied textures of wood are revealed when unaltered scraps of wood are inked and printed. Experiment by varying colors and overlapping shapes, as shown here. Photo, courtesy Gerald Brommer, teacher.

Experimental Techniques. Lutheran High School, Los Angeles. In (a), one of the two colors is printed upside-down. In (b), a woodcut is combined with linoleum and brayer prints on oatmeal paper. Photos, courtesy Gerald Brommer, teacher.

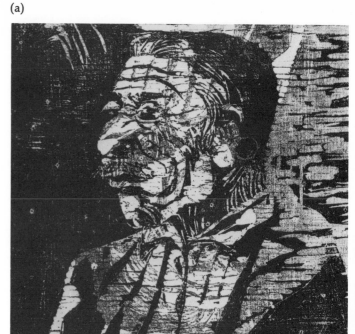

(b)

Two-color Woodcut. Lutheran Senior High School, Los Angeles. Note careful attention to the effective use of contrasting values and variety of textures. Photo, courtesy Gerald Brommer, teacher.

can withstand the necessary pressure without splitting or cracking; burnishing is the preferred method. Follow printing procedures described for scrap prints.

Notes:

1. Experiment with textures by cementing cardboard shapes, screen, scrap metal or textured metal foil to the surface of the block. Use these techniques only when they will improve design quality; too great a variety will destroy the character of the design, which should reflect the characteristics of *wood*.

2. Use small pieces of wood to create mini-blocks, to be used as wood stamps. With a strong cement, attach spools, corks or smaller pieces of wood to form "handles," for easier handling. (Design ideas: letters; numerals; animals; abstract shapes.)

Panels

Decorative panels or plaques may be designed from a variety of woods including planks, weathered barnboards, wood shingles, driftwood, scrap, parts from discarded furniture, pressed boards and plywood. The general contour of the panel may be rectangular, circular, free-form or cut to a particular shape, such as a figure or animal. Larger panels may be made by using plywood, Masonite or by joining several planks with battens attached to the back. (Use screws, nails or glue.)

Panels may be designed as flat surfaces or as relief surfaces; surface treatments (painting, staining, etc.) depend not only on the requirements of the design but on the characteristics of the wood as well. A beautifully grained, handsome piece of wood should not be covered by opaque paints or paper cut-outs; unattractive or marred wood can be improved by these treatments which will cover cracks, unsightly stains or other flaws.

Designs should relate to the shape of the wood; trace the contour of the wood on a durable paper (kraft paper, wrapping paper) and design within that shape. Work boldly, with felt-tip markers or thick crayons; if areas are to be cut away, indicate these areas on the design.

When the design is completed, transfer it to the wood by drawing directly on the wood or, more cautiously, trace it on the wood. (Use carbon paper, or cover the back of the drawing with light or dark chalk.) Finish the panel by *one* of the following procedures:

1. Paint the design using household *paints, enamels,* artists' *oil colors* or *acrylic colors*. (These paints are relatively durable and sealers are not required.)

 If a white or especially smooth surface is required, first coat the panel with gesso. Apply at least three coats, permitting each to dry before applying the next. Sand, if required.

2. Seal the wood with liquid floor wax, acrylic medium and color the design with *inks, wax crayons* or *oil pastels*. Felt-tip markers may be used to outline shapes before colors are applied. Experiment by scratching into the surfaces of crayoned areas, as in crayon etching.

3. Create a *relief design*, cutting into the wood with knives, gouges and "found" tools. Use a flexible shaft tool to incise lines, textures. Brush the surface and finish with stains, waxes or oils.

4. Build up the surface by adding shapes cut from wood. Layer the shapes in selected areas, working for variety. Attach shapes with screws, nails or glue. Finish with stains or paints; use spray paints to emphasize varying depths of the relief.

5. Seal the wood with acrylic medium or other sealer. Create the design by adhering *paper cut-outs,* seals or drawings with acrylic medium or glue. Complete design by painting or drawing in the areas around the paper motifs. When the design is complete, seal the entire surface with acrylic medium, P.V.A., decoupage medium or other sealer.

6. Paint the surface of the panel (Masonite, plywood, joined planks) with a flat color. Create a design from *found wood*: knobs, handles, dowels, strips, pop sticks, children's blocks, etc. Paint or stain the scraps and mount them on the wood panel with strong glue. Or, do not paint the panel: adhere wood scraps as found and, when the design is complete, spray paint the complete panel in a single color.

7. On a *plywood* panel: Create a relief design. Use a sharp knife, cutting through the layers of wood to create varying levels or projections. Finish by charring the surface with a propane torch. Clean the surface with a stiff brush and finish with *thin* oil stains. (Mix artists' oil colors with turpentine and a bit of linseed oil.) Brush the stain over the

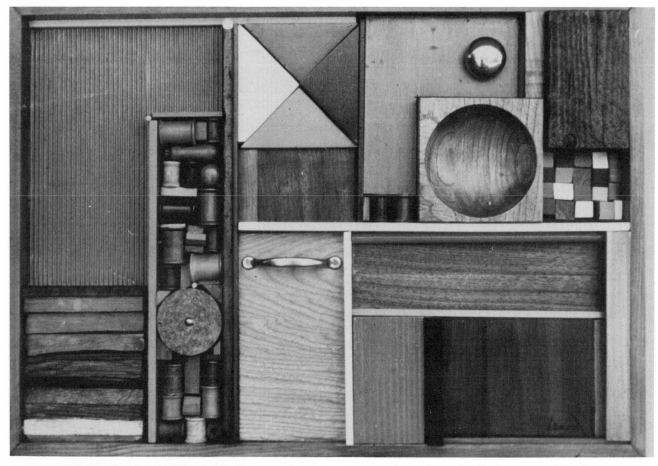

Domesticks. 23″ x 30″. Chris Lemon. Wood, in various shapes, combined with corrugated paper, bowl and pieces of hardware. Some of the elements are stained, others are painted. Note the variety of shapes and sizes and how they are visually balanced within the total composition. Photo, courtesy the artist.

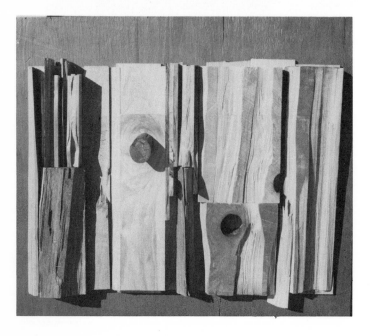

Wall Panel in Scrap Wood. 20″ x 24″. Lutheran High School, Los Angeles. Scrap wood on plywood sheet. Note how knot-holes provide contrasting shapes and how texture is achieved by grouping the narrowest strips of wood, on the left. Photo, courtesy Gerald Brommer, teacher.

entire surface, then wipe it away with a soft cloth until the desired effect is achieved. Seal with liquid wax.

Notes:

1. Many variations and combinations of techniques are possible: surfaces may be carved, incised or textured *before* they are painted; designs may be outlined by metal pastes extruded from a tube; bits of metal, stained glass or mirror may be added to create sparkling accents or mosaic-like elements. *The key to success is knowing the characteristics of the materials at hand and how they can be combined most effectively.*

2. Ideas for designing: Game boards; mottoes; clock-faces; story-book characters (cut out shapes or paint them on the panel); fanciful animals; cookie molds; icons; mobiles.

Constructions and Assemblages

Gathering materials for construction and assembling designs in wood is a "fun" project in itself; each day's search for usable wood "things" brings added excitement: an old newel post, a cracked wooden salad bowl, a box of wooden spools, the top from a wooden keg (or the keg itself), an old wagon wheel — all suggest design uses that are quite different from their original reasons for being. There is no formula for using these diverse shapes except that sufficient time should be allowed for creative "play" — time to study each item, to combine and arrange pieces until the imagination is triggered by the "right" combination of shapes, textures and colors.

In addition to wood, consider other materials that provide contrasting textures and colors: bits of metal such as washers, screws, drapery rings, nails, upholsterer's tacks, lids from bottles and jars and discarded costume jewelry.

Emphasize sound construction and good workmanship; a construction should not literally fall apart because the right glue or fastener was not available. *Epoxy cements* are most reliable for joining un-like materials or extremely heavy objects; other heavy duty all-purpose cements are reliable, particularly those manufactured by the Bond Adhesive Co. (See Sources of Supply.) Parts to be joined should be clean and properly finished by sanding, polishing or whatever is required for a better appearance. If the piece is to be mounted on a base, the material of the

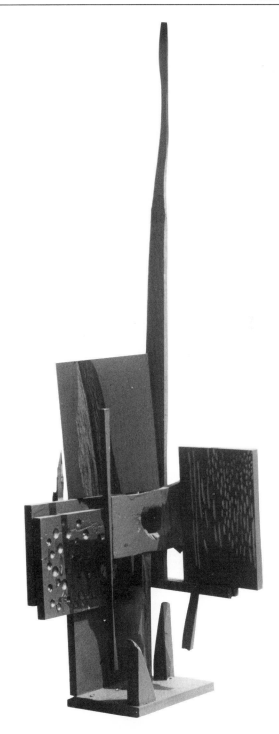

Wood construction. Height, 38". Lutheran High School, Los Angeles. Wood scraps. Some pieces were textured before assemblage. Photo, courtesy Gerald Brommer, teacher.

base, its scale and finish should be considered since the base, in fact, is a part of the total design.

Materials and tools required for constructing and assembling include those listed early in this chapter. Additional tools may be required if materials other than wood are used: tin snips, wire cutting tools and emery cloth are needed for metal. Add other tools, as needed, for additional materials.

In contrast to projects constructed or assembled from a collection of "parts," designs may be created by dividing a whole object into parts, then reassembling it in a form quite different from the original. In preparation for this approach to designing, think of a solid geometric shape, such as a sphere, pyramid or cylinder, in wood: if it were "sliced" horizontally or vertically, what kinds of shapes would result? How could they be rearranged by stacking, by threading on a steel rod or by being glued into a freestanding sculpture? Suppose the "slices" varied in thickness — how could this affect the arrangement?

Collect a variety of ready-made wood shapes and "slice" them by sawing. (A power saw will make sawing thick shapes much easier but handsaws may be used for smaller, light-weight shapes.) Look for cubes or blocks of wood, old wooden salad bowls, wooden plates, spoons, balls, newel posts, chair legs or turned wood discards from a furniture manufacturer or cabinet-maker's shop.

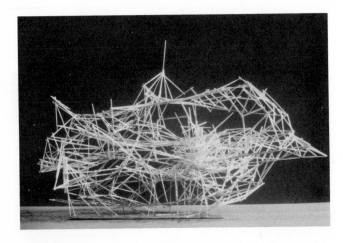

Toothpick Construction. Height, 14". Toothpicks provide a readily available inexpensive material for construction. Use a quick-drying clear cement, such as "Duco". Photo, courtesy Gerald Brommer, teacher.

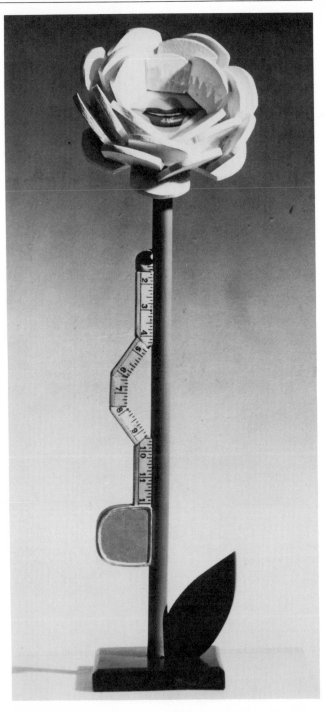

Wood Construction. Donn Russell. A whimsical inchworm is fashioned from a ruler; painted lips provide a feminine characteristic at the center of the flower. Designs such as this require only wood scraps, a bit of paint and imagination. Photo, courtesy United States Plywood Corp., New York.

Sky Columns. Wood. Louise Nevelson. Widely varying shapes of wood are unified by black paint. Note that the column on the right is hinged, to reveal an inner design. Photo, courtesy United States Plywood Corp., N. Y.

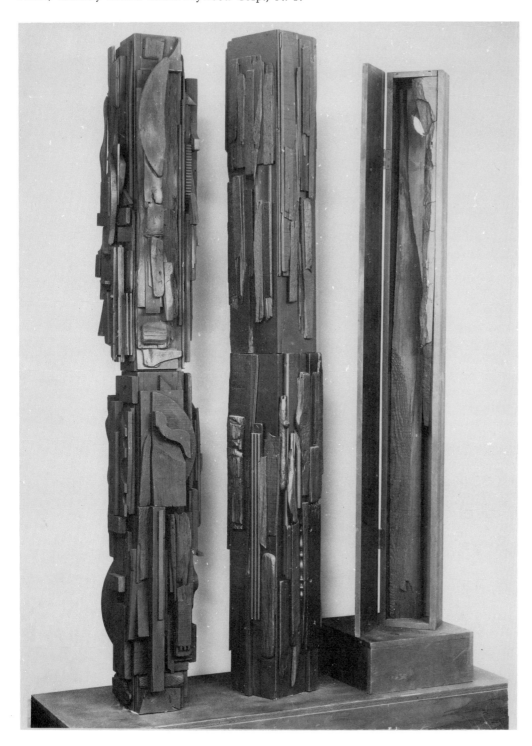

Brooch. Arline Fisch. Silver frame and rivets, tropical wood inlay. 2" x 2¾". Photo, courtesy the artist.

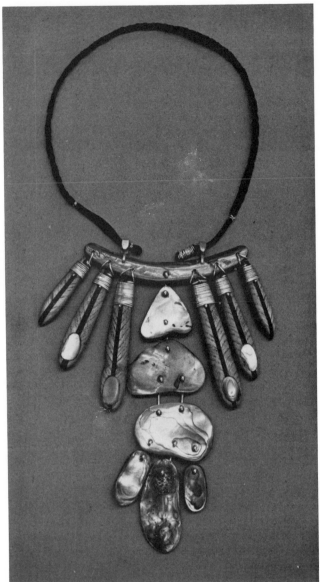

Necklace. Scott Corey. Wood, combined with abalone shell. The links are fused silver. Photo, courtesy Caroline Tupper.

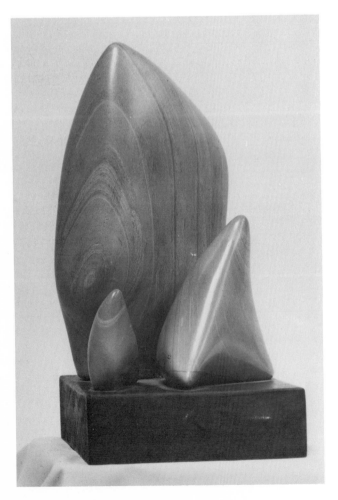

Sculpture in Diatomite. Fort Lee, N.J. Senior High School. Diatomite is a soft, natural material, formed under water, from minerals and fossils. The grain is similar to wood. Brand name, "Maple-Rok". Photo, courtesy Joan DiTieri, teacher.

Join the reassembled parts with glue, screws, nails or bore holes through them and insert a metal rod or thin wood dowel through *all* of the parts. Experiment by holding the rod horizontally then vertically; does this suggest movable parts that may be rearranged by the viewer?

Ideas for Designs:
1. A Noah's ark, complete with "assembled" animals — or a zoo.
2. All the characters from a favorite story.
3. A wooden "family portrait."
4. A nut cracker; a cigar store Indian; a totem.
5. A store sign. (Barber, baker, shoemaker, butcher, etc.).
6. Puppets. (Attach movable parts with bolts, washers and nuts to ensure free movement.)
7. Games or toys with movable parts; a set of blocks.
8. A weathervane; a mobile.
9. A "rock" music band. (Look for discards from musical instrument repair shops.)
10. Wood jewelry. Combine wood with wire, sheet metal or scraps of leather.
11. A class portrait, with each student making his own self-portrait from wood and found materials.

Note: In projects involving figures made by an entire class (zoo, Noah's ark, etc.) it is important to discuss overall size or scale, particularly if the figures are to be displayed together. This is especially important when working with younger students.

Wood Sculpture
Large blocks of wood for carving are rarely available for classroom use. Tree trunks are sometimes available, particularly in rural areas, but if a larger project is planned, planks must be laminated, or glued together, to build up the mass of wood required. This is an expensive and painstaking process: only select grade wood should be used, the boards should be planed accurately and be uniform in thickness; care should be taken in the manner in which the boards are angled or placed. A detailed description of this rather technical process is beyond the scope of this discussion. (For reference, see the Bibliography.)

Generally, large pieces of wood available for classroom use are logs, tree trunks or "found" wood which may include railroad ties, wood from wreck-

Wood Pull Toy. Baltimore City Schools. Scraps of wood and dowels.

Architectural Model. Baltimore City Schools. Balsa wood and cardboard.

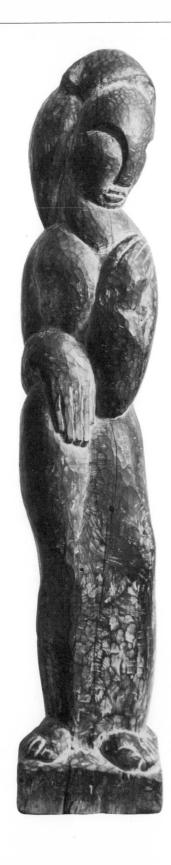

ing sites and driftwood. If unseasoned logs or tree trunks are used, expect the wood to crack or "check" as it dries. (Many wood sculptors will not work on unseasoned wood; others, feeling that these changes are characteristic of wood, choose to ignore them.)

The piece of wood to be carved should be studied carefully from all angles before the actual cutting of the wood begins. Design should be related to the mass and should reflect the characteristics of the wood at hand. Generally, forms should be compact and rounded; thin, fragile projections do not reflect the inherent strength of wood.

When the form the wood is to take has been determined, lines that define larger masses may be drawn on all sides of the wood; these lines will serve to guide the sculptor as he makes the first cuts in the wood to establish the general shape of the form. These lines will soon disappear as cutting progresses but are important as they remind the beginner that sculpture in-the-round is viewed from *all* sides, unlike painting or relief sculpture that is attached to a backing. The removal of the wood should proceed *gradually*, over the entire surface of the mass: there should be no attempt to finish one area completely before moving on to another because slight changes may need to be made as the interior of the wood is revealed.

The primary cuts in a large piece of sculpture are usually made with a wood carving *adze* or a hatchet; other tools may be improvised. As the work of defining contours continues, progressively finer tools are used: chisels, large wood *gouges* and a mallet, then wood *files*, followed by rasps and rifflers. Metal *scrapers* and *sandpapers* are used for final smoothing before waxes, stains, oils or other finishes are applied.

The carver should avoid "fighting" the wood; whatever knots or flaws are revealed must be incorporated in the finished forms. Cutting across the grain should be avoided unless absolutely necessary; such cuts often crush or splinter the wood, particularly soft woods. Undercuts weaken the surface of the wood.

Standing Figure. Wood. Dimensions not given. Jose de Creeft. The figure was carved from a single timber of Georgia pine which was seasoned by years as a support in subway excavations. The sculptor's direct approach is evident in the sensitively chiselled surface. Photo, courtesy, U. S. Plywood Corp., New York.

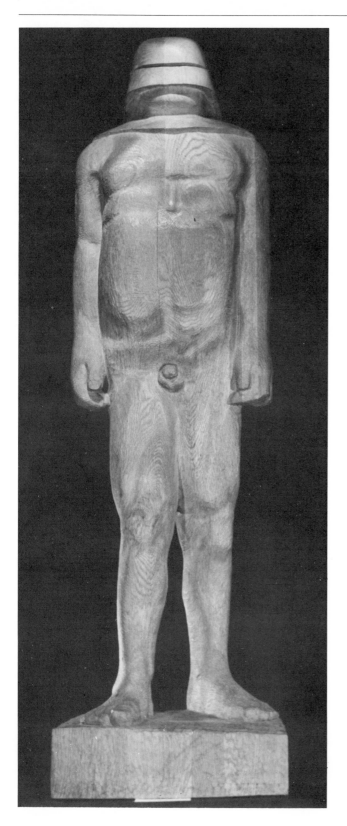

The beginner must learn how to hold and handle tools comfortably and effectively and should practice cutting at an angle, so that wood is removed in chips rather than chunks.

Tools should be kept sharp with *oil stones* or a mechanical *grinding stone*. Woodcutting tools become dull rather quickly unless the finest grade tools have been purchased and their proper care is essential.

Safety precautions: (1) Goggles, to protect the eyes, should be worn during wood carving and the sharpening of tools. (2) Hands should be kept in back of the cutting tool. (3) If a cutting tool is dropped, there should be no attempt to catch it; a painful cut could result from grabbing the tool blindly.

Warrior. Wood. Leonard Baskin. Dimensions not given. Size and continuity of material required in this work are achieved through lamination of wood. Note that, although the figure is composed of individual pieces of wood, they are laminated and treated in a manner that assures their working together for the effectiveness of the whole figure. Photo, courtesy United States Plywood, Corp., N. Y.

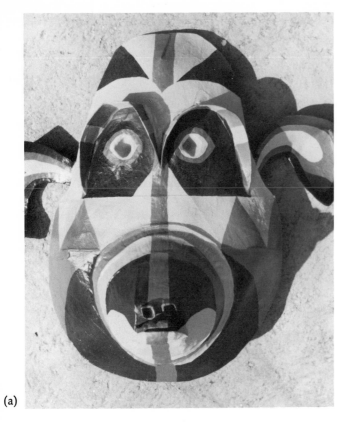

(a)

Masks. College students. Designed to be worn, these imaginative masks reflect the students' concern for sculptural forms and decorative pattern. In (a) note how spaces are divided to emphasize the eyes and snout-like nose. In (b) forms are joined to create a more complex mask. Both are built over paper and cardboard forms. Photos, courtesy Michael T. Lyon, University of Washington, Seattle.

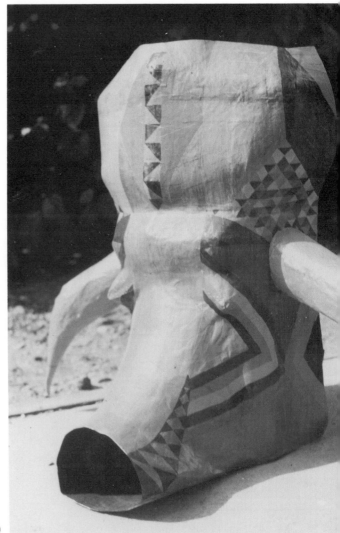

(b)

Chapter 10
Papier-Mache

One of the most widely used modeling materials, papier-mâché is inexpensive and lends itself to many construction and craft uses including masks, animals, figures, jewelry, decorative objects and display figures.

METHODS

Choose the method best suited to the project planned: the pulp method provides a material that resembles clay in its plasticity and is adaptable to modeling fine detail such as features on a puppet's face or jewelry. The *strip* method, probably the most widely used, is practical for such popular activities as mask making, figures, animals and decorative objects. The *sheet* method saves time in the designing of large display figures, stage "props," and even in small projects requiring little modeling or fine detail. The sheet of mâché, cut to size and molded, can be joined by applying strips of mâché or heavy tape.

Pulp Method
1. Tear newspaper into narrow strips.
2. Soak strips in water for a day or two or until strips have become sodden.
3. By hand, shred the paper into small bits.
4. Using a strainer or collander, drain the water from the paper, removing as much as possible.
5. Add enough wheat paste or flour paste to achieve the consistency of soft modeling clay.

Optional: Add one teaspoon of boric acid to each pint of water used for soaking to prevent mildew. A few drops of oil of cloves or wintergreen prevents an unpleasant odor that is apt to develop if the mixture is held over several days before use. A sprinkling of *plaster of Paris* makes a more clay-like texture. Acrylic modeling paste, kneaded into the wet pulp, makes a stronger, more plastic medium.

Strip Method
1. Tear newspaper into long strips.
2. Dip strips in wheat paste, flour paste or thinned library paste.
3. Place strips on a prepared form until the desired thickness is achieved.

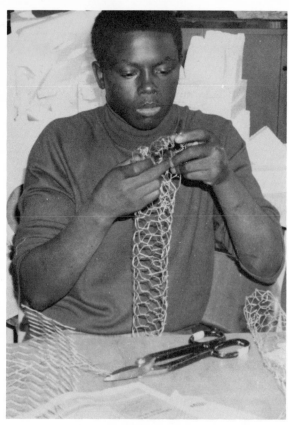

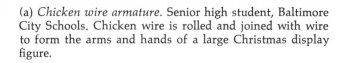

(a) *Chicken wire armature.* Senior high student, Baltimore City Schools. Chicken wire is rolled and joined with wire to form the arms and hands of a large Christmas display figure.

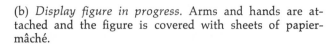

(b) *Display figure in progress.* Arms and hands are attached and the figure is covered with sheets of papier-mâché.

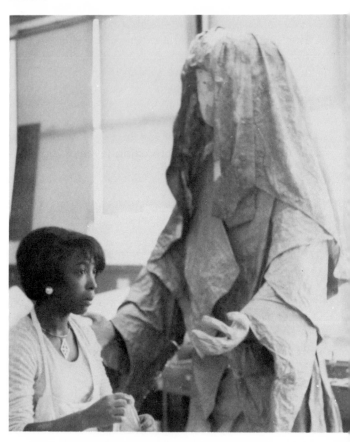

(c) *Shepherd.* The finished figure has been painted and details, including a beard, have been added. Photos, courtesy William Jessup, teacher, Edmondson High School.

Optional: Instead of applying strips to the form immediately after dipping them in paste, permit them to soak in the paste for a few minutes until they are somewhat softened. This makes for easier modeling and a smoother surface. If acrylic medium is substituted for the paste, a sturdier, more permanent finish is achieved. To assure an even layering of strips, use two different types of paper: newspaper for the first layer and colored comic sheets for the second layer. This is especially recommended when working with younger students who may lose track of where the first layer ends and the second begins. *Note:* It is important to *tear* the paper rather than cut it since the ragged unevenness of the torn edges makes for a smoother finished surface. For an especially smooth finish, use tissue paper for the final application, working it over the still-wet preceding layer or dipping it *quickly* into the paste.

Sheet Method

1. Smooth (by hand or brush) a coating of wallpaper (wheat, flour) paste over a sheet of newspaper.
2. Place another sheet of newspaper over the first and press it down firmly by hand or brayer (roller).
3. Cover the second sheet with paste and repeat the process until 6 to 8 layers have been applied.

Note: When the pasted sheets have dried to a leathery texture, they may be cut and molded into the desired form and allowed to harden. If forms must be joined to build a larger figure, use paper strips dipped in paste or cloth or paper tape. These joints should be as thick as the layers of pasted paper, otherwise the finished figure may be wobbly or come apart at the seams.

PROCEDURES FOR PAPIER-MÂCHÉ

Armatures

A sturdy, well-built armature, or "foundation," is essential for successful papier-mâché projects. Younger pupils, particularly, are eager to use the mâché and do not want to take time to build a stable support. The results are figures that wobble precariously or refuse to stand at all.

For simple, small forms the mâché may be used without an armature but, in general, the usual class-

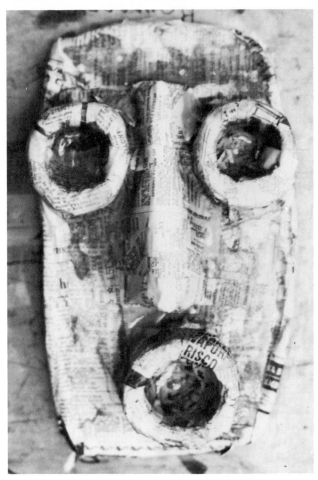

Basic Form for a Mask. The basic shape is made of cardboard. Eyes and mouth are rolls of newspaper and the nose is shaped from folded tagboard. Paste-soaked strips cover the entire surface. The mask is not designed to be worn and is essentially flat.

room project will require a support of some type. Make the type of armature or support that will best suit the project. *Figures* and *animals* that stand require sturdy, well-balanced armatures; *masks, decorative objects* and *jewelry* may be built over light-weight armatures that may even be removed when the papier-mâché has hardened. Whatever the type of support, it should be well-constructed for the purpose it is to serve.

Newspaper rolls are easy to make and inexpensive. Roll the newspaper, keeping the rolls fairly compact; use pieces of masking tape or twine to secure loose

ends. Tie the rolls together to form the general shape of the figure to be completed. Think of the newspaper rolls as the "skeleton," bending them wherever joints occur. Bind joints securely with strong cord, twine or florist's tape. Stand the armature upright and make adjustments: use crushed paper to fill in or strengthen joints, then tape or tie them securely. If the form is to stand on a base of wood or hardboard, attach it securely with tacks, staples, wire or small nails. If it is to stand on its own feet, finish them properly. (Ragged unfinished ends are unattractive and become more ragged with use.) Crushed newspaper may be tied or taped to the armature to fill out the form. It is now ready for the application of the papier-mâché strips.

Wire, of various kinds, makes a strong, lightweight armature, particularly for more complex figures. Collect wire that can be easily bent and shaped; coat hanger wire is usually too rigid for easy manipulation, particularly for younger pupils. Newspaper binding wire, stovepipe wire, electrical wire — collect a variety. Use stronger wire for the main lines of the figure and smaller wire to build shapes and masses. *Wire screen* and *chicken wire* may be rolled or shaped to make planes or body masses. Attach screen and chicken wire by threading fine wire through the mesh, then twisting it tightly. Fill in areas with crushed newspaper or aluminum foil, binding all securely with fine wire or twine.

Aluminum foil makes a strong lightweight but relatively expensive armature. It can be modeled fairly quickly, however, and is especially suitable for small forms. Simply crush the foil, pushing and pulling it to achieve the basic form of the figure to be completed. Foil is especially recommended for making supports for masks; students may even shape the foil over their own faces to achieve a basic form from which to work.

Wood is recommended as an armature for large forms such as those used for displays and stage "props" but, of course, may be used for even the smallest forms. Cut lengths to approximate the size of the form to be constructed and join with nails, glue or screws. Fill out the form with chicken wire, screen, crushed newspaper or coarse fabric. *Balsa wood* or *bass* wood — both are easily cut or carved

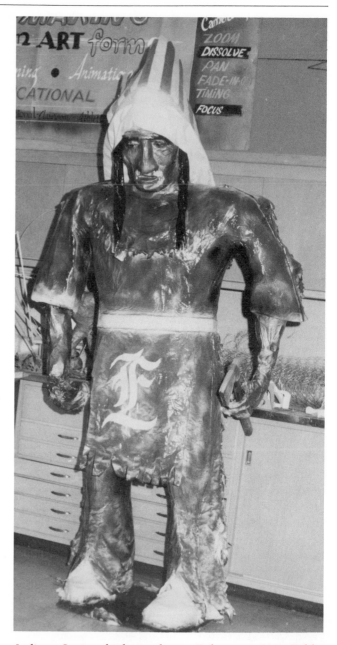

Indian. Senior high students, Baltimore City Public Schools. The school's "mascot" was constructed of papier-mâché (sheet method) over an armature of wood and chicken wire. A sturdy, well-built armature was necessary for this figure which is 7'6" tall. Photo, courtesy William Jessup, teacher, Edmondson High School.

Elf. The strip method is used to cover an armature made of stiff wire and rolled paper tubes. Facial features are shaped from pulp.

Kangaroo and Lion. Senior high students, Baltimore City Schools. Strips and sheets of papier-mâché over armatures of chicken-wire and crushed paper. Note life-like positions and expressive faces of animals. Elwood Miller, teacher.

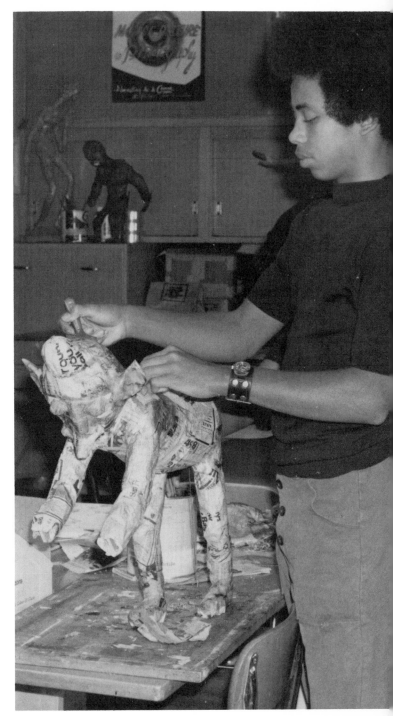

— may be used for small, lightweight forms. Join with quick-drying cement such as "Duco."

Plasticene, or *modeling clay*, lends itself especially well to smaller forms requiring detailed modeling such as puppet heads and, in some instances, masks. Shape the form from the clay, then cover it with papier-mâché. When the mâché has dried, cut the form down the center and carefully pull it away from the clay. Rejoin the pieces with papier-mâché **strips** applied along the seams. Obviously, very complex figures cannot be done in this manner but it is an effective method for heads, masks and other simple forms.

Plastic foam, such as Styrofoam, is lightweight **and** has an added advantage in that it may be carved and shaped with carving tools or kitchen knives. If separate pieces of foam are used, join them with plastic glue, wire pins, or lengths of stiff wire that will pierce the crisp plastic "foam." Test the glue to be used on a scrap of foam to be sure that it will adhere; some glues will dissolve plastic foam on contact.

Cardboard tubes and boxes are readily available and, when taped together, provide a strong, rigid support. In some instances, holes may be cut in the boxes and tubes inserted to provide legs, arms and necks for figures and animals. These joints should be securely taped so that the tubes do not slide too far into the boxes. Fill in with crushed newspaper and bind securely. Consider cylindrical salt and oatmeal boxes, egg cartons and shoe **boxes.**

Other Supports

Choose the support that can be incorporated into the general shape of the object or form to be built.

1. *Inflated balloons*. Rest the balloon on a circular band cut from cardboard while mâché is being applied; this prevents wobbling.
2. *Plastic containers*. Bleach jugs, starch jugs and others as available. Join with plastic glue.
3. *Stuffed paper bags*. Larger, longer bags may be stuffed and tied in sections. If more than one bag is used, join them securely with cord and strong paper tape.
4. *Pipe cleaners*. For small figures and animals.
5. *Bowls*. Ceramic or plastic. Papier-mâché may be applied to the inside or outside of a bowl. First,

cover the surface of the bowl with wet newspaper (no paste) or Vaseline for easy removal. (A smoother finish is obtained if the mâché is applied to the *inside* of the bowl.) Be sure that strips extend well over the edges of the bowl; they can be trimmed evenly before completely dry.

6. *Corrugated board*. Construct the armature as you would construct paper sculpture. *Score* the board to bend it easily; join parts by slotting or taping. Reinforce with cloth or paper tape or strips of papier-mâché.
7. *Found objects*. Light bulbs, fiberboard containers, cardboard cylinders (from rug and carpet stores), tin cans wrapped in newspapers, cardboard ice cream containers (gallon-size), cardboard paint buckets, and discarded objects such as lamp shade frames.
8. *Wooden clothespins*. Especially good supports for building heads, as for puppets. Model mâché heads on pins, then hang clothespins upside-down on line until the head has dried.

Finishing

Before applying a finish, check the surface of the form to see that it is as smooth as desired or required. If there are slight roughnesses, they may be sanded with fine sandpaper. If an especially smooth finish is desired, brush on a coat of gesso. *Acrylic* gesso is especially recommended because it is particularly durable and provides a ground for all paint media. White vinyl household paint may also be used as a ground or base coat.

Tempera paints are the most widely used and are relatively inexpensive. A bit of white glue added to the paints will lessen the danger of chipping or, when the paints are thoroughly dry, the form may be shellacked, varnished or brushed with acrylic medium to seal and protect it.

Acrylic paints are especially recommended because they will not chip off and no further sealant is required. If a high gloss is desired, acrylic gloss finish may be brushed over the surface.

Metallic and "antiqued" effects are often quite handsome on decorative objects and jewelry. Apply any metallic paint; temperas and spray types are suitable. When the paint has dried, brush on a coat of flat black

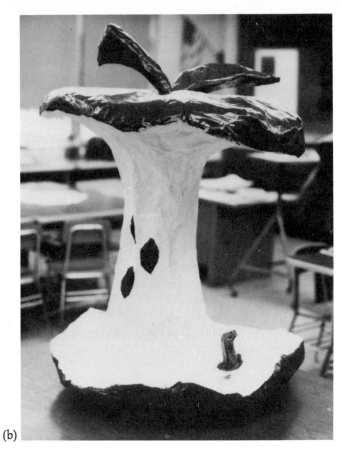

(b)

Giant Fruits. Senior high students, Baltimore City Public Schools. In (a), grapes are made of strips applied over balloons; leaves and stem are cut from sheets of papier-mâché. The apple core (b), was constructed of sheets and strips over a chicken-wire armature. Note worm emerging from lower part of apple. (c) The slice of melon, not quite complete, shows its base of wire and paper strips. Elwood Miller, teacher.

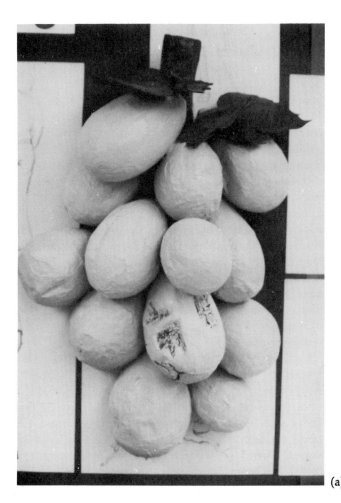

(a)

(c)

paint — or black with a bit of blue or green added — and permit to dry. (Use a water base paint.) With a damp sponge or cloth, wipe away the black paint, leaving traces of it in depressions and crevices until the desired effect is achieved. Shellac, acrylic medium or P.V.A. (polyvinyl acetate) may be brushed over the surface to seal and protect it.

Lacquer, Varnish. Clear, spray-on types are the most useful. *Note:* Do **not** apply lacquer over oil base paints.

Decorative papers of various kinds may be applied to papier-mâché in collage and decoupage techniques. Consider wrapping papers, wallpapers, paper "lace" mats, colored tissue, metallic leaf, colored pictures from magazines, paper seals.

Fabrics, lace, ribbon. Apply with thinned white glue. Test a sample of the fabric before applying it to find if the adhesive discolors it.

Dancing Figures. Senior high student, Lutheran High School, Los Angeles. Metal-paste, or "liquid" metal, over an armature of papier-mâché. 8" high. Photo, courtesy Gerald Brommer.

Enamels may be applied successfully. For better results, first seal the object with a mixture of one part white glue, one part water or with acrylic medium.

USES FOR PAPIER-MÂCHÉ

Puppetry
Build heads over cores of crushed newspaper, wadded, then taped or tied in place. (Insert cylinder of lightweight cardboard to serve as finger stall and neck of puppet before applying strips or pulp.)

Masks
Build over plasticene model, cardboard strips, heavy foil relief, boxes, dome shapes, balloons or paper bags stuffed with crushed newspaper.

Figures; Animals
Build on appropriate armature; newspaper rolls, cardboard cylinders and wire are most commonly used. Save cardboard rolls from tissue, paper towels and other papers.

Fabulous Bird. The body is built over a crushed paper core, wire forms the legs; beak and feet are modeled from pulp. Feathers add a decorative accent. Senior high student.

Humpty-Dumpty. Elementary student, Baltimore City Public Schools. A papier-mâché body is combined with paper sculpture and box construction to create a favorite story-book character.

Hand Puppet. Elementary student, Baltimore City Public Schools. Strip method, over crushed newspaper core. Hands are made of felt mitten shapes; yarn and cotton batting are used for moustache and hair.

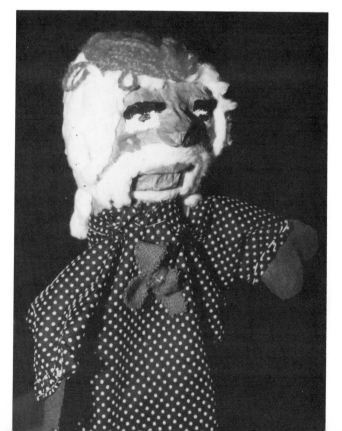

Bowls, Trays

Build over plastic or ceramic bowls; use metal or plastic trays as forms or construct a tray from corrugated cardboard.

Jewelry

Model small pieces, such as earrings, small pins and pendants from *pulp*. Create a "core" for a bracelet from tagboard strips pasted, in layers, around a glass jar. (Coat jar with plastic wrap or *wet* newspaper first — no paste — for easy removal.) Decorate by painting or gluing on interesting textural materials such as cord or lace. Set "jewels," from costume jewelry, in small dabs of fine paper pulp mixed with white glue. Push "jewel" well into the pulp to ensure adhesion. Set bits of mirror in *acrylic modeling paste* or *bread paste.* (See Improvised Materials, Chapter 1.)

Decorative Objects

Boxes, vases, lamp shades, wig stands, banks, picture frames, hand mirror frames, "fun" furniture, wall panels.

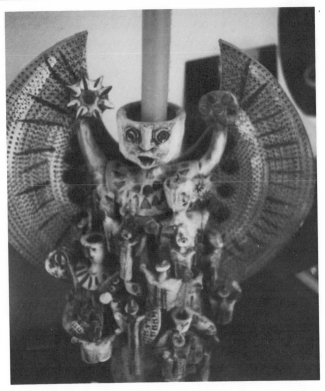

Candle Holder. Michael T. Lyon. An intricately modeled design, incorporating pulp and strip methods. Photo, courtesy the designer.

Head Dresses. College students. Fanciful designs created from wire, paper, cardboard, yarns and found materials. Photos, courtesy Michael T. Lyon, University of Washington, Seattle.

Sources of Supplies

Plastics

Poly-Dec Co., Inc.
P.O. Box 541
Bayonne, N. J. 07002
(Plastic mosaic tiles,
pellets)

Thermoset Plastics
Indianapolis, Ind.
(Epoxy mortar)

Macmillan Arts &
 Crafts, Inc.
College Park, Md.
(General)

Bergen Arts and Crafts
14 Prospect St.
Marblehead, Mass. 01945

Metal Pastes

The Sculp-Metal Co.
701 Investment Bldg.
Pittsburgh, Pa. 15222

Art Brite Chemical Corp.
81 Broadway
Jersey City, N. J. 07306

Metal

T. B. Hagstoz & Son
709 Sansom St.
Philadelphia, Pa. 19106

Sax Art Crafts
207 N. Milwaukee Ave.
Milwaukee, Wisc. 53202

California Crafts Supply
1096 N. Main
Orange, Ca. 92667

Economy Handicrafts
47-11 Francis Lewis Blvd.
Flushing, N. Y. 11361

Acrylic Paint Media (Colors, Medium, Modeling Paste)

M. Grumbacher, Inc.
460 W. 34th St.
New York, N. Y. 10001

Bocour Artist Colors
552 W. 52nd St.
New York, N. Y. 10019

Adhesives

Practical Drawing Co.
P.O. Box 388
Dallas, Tex. 75222

Slomon's Labs
32-45 Hunters Point
 Ave.
Long Island, N. Y. 11101

Bond Adhesive Co.
Box 406
Jersey City, N. J. 07303
(Highly recommended
for all adhesives)

Adhesive Products Corp.
1660 Boone Ave.
Bronx, New York 10460
(General)

Triarco Arts & Crafts
P.O. Box 106
Northfield, Ill. 60093

T. T. Hagstoz
709 Sansom St.
Philadelphia, Pa. 19106

Glass

Blenko Glass Co.
Milton, W. Va.
(Glass, in sheets,
cullet, chunks)

Willett Glass Studios
Philadelphia, Pa.
(Glass)

Whittemore-Durgin
Hanover, Mass. 02339
(General Supplies)

Kay Kinney Glass
Laguna Beach, Ca.
(General Supplies)

Ceramics

American Art Clay
4717 W. 16th Street
Indianapolis, Ind. 46222

Macmillan Arts &
Crafts, Inc.
9520 Baltimore Ave.
College Park, Md. 20740

Weaving; Stitchery

Lily Mills
Shelby, N. C. 28150
(Yarns, looms, needles,
general supplies, instruc-
tion charts)

Trait Tex Industry
6501 Barberton Ave.
Cleveland, Ohio 44102
(Yarns)

Macmillan Arts &
Crafts
7520 Baltimore Ave.
College Park, Md. 20740

Aiko's Art Materials
Import
714 N. Wabash Ave.
Chicago, Ill. 60605

Jewelry Supplies; Enameling

Thomas C. Thompson
1539 Old Deerfield
Road
Highland Park, Ill. 60035

Southwest Smelting &
Refining Co.
1712 Jackson
Dallas, Texas 75221

Tools (Professional Grade)

Beno J. Gundlach Co.
Belleville, Ill. 62221

The Starrett Co.
Athol, Mass. 01331

Tools (General, Student Grade)

Dremel Mfg. Co.
Racine, Wisc. 53401
(Power tools for crafts)

The Craftool Co.
Industrial Rd.
Wood-Ridge, N. J. 07075

Art Tissue

The Crystal Tissue
Company
Middletown, Ohio
45042

Economy Handicrafts
47-11 Francis-Lewis
Blvd.
Flushing, N. Y. 11361

Dennison Mfg. Co.
300 Howard St.
Framingham, Mass.
01701

Wood (Articles, Blocks, General Supplies)

Creative Hands, Inc.
4146 Library Road
Pittsburgh, Pa. 15234

Hunt Manufacturing Co.
1405 Locust Street
Philadelphia, Pa. 19102

Dick Blick
P.O. Box 1267
Galesburg, Ill. 61401

Triarco Arts & Crafts
P.O. Box 106
Northfield, Ill. 60093

Bibliography

Clay

Ball, F. Carlton and Lovoos, Janice. *Making Pottery Without a Wheel*. New York: Reinhold, 1965.

Kenny, John B. *The Complete Book of Pottery Making*. Philadelphia: Chilton, 1949.

Leach, Bernard. *A Potter's Book*. New York: Transatlantic Arts, 1951.

Rhodes, Daniel. *Clay and Glazes for the Potter*. Philadelphia: Chilton, 1957.

Supensky, Thomas G. *Ceramic Art In the School Program*. Worcester, Mass.: Davis Publications, Inc., 1968.

Petterson, Henry. *Creating Form In Clay*. New York: Reinhold, 1968.

Fabrics

Belfer, Nancy. *Designing In Batik and Tie Dye*. Worcester, Mass.: Davis Publications, Inc., 1972.

Green, Sylvia. *Patchwork for Beginners*. New York: Watson-Guptill, 1972.

Johnston, Meda Parks and Kaufman, Glen. *Design on Fabrics*. New York: Reinhold, 1967.

Maile, Anne. *Tie and Dye Made Easy*. New York: Taplinger Publishing Co., 1972.

Rainey, Sarita R. *Wall Hangings: Designing with Fabric and Thread*. Worcester, Mass.: Davis Publications, Inc., 1971.

Robinson, Stuart and Patricia. *Exploring Fabric Printnig*. Newton Centre, Mass.: Charles T. Branford Co., 1971.

Fibers

Duncan, Molly. *Spin, Dye and Weave Your Own Wool*. New York: Sterling Publishing Co., 1973.

McNeill, Moyra. *Pulled Thread Embroidery*. New York: Taplinger Publishing Co., 1972.

Meilach, Dona. *Creating Art from Fibers and Fabrics*. Chicago: Henry Regnery, Co., 1973.

Rainey, Sarita. *Weaving Without a Loom*. Worcester, Mass.: Davis Publications, Inc., 1966.

Phillips, Mary Walker. *Step-by-Step Macrame*. New York: Golden Press, 1970.

Sezd, Mary. *Designing with String*. New York: Watson-Guptill, 1967.

Glass

Eppens-van Veen, Jos. H. *Colorful Glass Crafting*. New York: Sterling Publications Co., 1973.

Isenberg, Anita & Seymour. *How to Work in Stained Glass*. Philadelphia: Chilton, 1972.

Kinney, Kay. *Glass Craft: Designing, Forming, Decorating*. Philadelphia: Chilton, 1962.

Schuler, Frederic & Lilli. *Glassforming: Glass-making for the Craftsman*. Philadelphia: Chilton, 1970.

Wood, Paul W. *Stained Glass Crafting*. New York: Sterling, 1967.

Papier-Mâché

Kenny, Carla and Kenny, John B. *The Art of Papier-Mâché*. Philadelphia: Chilton, 1968.

————, *Design In Papier-Mâché*. Philadelphia: Chilton, 1971.

Plaster

Meilach, Dona Z. *Creating With Plaster*. Chicago: Reilly and Lee, 1966.

Plastics

Newman, Thelma. *Plastics As An Art Form*. Philadelphia: Chilton, 1969.

Newman, Jay Hartley and Newman, Lee Scott. *Plastics for the Craftsman*. New York: Crown, 1972.

Roukes, Nicholas. *Crafts In Plastics*. New York: Watson-Guptill, 1970.

Wire and Metals

Brommer, Gerald. *Wire Sculpture and Other Three-Dimensional Construction*. Worcester, Mass.: Davis Publications, Inc., 1968.

Morris, John. *Creative Metal Sculpture*. New York: Bruce Publishing Co., 1971.

Rothenberg, Polly. *Metal Enameling*. New York: Crown, 1969.

Solberg, Ramona. *Inventive Jewelry-Making*. New York: Van Nostrand-Reinhold, 1972.

Ullrich, Heinz & Klante, Dieter. *Creative Metal Design*. New York: Reinhold, 1967.

Wood

Brommer, Gerald. *Relief Printmaking*. Worcester, Mass.: Davis Publications, Inc., 1970.

Laliberte, Norman and Jones, Maureen. *Wooden Images*. New York: Reinhold, 1966.

Meilach, Dona Z. *Contemporary Art with Wood*. New York: Crown, 1968.

Wilcox, Donald. *Wood Design*. New York: Watson-Guptill, 1968.

Index

Collage [handwritten annotation]

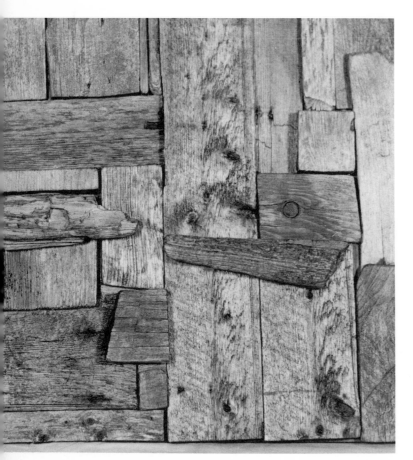

Acknowledgments

I wish to express my sincere appreciation to the many individuals and business firms who have assisted in the gathering of illustrative materials for this manuscript. Their cooperation has provided a real and substantial assistance in the completion of my work.

Special thanks go to Joan DiTieri, art teacher, Fort Lee, N. J., Senior High School; Michael Lyon, University of Washington, Seattle; Caroline Tuttle, jewelry teacher at El Camino Real High School, Woodland Hills, Calif.; and to Dr. Jay D. Kain, University of Minnesota, who made their extensive collections of illustrative materials available to me. Appreciation is extended to Ramona Solberg, author of *Inventive Jewelry Making*, and to Van Nostrand-Reinhold, for permission to reproduce photographs appearing in Miss Solberg's book. Lily Mills and Eleanor Hayes are thanked for their generous contribution of photographs and charts for stitchery and macrame. Contributions by other artists, teachers, and friends are noted in captions since a more extensive listing here is not possible.

My sincere gratitude is extended to all who assisted, not only with visual materials, but with the equally important contributions of interest, encouragement and understanding.

V. G. T.